The Courthouses of Texas

The Courthouses of Texas

A Guide by Mavis P. Kelsey, Sr., and Donald H. Dyal

Texas A&M University Press

COLLEGE STATION

Library of Congress Cataloging-in-Publication Data

Kelsey, Mavis Parrott, 1912–
 The courthouses of Texas : a guide / Mavis P. Kelsey, Sr. and
Donald H. Dyal. — 1st ed.
 p. cm.
 Includes bibliographical references and index.
 ISBN 0-89096-546-3. — ISBN 0-89096-547-1 (pbk.). — ISBN
0-89096-558-7 (limited)
 1. Courthouses—Texas—Guidebooks. I. Dyal, Donald H.
II. Title.
NA4472.T4K46 1993
725′.15′09764—dc20 93-7022
 CIP

Contents

Preface

I T MAY SEEM ODD TO SOME that a courthouse would hold
such intense attraction that many people plan vacations and
trips to include visits to communities with notable courthouses.
Nevertheless, it is common upon visiting an old courthouse to
find yourself jostling with camera-laden genealogists and other
tourists angling for the best photographs. Indeed, in some of the
more remote or sparsely populated counties, clerks and other
courthouse denizens comment that on many days there are more
folks in the courthouses wearing shorts and polo shirts than trans-
acting business.

The reasons for this fascination vary with the individuals con-
cerned. But it is clear that the emotional attachment many Tex-
ans have to their courthouses and to their architectural styles has
its roots in the relationship of Texans to each other and to their
government—the *local* government. As Paul Scott used to say, a
century ago the only federal officials a Texan knew were the post-
master and a census taker once every ten years. Since the state
government had virtually no local presence, the county was the
source of government contact. The county clerk recorded deeds,
issued marriage licenses, and, after the turn of the century, also
recorded births. The county tax assessor and collector annually
appraised property and collected taxes. The school superinten-
dent supervised the education of children. And of course, justice
emanated from the bench of the district judge. The county sheriff
enforced and implemented the court's decisions; the records of
the court reminded the citizens of past decisions. In addition,
county officials called upon citizens for jury duty, for road main-
tenance (every able-bodied male was eligible), and for service as
election judges. The county commissioners court provided funds
to care for those unable to care for themselves. When a citizen
died, it was the county judge who ensured that the estate was
lawfully administered. From birth throughout life, and even after
death, the lives of Texans were intertwined with the county gov-
ernment. Such a government—intimate and intensely personal—
encouraged an enduring loyalty and an emotional tie to people
who saw the courthouse as the architectural embodiment of jus-
tice, democracy, well-regulated government, and frank participa-
tion in the democratic process. Architectural historian Willard B.
Robinson commented that many courthouses reflected this egali-

tarianism architecturally; there was not one entrance but four. You could approach justice from any direction.

Besides the jurisprudence and recording functions of early courthouses, there were also important social functions. Dances, picnics, patriotic celebrations, parades, auctions, lectures, concerts, and innumerable other social events occurred in, at, or near the courthouse. The county courthouse was the focus of much of community life. Ideals of patriotism, civic duty, and civic pride centered in the courthouse. Little wonder, then, that many courthouses occupied the physical center of the county seat, and many had a courthouse square of distinction and prominence. This square also served as a market square during agrarian times, and historic squares or their vestiges remain in many rural Texas counties.

The promotional literature of land speculators and railroads prominently featured courthouses as an enticement for new inhabitants. Real estate values near the courthouse were always higher than elsewhere. The county fathers, aware of these opportunities, invested in stylish courthouses not just as symbols of pride and justice but also as an economic promotion to would-be investors or settlers. As a potent symbol of the civic, social, and economic viability of a county, the courthouse contained costly materials, ornate embellishment, and a design that evinced pride. The courthouse had to be an architectural statement of bustling enterprise; it was tangible evidence of prosperity, particularly in a young and growing region like Texas. These multiple uses or functions of county courthouses define the centrality of the courthouse in the minds and experiences of Texans, which sends Texans in search of other courthouses.

Following a personal essay by Dr. Mavis P. Kelsey, Sr., on his experience touring Texas counties and visiting their courthouses, the guide marches alphabetically through the 254 counties of the state, listing each county and its seat (with 1990 census figures). The number of courthouses each county has had follows—a tangled and confused area of history. Many histories list temporary courthouses of log or wood construction; others do not. Complicating the identification problem is the predilection of numerous early courthouses to burn to the ground—some more than once—thereby incinerating county records. (Indeed, the magnificent Hill County courthouse in Hillsboro burned while this book was in press.) The files of the Texas Historical Commission and hundreds of county and community histories filled many of the gaps. Listed, then, are those courthouses built by the county on county land (rented or leased quarters thus excluded) as found in these sources. The year noted is the year of completion or occupancy of the county. Next is a description of the current courthouse with some architectural description. The comments about architectural style come from Willard B. Robinson's books and

from the *Catalog of Texas Properties in the National Register of Historic Places.* The street location of the courthouse is essential to the guide, and the Notes section provides some ancillary information about county organization and the derivation of names. Many of these comments draw on Tarpley's *1001 Texas Place Names,* Delbert R. Ward's *The Urban Stars in the Texas Crown,* and, of course, the venerable but essential *Handbook of Texas.*

In our division of labor for the book, Dr. Kelsey took the photographs (except where noted in the credits), wrote the introductory essay, and compiled the appendixes. I wrote the county-by-county descriptions and the bibliographic essay. Dr. Kelsey has also provided financial support for the book's publication and has graciously signed over all royalties to Special Collections, Sterling C. Evans Library, Texas A&M University. While my own debt to Dr. Kelsey (who conceived this project and traveled to each county), the Texas Historical Commission, the staff of Special Collections at the Evans Library at Texas A&M University, and to many others is great, the responsibility for any mistakes is mine only.

<div style="text-align: right">Donald H. Dyal</div>

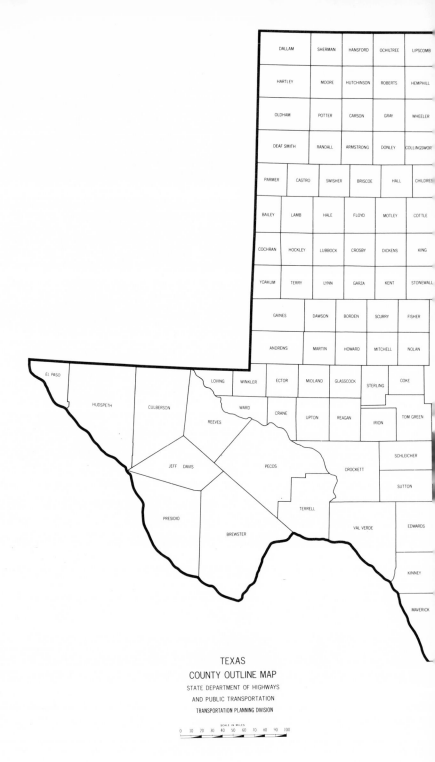

TEXAS
COUNTY OUTLINE MAP
STATE DEPARTMENT OF HIGHWAYS
AND PUBLIC TRANSPORTATION
TRANSPORTATION PLANNING DIVISION

SCALE IN MILES
0 10 20 30 40 50 60 70 80 90 100

The Courthouses of Texas

A Personal Tour
of the Courthouses
of Texas

Introduction

THE STATE OF TEXAS is divided into 254 governmental units. These are our counties, our bastions of democracy. Here we know and elect the officials who serve us on a person-to-person basis in our county courthouses. In most counties we are proud of our county courthouse, the only architectural landmark that many sparsely settled counties have. We are fiercely loyal to our home town and county. We train our children to defend them on the playing fields. Wherever we may roam, we proudly proclaim our town and county of birth as our native home. This loyalty is especially true for counties outside the great metropolitan areas and is exceeded only by our pride in the State of Texas itself.

The counties of Texas are surprisingly diverse. This is easily understood when we consider the geographic features of the state. According to the 1992–93 *Texas Almanac,* Texas is the second largest state, with 266,807 square miles of land, or 7 percent of the area of the United States. Its boundaries extend from 25°50′ to 36°3′ north latitude, and from 93°31′ to 106°38′ west longitude. Texas has a circumference of 3,816 miles following all the meandering of its borders, including 1,248 miles that it shares with Mexico. As the crow flies, it is 801 miles from the northwest corner of the Panhandle to the southern tip on the Gulf of Mexico and 773 miles from the Sabine River to the Rio Grande west of El Paso. By highway travel these distances approach 1,000 miles. There are ten peaks in the Trans-Pecos region above 8,000 feet, with Guadalupe Peak in Culberson County at 8,749 feet. There are 624 miles of coastline on the Gulf of Mexico. Fort Davis, the seat of Jeff Davis County, has an elevation of 5,050 feet, while Galveston, the seat of Galveston County, is 8 feet above sea level.

Texas is noted for extremes in weather, from −23 degrees Fahrenheit in Seminole, Gaines County, in 1933, and in Tulia, Swisher County, in 1899, to 120 degrees Fahrenheit in Seymour, Baylor County, in 1936. Annual rainfall has varied in this century from 1.76 inches at Kermit, Winkler County, in 1956, to 109.38 inches in Clarksville in Red River County in 1873. The coastal area is noted for hurricanes, the rest of the state, for tornadoes.

Among the varied geographic features are the beaches and bays of the Gulf Coast; the bayous of the Big Thicket National Park in East Texas; the Cross Timbers; the Chihuahuan Desert and Rocky Mountains of the Trans-Pecos; the semitropics of the Lower

Rio Grande Valley; the Permian Basin, the South Plains, and the Panhandle; the Balcones Escarpment, the Hill Country, and the Edward's Plateau of Central Texas; the pine forests of East Texas, and the many thousands of miles of plains throughout Texas.

Texas has hundreds of inland lakes (second only to Minnesota) and numerous rivers and streams, caves, canyons, wetlands, bays, and islands. Many of our natural features are being carefully acquired and preserved by the Texas Parks and Wildlife Commission. The National Trust for Public Land has been helpful in acquiring some of Texas' natural treasures. The Texas Nature Conservancy has recently acquired the 18,500-acre Dolan Falls Ranch in Val Verde County. A number of county governments attempt to preserve local features. The National Register of Historic Sites has been helpful in preserving some of the hundreds of archeological sites. All in all, there seems to be some improvement in preserving our natural heritage. Unfortunately, the national forests, property of all the citizens, are being systematically destroyed by the lumber industry, and urban expansion is taking its toll.

Texas is the third largest state in population with 16,986,510 people in 1990. This is a 19.4 percent increase over 1980, with most of the growth occurring in metropolitan areas. The Houston Metropolitan Area is the most populous, with 3,306,937 people, while Loving County has only 107 people. In the decade from 1980 to 1990, the state's Hispanic population increased 45 percent; black population, 17 percent; and that of other ethnic groups, 88 percent. Crystal City, seat of Zavala County is 98 percent Hispanic. Approximately 60 percent of the total state population is now Anglo.

Brewster is the largest county, with 6,193.1 square miles, larger than Connecticut and Rhode Island combined. The smallest county is Rockwall, with 148.6 square miles. Mills County (county seat, Goldthwaite) is the most centrally located county, according to the *Handbook of Texas,* but this claim is disputed by the citizens of McCulloch County in Brady and Hamilton County in Hamilton.

In addition to its physical attractions, Texas has hundreds of museums and thousands of historic sites. Every county has something interesting and unique to reward the Texas traveler or courthouse buff. This guide would become unwieldy if we tried to include all this information for each county. We will mention a few attractions, especially for the less populous counties.

Evolution of the Counties of Texas

BY THE TIME that Texas had become firmly established as a republic in 1837, twenty-three municipal districts had been organized. Most of these had already been established by the Spanish and Mexican governments.

The Municipal Districts of the Republic of Texas

Austin	Jackson	Refugio
Bastrop	Jasper	Sabine
Bexar	Jefferson	San Augustine
Brazoria	Liberty	San Patricio
Colorado	Matagorda	Shelby
Goliad	Milam	Victoria
Gonzales	Nacogdoches	Washington
Harris	Red River	

When the Red River District was organized by the Republic of Texas in 1837, the area had already been claimed in 1820 by the Arkansas Territorial Government of the United States as part of Miller County, Arkansas. In 1831, the county seat of Miller County was established at Jonesborough, near present-day Clarksville. Only after Texas joined the union on December 29, 1845, was this boundary dispute settled. Clarksville became the county seat of Red River District, Texas, while the county seat of the remaining part of Miller County in Arkansas was established in Texarkana, Arkansas.

In 1845, before the Republic of Texas became a state of the union, the congress of the Republic created the county court system, which authorized, among other things, a chief justice to be appointed by the president, a place to hold court, and a jail to hold prisoners for each county. Congress empowered itself to create new counties out of the existing twenty-three districts. These powers were carried over when Texas became a state; meanwhile, county citizens had been granted the power to elect their own officials and locate their county seat.

The larger districts were divided into numerous counties. Bexar, the "Mother of Counties," extended west to El Paso, south to the lower Rio Grande, and north to the top of the Panhandle. It was divided into more than one hundred counties. Red River District contributed thirty-five counties; Milam, Nacogdoches, and San Patricio counties were also large sources of new counties. By 1921, when Kenedy became the last new county, there were 254, and no changes have occurred since then.

The Spanish Governor's House in San Antonio may be the only remaining building where court was held in Texas during Spanish and Mexican ownership. Among the Texas county courthouses built during the Republic of Texas were ones in Colorado in 1836, Brazoria in 1839, Harris in 1838, and Harrison in 1839. None of these buildings survive.

The size of counties was usually determined by the distance citizens could go to reach the county seat and get back in a day by horseback or horse-drawn vehicle. A 30-mile round trip was indeed a good day's travel for an outlying farmer or rancher. Thus,

the usual county is about 30 miles in diameter, containing about 900 square miles, or 576,000 acres. Before there were significant settlements, numerous counties of the northwest Texas plains were laid out in 30-mile squares without regard to geographic features, and included thirty-six townsites of 5-mile squares. The county seat was to be located within three miles of the center. There are many exceptions, especially the huge counties of southwest Texas and the Big Bend and a few very small counties. Some counties were assembled from parts of adjoining counties. The average size for all Texas counties is 1,050 square miles, the size of Rhode Island. When the people of a designated county could muster 150 or sometimes as few as 75 names, including those of horses and dogs in some instances, they could petition for organization of the county to carry out all its functions.

The Courthouse Square

WHEN TEXAS FIRST BECAME SETTLED as a Spanish province, its communities were to be laid out according to centuries-old rules that had their origin in Rome. The center was to be an oblong plaza with public buildings around it and streets emanating from it. After Mexican independence, the State of Coahuila y Texas continued to regulate city plans. Streets were to be 60 feet wide, with a central square, or *plaza constitucional,* of 120 feet square. Several blocks around the square were designated for a church, market place, and other municipal purposes. At least one of the twenty-three municipalities existing in Texas on the eve of independence, Liberty, had been laid out in 1831 according to this plan, which still is evident today. The first courthouse was built on the *plaza constitucional* in 1831, and the fifth courthouse is now on that same square, which is described by historical markers in place there (Willard Robinson, *Texas Public Buildings of the 19th Century*). This site is the oldest continual location of a county courthouse in Texas.

With waves of immigrants coming to the Republic of Texas, the concept of the city public square and county courthouse soon took on the characteristics of early American city design. The majority of Texas county seats today are of that pattern.

Before the days of heavy traffic and bypass loops, the main highway usually entered the county seat on the main street and passed right by the courthouse square. Weatherford, the seat of Parker County has the finest perspective of its courthouse that I have ever seen. The courthouse square sits on an eminence above the surrounding countryside. Roads come into the center of the square from four directions, and the courthouse, in all its splendor, can be seen for miles—a Victorian building with its high clock tower. In season farmers' wagons loaded with watermelons used to crowd the square. My father said it was the largest water-

melon market in Texas. I learned later that some Weatherford citizens took eleven watermelons to the Saint Louis World's Fair in 1904. Each weighed more than one hundred pounds, and Weatherford was proclaimed "Watermelon Capital of the World." We always stopped and bought several melons to take to our relatives in Throckmorton when we were on our way west or to take home to Deport, Lamar County, when we returned east. We also had relatives in Weatherford with whom we often stopped for a brief visit. My great-great grandfather, Rev. William Martin Massie, is buried in Parker County in the Long Creek Cemetery. Descent from him makes me a fifth-generation Texan.

In the eastern half of Texas the courthouse square was often the cotton market. At harvest time you could hear the gins humming and the creaking of mule-drawn cotton wagons. The square would be crowded with wagons holding from one to three bales of cotton. The mules would stand quietly in their traces or would be unhitched and led to the livery stable or a vacant lot. The cotton buyers, including those from Anderson Clayton Company, circulated among the wagons, cutting small samples of cotton from the bales to test the length of fiber. "Fair-to-middlin'," "middlin'," and "strict middlin'" were some of their terms. Anyone in the cotton belt knew that if you felt pretty good, you were "fair-to-middlin'." The farmer would sell his cotton for the best offer, take his check to the bank, pay on his loan, and keep a little to buy necessities—Bull Durham tobacco to roll cigarettes; flour in a cotton sack (so his wife could use the sack to make clothes or cup towels); dried beans (more navy and butter beans in East Texas, whereas pinto beans were popular in West and South Texas); coffee beans to be ground at home; sugar, salt pork, Arm and Hammer baking soda, Comet rice, flour, and corn meal. Many farmers would bring their own corn to the local grist mill for custom grinding. An occasional Saturday morning chore for me as a boy was to shell about half a bushel of corn and take it to the mill to be ground into meal.

Some cities have, instead of a busy square, a relatively long business district on the main street, leading up to an imposing courthouse established on an elevation in broad sight of every visitor. Anderson, seat of Grimes County, and Post, seat of Garza County, are fine examples. In some cities, the courthouse is less prominent even though a busy main street passes by one side of the courthouse square (Canyon, seat of Randall County). And in a few towns the courthouse is completely removed from the center of the city (Del Rio, seat of Val Verde County, and Plainview, seat of Hale County). In one county the courthouse is "across the tracks" and still has a fence around it to keep the cattle out. Enclosed in the same fence are the sheriff's residence, the jail, and the windmill (Channing, seat of Hartley County).

Still, one of the most pleasant sights is the county courthouse

square. There must be more than 150 traditional courthouse squares in Texas today. They have a lot in common, but their diversity makes it fun to visit one after another. In my travels I have found many people doing just that.

First, there is the pleasure of driving through the interesting countryside of Texas with its infinite variety. If you are in no hurry, you can stop to read some of the ten thousand historical markers you will certainly pass. There are regional radio stations, broadcasting local news, sales and swap programs, weather, farm markets, and country and western (C&W) music. The radio ministry available on several channels preaches God's message: "Send money." I rarely listen to C&W music, but it does pass the time in the car. Along with the more traditional songs are many that are more sexually explicit, a reflection of the culture. Among the songs I heard while touring county courthouses were one that claimed "a six pack of beer and a bottle of wine; gotta be mean to have a good time," one about "I Found a Note My Grandma Wrote," and one titled "I'm Having Day Dreams about Night Things."

As you approach town you may see from miles away the tower of a nineteenth-century courthouse in any city lucky enough to have one that has been preserved. Quoting the artist laureate of Texas courthouses, Buck Schiwetz: "By whatever route you enter the city the tower of the Lavaca County courthouse at Hallettsville will first command your attention. . . ." When you drive into town, any passerby will proudly tell you how to get to the courthouse. To many, the county government is still the most important governmental body there is.

On the square the traveler may find anything from a thriving busy scene to an almost vacant declining village square. Dozens of each type can be named, but a few examples will suffice. Halletsville, Lavaca County, is an example of a busy square. I smelled barbecue the instant I drove onto the square in November, 1991. There are messages on the walls in these barbecue restaurants, such as "To all Employees: New Incentive Plan, Work or Get Fired." All thriving county squares smell of barbecue because that's what many people want for lunch when they come to town to do business. In spite of the much-publicized chili cook-offs, I believe barbecue is insidiously replacing chili as the official state dish. It is easier to get a take-out barbecue sandwich for the road than it is to sit in a cafe to eat a bowl of chili with crackers.

The other extreme of a busy square is Lipscomb, Lipscomb County, in the northeast corner of the Panhandle. Here the imposing courthouse stands virtually alone. The grass-covered vacant streets around the square have only a couple of houses and empty old wooden stores. But there's something inspiring and beautiful about it. The imposing building and its grounds are well kept, the flag is flying, and there's a handsome war memo-

rial topped by a spread eagle. This brave scene more than justi-
fies the long journey across the lonesome plains.

Ninety-one counties had a decrease in population between 1980
and 1990. New highways are bypassing the towns, and businesses
are moving from the square to the bypass or are closing because
of the competition of large shopping malls or discount stores.
Rapid travel makes it easy to go fifty miles to a city to shop. Horse-
drawn travel disappeared years ago, making the commercial as-
pects of the small-county system obsolete. In sparsely populated
areas there are now regional business centers that serve several
counties. Only those county seats lucky enough to become re-
gional centers are thriving. The declining county squares like
Lipscomb have vacant buildings; some have fallen to the ground,
while others have been removed. Some Panhandle counties have
grown with the feedlot industry. Swisher County feeds 169,000
cattle daily and has the largest packing plant in the world. A
traveler can smell a feedlot for miles downwind.

Many counties, cities, historical societies, garden clubs, and
other organizations make great efforts to preserve and restore their
squares. Some are listed in the National Register of Historic Dis-
tricts. The Texas Historical Commission helps preserve nineteenth-
century buildings. The results are heartening, bringing tourists
to Texas and keeping Texans at home to enjoy their own state.
Many old buildings are being authentically restored and occu-
pied by antique shops, restaurants, and museums.

There are hundreds of historical markers and monuments on
courthouse squares, including two dozen Confederate monu-
ments. On the square at Fairfield, Freestone County, is a Con-
federate cannon used in the Battle of Val Verde in New Mexico.
Val Verde County was named in honor of this battle. The ma-
jority of courtyards contain war memorials. Some recent ones
imitate the style of the Vietnam monument in Washington, D.C.,
with a smooth black marble wall. Names of county citizens who
died in that war are engraved on the wall, along with the names
of those who gave their lives in previous wars. When I traveled
to West Texas in May, 1991, I saw hastily constructed markers
for Desert Storm on most courthouse squares. Most, but not all,
squares have flag poles displaying the Texas and the United States
flags. Nearly all courthouses and squares are decorated and bril-
liantly lit for the Christmas season. I was cheered to see several
Nativity scenes on courthouse squares during a tour through the
eastern half of the state during December, 1991.

Time capsules have been placed in many counties, including
Culberson, Jackson, Eastland, Ochiltree, San Augustine, and
Coryell—one will be opened as early as A.D. 2000. I remember
when Eastland County gained national fame in 1926. The old
courthouse was torn down after thirty years to be replaced by
a new one. The cornerstone from the old building was opened

before a large gathering including several ministers. A horned toad, sworn to be entombed for thirty years, promptly came alive. He was named Old Rip, after Rip Van Winkle, and was taken on a triumphant tour around the United States. Unfortunately, after six months, Old Rip contracted pneumonia and died. He was embalmed and placed in a specially built casket, where his body can be viewed today in the Art Deco–style Eastland County courthouse.

Many courthouse squares have signs supporting their high school teams: the Eagles, Broncos, Bulldogs, Wildcats, Coyotes, Tigers, Cowboys, Mustangs, Rebels, to mention a few. There are signs showing a thermometer for the United Way campaign indicating how many dollars have been raised. Signs are not allowed on some squares, but in others, the citizenry is out for results, to heck with the looks of the courthouse square. "Ding Dong Daddy from Dumas" is displayed on the Dumas square in Moore County, but there is no sign for "Eighter from Decatur" on the square in Decatur, Wise County, even though that slogan was so popular that a song was once made of it. There's a dairy cow at Stephenville, Erath County; an albino buffalo at Snyder, Scurry County; a Navy fighter plane at Beeville, Bee County; and windmills and oil derricks on several squares. On the Rockwall square is a section of the rock wall for which the county is named. Some say it was laid by ancient people, but geologists say it is a natural phenomenon.

Ballinger, on the Runnels County square, has a renowned statue, *Cowboy and His Horse,* a life-size bronze by Coppini. And while we're speaking of statues, there are ones of Alley Oop in Iraan, a mule at Muleshoe, a giant roadrunner (Paisano Pete) at Pecos, a giant jackrabbit in Odessa, dinosaurs at Glen Rose, and Popeye at Crystal City. There is an old dunking trough in Madisonville, another famous attraction that speaks of the Old West.

It is entertaining to shop in the businesses on a thriving county square. Nearly always you will find something you have been looking for. In Lampasas I bought a long-sought pecan cracker like the one my family used at home seventy years ago. Around the typical square you might expect to find a drug store, restaurant, bank, museum, dry goods store, law office, abstract office, hardware and garden supply store, antique store, local newspaper, furniture and electrical appliances store, beauty parlor, shoe and boot shop, bar and pool hall, filling station, and a gift shop. Smaller counties may have a garage or a feed store, and larger ones may have a florist. As mentioned elsewhere, pawn shops and bail bond houses are increasingly common. There are all kinds of local, state, and federal service offices and courthouse annexes. I don't recall doctor's offices, funeral homes, or liquor stores on the square. Small wonder there are few liquor stores, since only thirty-seven counties in Texas are wholly wet as of 1991. With

local options on alcohol sales, we find various restrictions in 197 counties, and 57 are wholly dry. County-line liquor stores are a common sight, but you may have to drive a hundred miles to find one.

Trees are important landscape elements in more than half of the courthouse grounds. Live oaks are seen on a large number of courthouse grounds over the state, but they are not often seen in North Texas, and I have found none in the Panhandle or far West Texas. Since these are evergreen and completely surround some courthouses, it is sometimes difficult to obtain a good view of the courthouse. Pecans, the official state tree, are probably the most common tree, especially throughout Central Texas. Some are fine papershell varieties and provide fun for courthouse visitors who pick up the pecans and sometimes shell them on the spot. Many South Texas courthouse grounds feature palm trees— for example, Kenedy, Jim Hogg, Kleberg, Maverick, Galveston, Nueces, and Dimmit. Tall yuccas grow in front of Culberson County courthouse. Pines, magnolias, and horse chestnuts are seen on several East Texas grounds; mesquites, poplars, and cedars stand in some courthouse yards.

Fine specimen or historic trees grow on some courthouse squares. The giant live oak tree on the square in Columbus, Colorado County, cannot be captured in a photograph of the courthouse. However, Buck Schiwetz included both the historic tree and the courthouse in his painting of the building, one of his many fine pictures of Texas courthouses. The Fleming Oak on the courthouse grounds in Comanche County has this historic marker: "Camped here in 1854 with his father, Young Martin V. Fleming hid behind this tree and saved himself when hostile Indians rode through the grove. Years later, paving contractors started to cut the oak but were stopped by Uncle Mart with his gun." The old tree was quite healthy when I saw it in May, 1991. A grove of fine trees graces a park across the street from the Sutton County courthouse in Sonora. Shackelford County at Albany has a large, four-block courthouse square. In May, 1991, the grounds were covered with bluebonnets, which created a beautiful scene against the backdrop of the courthouse. The grounds at Shackelford County are enhanced by a bandstand, as are those at Robert Lee, Columbus, Freestone, and Wharton and other counties. Some courthouse grounds are totally neglected except for mowing the grounds, while others have well-tended gardens and landscaping. Post, in Garza County, had a well-kept rose and bluebonnet garden in full bloom when I visited there in May, 1991.

In earlier times, disputes sometimes arose over the location of the courthouse. I have counted ten such disputes, which led to shootouts in at least two counties, Blanco and Castro. At one time, citizens could vote every two years on the location of their

county seat until forty years had passed, after which no more elections were allowed. Thus, some county seats were changed several times. Dirty work often resulted. Courthouse records were sometimes moved during the dark of night to another town, where they were protected with armed guards. These controversies sometimes lasted for years. Other relocations of county seats resulted from changes in county boundaries, since state laws required the county seat to be within three miles of the center of the county. If the town was bypassed by the railroad, the county seat would also probably be moved. A historical marker in Crosby County states that 119 changes occurred in the location of county seats, five times each for two counties involved. Lubbock is one of the counties where three factions disputed the location of the county seat, but the matter was settled without violence.

Some fifty or more courthouses have burned down, a few from incendiary fires set to destroy indictment papers. Arson was suspected in Hardin, Anderson, and Navarro counties. Eventually, fireproof vaults were built to preserve records. Crimes of this sort have pretty much disappeared since the middle of the twentieth century, but we face the next century troubled by a new kind of vandalism against courthouses and other public property. Vandals prize the metal plates off historical markers, knock over tombstones, use highway signs for rifle practice, and kill game from the road. County sheriffs tell me these are only the lesser crimes in our increasingly lawless society.

An increase in crime has caused profound changes in the traditional courthouse square. The county sheriff's work load has multiplied. The largest space in many counties, by necessity, has become the sheriff's office, with a large parking lot for patrol cars. Attached or freestanding annexes have been built for the sheriff's office. Radio towers are built to communicate with the patrol cars. I counted seventy freestanding radio towers and five on top of old nineteenth-century courthouse towers. Jails have expanded and in large cities the jail may be the largest public building. Houston has several thousand jail cells. They have just opened a new jail for four thousand more beds. Exercise yards are a federal requirement. I saw several of these with high fences topped by spirals of barb wire. In Albany, Shackelford County, a prisoner was being visited through the fence by his family. I saw some courthouses with rooftop exercise yards enclosed by wire nets. Several courthouses have adjoining lockups where a patrol car can drive in, with the gates closing automatically so that prisoners can be passed securely into jail. Some of these areas are also used for prisoner exercise yards. Confiscated autos of drug offenders may be parked on the courthouse grounds or nearby; I saw a large collection of these old vans, speedsters, and other cars with flat tires parked at the Medina courthouse. Such altera-

tions detract from the grounds and the architectural integrity of the courthouse.

Metal detectors are used in at least one courthouse's entrances. On January 20, 1992, Harris County installed metal detectors and security guards at all entrances to its courthouse. On the first day they were used fifty-six knives, eight mace guns, and one stun gun were found. In county after county, the square is now occupied by law offices, neon-lit pawn shops (like Pappa Daddy's on the Hockley County square in Levelland), and bail bond offices. If business buildings are not available for rent, bail bond offices are located in mobile homes or other temporary structures.

San Augustine County provides an example of how drug dealers have invaded the country towns. Things had got so bad that children were stopping cars on the city streets to sell crack. When Sheriff Charles Bryan was elected in 1989, he went to work cleaning out a major cocaine distribution center for East Texas and adjoining West Louisiana. With a concerted effort by the FBI, Texas Department of Public Safety, and carefully selected regional lawmen, more than one hundred officers suddenly converged on San Augustine one day with indictments and arrested several dozen drug dealers. They confiscated well over $1 million in assets and eighty-five pounds of cocaine. A native citizen, the local drug kingpin, was sentenced to life imprisonment without parole. Three hundred people gathered on the square to cheer the officers as they brought the dealers into jail. The event was covered by CBS and shown worldwide. Sheriff Bryan said he received congratulations from all over the world—London, Turkey, Egypt, and elsewhere.

The Courthouse Building

EVOLUTION OF COUNTY COURTHOUSE BUILDINGS in Texas is described in considerable detail by Willard B. Robinson in his splendid books: *The People's Architecture, Texas Public Buildings of the 19th Century,* and *Gone from Texas.* Robinson divides Texas courthouses into six architectural groups, which evolved in rather distinct chronological order from the time Texas became a state until the present time.

The Early Log Courthouse

In several counties court was first held under a tree. One such place is commemorated by a historical marker in Greenville, Hunt County, where court was first held in 1847. For some counties, court was first held in a residence. The first court in Garza County was held in a tent. Many first courthouses were log structures, and dugouts served a few West Texas counties. The log courthouse of Comanche County was a residence when it was first

used as the courthouse in 1856. It is still standing and has been moved to the present courthouse square, where it now serves as a museum. I have included this building in my photograph of the current Comanche courthouse.

I have personal records of one log courthouse. The first chief justice of Grayson County, Republic of Texas, was James G. Thompson, appointed by Pres. Anson Jones in 1845. He was the great-grandfather of my wife, Mary Wilson Kelsey. Tradition has it that the first court was held under a tree; then Thompson was given a contract to build the first courthouse in 1847. The log building was twenty feet by twenty-four feet and was nine feet high; it had two doors and two windows. The opening celebration on July 4, 1847, was under a brush arbor. A barrel of whiskey was opened and a fiddler played as long as there were any who cared to dance. In 1853, after the courthouse had been abandoned for a new one in another location, the old one was destroyed by a party of young men on a spree. They tore it down to get goose eggs from a nest under the floor. A jail was also built, "but the people were so honest they had no use for it and converted it to a hotel."[1]

Indigenous Architecture
Between the time of annexation and the Civil War, Texas grew rapidly and new counties were organized. By the Texas Territorial Compromise of 1850, the United States paid Texas $10 million for one-third of its land—98,300 square miles. Texas used the money to pay debts, to establish a school fund, and to build a capitol and county courthouses. The capitol burned down in 1881, and none of the courthouses have survived. The typical courthouse built during this period was a two-story box-shaped building made of wood, stone, or brick. Some had a central tower. There were a few embellishments such as bays, pediments, arched doors or windows, porches, and shutters. Bexar, Guadalupe, and Gonzales counties offered examples. Smith County's courthouse was more elegant—a three-story building with an imposing tower. Cass County started construction on a Neoclassical courthouse in Linden in 1859. This courthouse, although with major alterations, is the only antebellum courthouse that has survived. It has remained in continuous use as a county courthouse.

The two-story box-like structure continued to be used after the Civil War, until about 1900. A few were built even later in

1. Lucas Davis, Mattie Davis, and Mita Holsapple Hall, *A History of Grayson County, Texas* (Sherman, Tex., 1936); Graham Landrum, *An Illustrated History of Grayson County* (Fort Worth, 1960); Mary W. Kelsey and Mavis P. Kelsey, *James George Thompson, 1802–1879: Cherokee Trader, Texian, Secessionist—His Papers and Family History* (College Station: Texas A&M University, Sterling Evans Library, 1988).

the sparsely settled western counties when they had the required number of people to organize a county government. Somervell County has the best standing example; it was built in 1893. A number of others of these structures still exist, some with an annex built to handle a larger population. A few examples are in Edwards County at Rocksprings, 1891; Jim Hogg at Hebbronville, 1913; Real at Leakey, 1913; King at Guthrie, 1914; Leon at Centerville, 1886; and Loving at Mentone, 1935.

Post–Civil War and Post-Reconstruction Courthouses
No courthouses were built during the upheavals of the Civil War and Reconstruction periods. Then an era of great prosperity followed, and between 1870 and 1900 many great courthouses were built. Architects were employed to design imposing, ornate buildings. Some great architects of Texas courthouses included Atlee B. Ayres, W. C. Dodson, J. Riely Gordon, Eugene T. Heiner, Alfred Giles, the Ruffini brothers, and Nicholas Clayton. This was the "golden era" of courthouse construction. Usually designated collectively as Victorian, these courthouses were built mainly in French Second Empire, Renaissance Revival, and Romanesque Revival styles. These buildings may have features of more than one style, though, and may be labeled differently by two or more observers. A brief description of the styles will be helpful in classifying the courthouses.

French Second Empire style evolved in Paris during the reign of Napoleon III and is characterized by classical ornamental details, Mansard roofs, patterned slate shingles, dormers, high brick chimneys, crestings, bracketed cornices, quoins, stilted arches, and pilasters. Although short-lived, this style was enthusiastically accepted all over Europe and America as the creation of the most culturally esteemed capital of Europe. Thousands of buildings, including public buildings and elegant residences, were constructed in Second Empire style. Examples include Brewster, Caldwell, Concho, Goliad, Hill, Hood, Lampasas, Parker, and Shackelford county courthouses.

Renaissance Revival, characterized by features of both the Italian and the French expressions, brought box-like buildings with repetitive windows, arches, and columns, lintels with hoods returning part way down the sides, balustrades, pilasters, and engaged columns. Some buildings had domes raised on a drum, quoins, cornices, projecting eaves supported by consoles, and triple and central windows. The features are orderly and delicate, with fine ornamentation, not heavy like the Romanesque style. Alfred Giles used these features a lot. Examples include the courthouses in Anderson, Bandera, Colorado, Harrison, Leon, Red River, and Tarrant counties. The restored Tarrant County courthouse in Fort Worth offers an example of the grandeur of the nineteenth-century courthouse. An annex was built to accom-

modate many of the functions that had crowded out the rotunda, grand stairways, and some court rooms. The original structure was completely restored to its first function as a "house of courts." I happened to be in town to attend the opening ceremony for the restoration.

Romanesque Revival style has features of the eleventh through thirteenth centuries; the Roman arch is the hallmark. Features are heavy and somber. The thick walls are made of rusticated stone. The doors and windows are usually small and round-arched; columns are short with carved heavy capitals. The towers, buttresses, and bays are massive. Some buildings have Gothic or Moorish features. Examples include Bexar, Bosque, Dallas, DeWitt, Erath, Fayette, Gonzales, and McCulloch counties. Richardson Romanesque style is a variation of the Romanesque Revival, developed by prominent Boston architect Henry Hobson Richardson. Richardson is credited with being the first—and perhaps only—American to create a personal monumental architectural style in the nineteenth century. This style exploits color, texture, pattern, and polychromy by using stones from different quarries. It also features masonry patterns, rustication, turrets, and rounded arches. Examples are found in Comal, Ellis, Denton (also has Second Empire features), Hood, Hopkins, Lee, and Wise counties. The Ellis and Wise county courthouses are very similar to one of Richardson's greatest buildings, Trinity Church in Boston.

Victorian style refers to any of these revivals of architectural styles occurring during the reign of Queen Victoria. The distinguishing feature of Victorian architecture is gingerbread ornamentation. Victorian is mentioned here because it is a popular word used to describe most nineteenth-century Texas courthouses.

These nineteenth-century buildings are the architectural treasures of Texas. While traveling across Texas, I was struck by the majesty, the prestige, the pride, the authority, and the heritage these buildings embodied. I had to stop to photograph the scene of the city square and the imposing courthouse—a nostalgic view of boyhood memories. This project began in 1989 and eventually led me to photograph other styles of courthouses as well. With my friend Angus Anderson, another native Texan who is from Texarkana, I undertook trips totaling more than ten thousand miles and photographed all the courthouses of the state. After I had photographed them all and realized that very few people had done this, I decided to publish a guide to be used for short excursions or for the courthouse buffs determined to see them all.

In my estimation Shelby, Red River, Grimes, Ellis, Wise, Hill (before its awful fire), Denton, Parker, Shackelford, and Tarrant county courthouses to be the best ten. Bexar, Caldwell, Comal, Concho, Coryell, DeWitt, Erath, Fayette, Gonzales, Goliad, Harrison, Henderson, Hood, Hopkins, Lampasas, Lavaca, Lee,

Llano, McCulloch, Presidio, Victoria, and Wilson counties also have great nineteenth-century courthouses.

A Catalogue of Texas Properties in the National Register of Historic Places, compiled by James Wright Steely, lists eighty-four courthouses registered in Texas, with sixty-three built before 1900. Of these, some sixty are still in use, all or in part, for county governmental functions. Many have attached or freestanding annexes. Seventy-five courthouses have Texas Historic Landmarks plaques and fifty-five have State Archeological Landmarks plaques.

The five functioning Texas courthouses built before 1900 which are not in the *National Register* are: Haskell at Seymour (1891), beautifully remodeled in 1931; Karnes at Karnes City (1894); Runnels at Ballinger (1889), altered, with tower removed; Coleman at Coleman (1884), with modern alteration in 1952; and Tyler in Woodville (1891), which has undergone extensive alterations.

Courthouses Built Between the Civil War and the Turn of the Century

Archer, 1892	Hamilton, 1886
Bandera, 1890	Harrison, 1900
Bastrop, 1883	Hill, 1890
Bell, 1884	Hood, 1890
Bexar, 1892	Hopkins, 1894
Bosque, 1886	Jasper, 1889
Brewster, 1887	Karnes, 1873
Caldwell, 1894	Kendall, 1870
Cass, 1861	Lampasas, 1883
Clay, 1884	Lavaca, 1897
Coleman, 1884	Lee, 1897
Colorado, 1891	Leon, 1886
Comal, 1898	Llano, 1892
Concho, 1883	McCulloch, 1899
Coryell, 1897	Maverick, 1885
Dallas, 1892	Medina, 1892
DeWitt, 1897	Milam, 1892
Dickens, 1893	Morris, 1882
Dimmit, 1884	Parker, 1885
Donley, 1894	Presidio, 1886
Edwards, 1891	Red River, 1884
Ellis, 1896	Robertson, 1882
Erath, 1892	Runnels, 1889
Fannin, 1889	Shackelford, 1883
Fayette, 1891	Shelby, 1885
Goliad, 1894	Somervell, 1893
Gonzales, 1896	Sutton, 1891
Grimes, 1893	Tarrant, 1895

Throckmorton, 1890 Wharton, 1889
Tyler, 1891 Wilson, 1884
Val Verde, 1887 Wise, 1896
Victoria, 1892

The Texas Renaissance
The next important stage in courthouse style overlaps the previous stage. Robinson refers to it as Texas Renaissance, and it occurred from about 1900 until the WPA constructions of the Great Depression. Its architects included Lang and Witchell, David S. Castle, and C. H. Page. This was a period of rapid expansion of transportation—railroads, automobiles and paved roads, and electric street cars; larger cities; new wealth from cotton, cattle, timber, and oil; and the settlement of the Panhandle and Plains. In 1899 an act was passed requiring county commissioners to submit the issuance of bonds to a vote of the taxpayers. In many counties, taxpayers proudly voted bonds for construction of monumental courthouses, attempting to surpass those of neighboring counties. These buildings reflected new styles such as Beaux-Arts, Renaissance and Classical Revival, and Mission Style. In a display of pride, the county name and the Texas star often are prominently displayed on these buildings, and a heroic statement may be engraved on the frieze or over the entrance. Domes, pediments with columns, colonnades, and red brick walls with white stone moldings are characteristic features. The San Saba County courthouse (1911) is a perfect example, displaying all of these elements. Over the main entrance is the Texas star, beneath which is "San Saba," and beneath this "From the People to the People." The Cottle County courthouse proclaims "Liberty and Justice, No one will sell, deny or buy Justice." Moore County states, "To No One Will We Sell, Deny or Delay Justice," and Ochiltree County courthouse announces it is "Dedicated to the Purpose of Justice to all Mankind."

The National Register lists twenty courthouses out of the many which were built during this period, most of which still serve the county government. Some of these courthouses are listed in the Register according to their architectural style. Beaux-Arts: Fort Bend (1908); Hale (1910); Hays (1908); Harris (1910), a new modern building is also occupied; Williamson (1911), and McLennan (1901), styled after St. Peter's Cathedral in Rome. Classical Revival: Examples are Lynn (1916), Cameron (1912), Dimmit (1884, remodeled in 1927) and Nueces (1914), now unoccupied. Renaissance Revival: Webb (1909), and Hudspeth (1919), the only adobe courthouse in Texas.

Several courthouses in the Panhandle designed by the same architect are almost identical: Armstrong (1912), Briscoe (1922), Crosby (1914), and Lipscomb (1916). Other typical examples of

the Texas Renaissance period, mainly Neoclassical, with the year of construction are:

Blanco, 1916	McMullen, 1930
Briscoe, 1922	Marion, 1912
Brooks, 1914	Mills, 1913
Brown, 1917	Mitchell, 1924
Burleson, 1927	Montague, 1912
Cochran, 1926	Oldham, 1915
Crockett, 1902	Palo Pinto, 1940
Dallam, 1922	Parmer, 1916
Deaf Smith, 1910	Pecos, 1911
Duval, 1916	Polk, 1923
Freestone, 1919	Rains, 1908
Garza, 1923	Randall, 1908
Glasscock, 1909	Reagan, 1927
Gray, 1928	Roberts, 1913
Hall, 1923	Rusk, 1928
Hardeman, 1908	Sabine, 1906
Hartley, 1906	San Augustine, 1927
Hemphill, 1909	San Jacinto, 1917
Hockley, 1928	Schleicher, 1924
Jim Wells, 1912	Sherman, 1922
Jones, 1910	Stephens, 1926
Kenedy, 1921	Swisher, 1909
Kimble, 1929	Tom Green, 1928
Kinney, 1910	Trinity, 1914
Kleberg, 1914	Uvalde, 1927
Lamar, 1917	Webb, 1909
Limestone, 1924	Wheeler, 1925
Live Oak, 1919	Winkler, 1929
Lynn, 1916	Wood, 1925

Moderne-Style Courthouses
Although several appeared earlier, including Eastland (1928), these buildings were mainly financed by the Public Works Administration (PWA) after 1933 and built during the Great Depression to provide work for the building crafts as well as for designers, architects, artists, and sculptors. Not only were new courthouses built, but some existing ones were extensively remodeled in this style (Wharton, built in 1889, remodeled in 1935 and 1957). Reminding the public that these buildings were federally financed, the New Deal and National Recovery Administration (NRA) were emphasized in the decorations, with federal eagles and shields sculpted over the doors and on the roof corners. Robinson uses the terms Moderne, International, Art Deco, and Stripped Classicism to describe these buildings. The architecture is characterized by repetitive ornamen-

tal features in geometrical form, such as Navajo zigzag patterns, chevrons, and foliage designs (Art Deco). Relief images portray local history, often in low relief (Young County, 1932). To the average person, Art Deco elements are the most easily recognized. Art Deco is a twentieth-century crisp, decorative form named after its first clear manifestation at the Exposition International des Arts Décoratifs et Industriels Modernes in Paris in 1925. Buildings are usually oblong, formed by a large cubical central mass, and flanked by symmetrical smaller cubical masses. There is one elegant formal entrance instead of the usual two or four similar entrances on opposite sides. Stripped Classicism emphasizes vertical lines and smooth surfaces, while flat or fluted pilasters replace the columns prominent in Beaux-Art and Classical Revival. By and large, these are very attractive courthouses. One of the greatest is the Cottle County courthouse. Some examples of Art Deco and Stripped Classicism are:

Castro, 1940	Lubbock, 1950
Chambers, 1936	Menard, 1931
Cherokee, 1941	Moore, 1930
Childress, 1939	Motley, 1948
Comanche, 1939	Potter, 1932
Eastland, 1928	Rockwall, 1940
Falls, 1939	Rusk, 1928
Grayson, 1936	San Patricio, 1928
Gregg, 1932	Travis, 1930
Guadalupe	Ward, 1940
renovation, 1947	Washington, 1939
Houston, 1939	Wharton
Jefferson, 1932	renovation, 1930s
Knox, 1935	Young, 1932
Liberty, 1931	

Modern-Style Courthouses

The Modern style, often called Institutional style, is characterized by twentieth-century cubical forms, often asymmetric, with absence of applied decorations. After World War II, very large annexes were needed by the large, populous counties. The Modern architectural style was used in the name of economy and efficiency and has resulted in a number of monstrosities and the denaturing of some charming old courthouses by removal of their decorative features.

During the Modern period after World War II, nearly every nineteenth- and early twentieth-century courthouse underwent some degree of remodeling, with disastrous results for many. Examples include: Fannin (1889), remodeled in 1929 and 1965; Swisher (1909), remodeled in 1962; Scurry (1911), remodeled in 1950 and 1972; and Coleman (1884), remodeled in 1952. Ector

County even obliterated a 1938 Moderne beauty and replaced it with walls of fenestrated concrete blocks. Some fine old courthouses were demolished during this period. In others, the exteriors underwent removal of ornate features; walls were covered completely by flat surfaces, and towers and Mansard roofs were removed. Over the years at least thirty handsome courthouse towers have been removed. Courthouse grounds have given way to paving and parking lots. Box-like attached annexes were built. Robinson reports that eclecticism was considered immoral and the use of ornamentation a social crime. Walls were treated neutrally, or sometimes covered by metal skins without windows. Some examples are Titus (1895, 1940), Modern remodeling in 1962 and again in 1990; Austin County in 1960 replaced an 1888 courthouse which burned; Montgomery County Moderne courthouse underwent Modern treatment in 1965. Other examples of Modern-style buildings are found in Brazos County (1955); Zapata (1953); and Coke (1956).

These uninteresting buildings are also known as institutional government buildings. They provide the most space for the money, but they fall short in cultural value. They evoke no pride in the government they represent. They make no statement of the governmental authority embodied in the structure. Some counties can afford a better courthouse, but I cannot criticize those counties with minimal resources and scanty population, which can afford only the most economical building. Architects have told me that the courthouses of the 1950s were at the lowest ebb in architectural style. A few Modern courthouses are redeemed by a simple, yet elegant, facade or entrance: Stonewall, Kent County (1957), and Kaufman, Kaufman County (1956), are examples.

By 1955, there were many complaints that these Modern buildings were uninteresting. The architects reacted by attempting decorative features (Matagorda, 1965, Galveston, 1966). One style referred to as Brutal employs huge, solid-appearing vertical masses or columns supporting massive cantilevered windowless floors, and parapets. Brazoria (1976), Scurry (1972), Taylor (1972), Wichita, and Collin counties are examples. Another style features buildings supported by freestanding columns without capitals or base decorations. (Examples, Bowie, Ector, and Taylor counties). There are a number of one-story flat, rambling courthouses in this Modern group which are often known by the uncomplimentary term of "motel" style. The most surprising location for one of these is in Nacogdoches (1958), one of the oldest county seats of Texas, where one would expect a traditional building. Others are in Aransas, Baylor, Borden, Culberson, Fisher, Martin, and Zavala counties. Robinson lists a few other Modern courthouses: Hidalgo, Jackson, Montgomery, Fannin, Midland, Swisher, Brazos, Austin, Kaufman, Calhoun, Hardin, Panola, Zapata, Gaines, and Kent.

The Future Style

We may see yet another style of architecture in courthouses appearing in the 1990s. In December, 1991, El Paso County had a grand opening ceremony for a new high-rise courthouse, built of flat surfaces covered with reflective colored glass, a style popular for commercial buildings around the world. The El Paso courthouse had not been completed in May, 1991, when I photographed a half-covered building. Buildings of this style can be attractive buildings, although they provide limited opportunity for ornamentation.

Some of the cheaply built courthouses of the 1950s should now be ready for replacement. I hope they will be replaced by structures designed for beauty as well as for function and that the courthouse squares can be preserved. Expanded services could be housed in attractive buildings across the street. It is important to preserve the courthouses that are historic treasures because they are the only public structures distributed throughout the state. The heritage and culture embodied in our public buildings is gaining some protection by Texas laws. The Texas Courthouse Acts of 1971 and 1972 require county governments to notify the Texas Historical Commission of intentions to demolish historic courthouses or to alter their exteriors. The Historical Commission can prevent proposed structural changes for a period of 180 days while alternatives are being studied. However, if viable solutions cannot be developed, these historic buildings may come down. Apparently, unsightly alterations, annexes, and encroachments on courthouse grounds still go on without approval. Persons who propose changes would benefit by first taking a tour of county courthouses to see the difference in good and bad design, in attentive care and neglect, and between a proud structure and a nonentity. In 1989, the Seventy-first Texas Legislature established the Texas Preservation Trust Fund as a pool of public and private monies. The interest earned and designated gifts will be distributed by the Texas Historical Commission as matching grants or loans for preservation of historic buildings, including courthouses. The Texas Trust for Historic Preservation is a new grass-roots organization formed for the same purpose.

Domes, Towers, Clocks, and Other Features

Around two hundred Texas courthouses have been built with towers or significant domes. Each of these structures required a heroic effort in design and expenditure. Planning the tower often caused controversy. There were many opinions voiced about selecting the architect and approving his design. The bids for construction might have been surprisingly high. There were always voters who didn't want to spend money for a tower. In some counties, years went by while residents tried to reach a consensus or obtain financing. Once approved, construction of a tower invari-

ably presented problems. Unanticipated reinforcements had to be installed, contractors had to be replaced; some towers had to be removed for fear of collapse (Dallas County). Some deteriorated and could not be maintained (Montague). A storm ruined the tower at Goliad.

Rapid growth of cities and increased space requirements resulted in the demolition of several great courthouses and their towers. Harris County demolished two courthouses with beautiful towers before it saved the present one. El Paso lost one of the finest courthouses ever built in Texas. Fire destroyed more than a dozen. Incendiary fires were thought to be responsible for the destruction of courthouses of Navarro County in 1855, Wilson in 1884, Titus in 1895, and Anderson in 1913. The citizens themselves were responsible for the loss of many fine old courthouses and towers. In spite of the fact that these monumental structures were built to last forever, each new fad in architectural style brought forth a movement to make major alterations or to tear the courthouse down and replace it with a stylish new one.

There are seventy-two county courthouses with significant towers or domes remaining in Texas. Sixty were built before 1900, and twelve were built between 1900 and World War II, after which no towers or domes have been built. Not only were no new towers built, but a number of existing courthouses even lost their towers. I have studied forty-five courthouses that have undergone extensive remodeling of external structures. Of these, twenty-nine had their towers or domes removed. Some were removed in the 1930s to provide work for the PWA program. Many were removed along with other alterations to create a new architectural style. The Fannin County courthouse (1889) had a fine tower, which was removed in 1929 after a fire. Eventually the building was "denatured" to create a Modern building. "Only the ghost remains," according to Robinson. Archer County courthouse (1892) had a Second Empire Mansard roof and tower removed in 1928. As late as 1950, a beautiful tower was removed from the Bell County courthouse. It would require several million dollars to replace it. The beautiful Bosque County courthouse had its tower removed in 1935, leaving a clock tower that looks like a bump. The tower was removed at Montague and replaced by a small, flat, oblong structure which, the citizens say, looks like a chicken house.

It gives one quite a surprise to drive into a town and find a courthouse with the top cut off. This is especially noticeable in Dickens, Sabine, Milam, Oldham, Robertson, and Runnels counties, but the "most outrageous remodeling award" goes to Swisher County in Tulia. The Modernists started with a 1909 Renaissance Revival building having a fine clock tower, walls of red brick, pediments, tan sandstone pilasters, and an arched entrance. They removed the tower, pediments, and entrance, cut off the top floor flush with the top of the second-story windows, stripped the walls

23

of all ornamentation, and put on a thin, flat roof with no over-hang or cornices. They built a one-story lean-to annex on each side and painted the whole structure white. A citizen of Panhandle told us that all the county officers and commissioners were voted out at the next election following this destruction.

There were other conversions designed to match the prevail-ing style. Hamilton County courthouse, built in 1886 as a Sec-ond Empire structure, was converted in 1931 to Classical Revival by removing the Mansard roof and tower and building porticos with Greek columns and pediments. The Coleman County court-house, built in 1884 in Second Empire style with a tower, was completely denatured in 1956 and transformed into a Modern-style building. The Jasper County courthouse lost its tower in 1957 during the Modern upheaval. The Sabine County courthouse was damaged in 1909 by fire, which destroyed the Beaux-Arts dome and clock tower which were never replaced.

The Clay County courthouse (1884) had one of the finest towers in the state, but it was replaced by an octagonal dome, appar-ently to make a Beaux-Arts impression. The Dimmit County courthouse (1884) was converted from an Italianate style to Clas-sical Revival in 1927. Ector County surrounded a fine Moderne Bauhaus structure (1938) with a large, flat building walled with fenestrated concrete in 1964. In Midland, the fine Moderne court-house with Stripped Classicism features was covered up by a Mod-ern remodeling. The Scurry County (1911) Neoclassical court-house had the towered dome removed and the walls "entombed in a polished granite shell with Brutal columns," according to Robinson. The Titus County courthouse of 1895 was remodeled in 1940 and converted to Modern style in 1962 by being covered with a windowless metal skin.

The 1889 Second Empire courthouse at Wharton was de-natured to Moderne in the 1960s. Wichita County had one of the most monumental courthouses in Texas. It was built in 1916 with an impressive colonnade and other Classical Revival features. It was completely denatured in the 1980s, and the monumental features were replaced by flat surfaces of brick and glass. A lofty courthouse tower or prominent dome is the most impressive visual feature of many courthouses and is often the reason that people will stop to see a courthouse. Nothing better imparts the aura of majesty and authority to a courthouse.

Still another attractive and important feature of the courthouse tower is the city clock. We found clocks on forty-seven towers and all but one of these had clocks on all four sides. There were seven courthouses which had lost their towers but retained the clocks on the remaining walls, most on all four sides. A number of towers had chimes. The boldface clocks and chimes regulate people's schedules, a pleasing function of the courthouse tower. People joke that they don't want to spend money on four clocks

because it is confusing when each clock shows a different time and none is correct.

The courthouse tower or dome also may be decorated by an inspirational statue. We counted eleven Statues of Justice. She was holding a balance in one hand and a sword in the other and was blindfolded in all instances, except in Bee County, where the county fathers believed she could do a better job if she saw what was going on. Stonewall County apparently saved their Statue of Justice from the old courthouse and mounted it at the entrance to their new one-story building. Several courthouses display a Statue of Liberty on top of their tower; others an eagle, and others less romantic place a wind gauge on the tower. A few counties were able to distribute all these symbols around the rooftop.

There is not space here to describe the fine interiors of some Texas courthouses. A large book could be devoted to the beautiful nineteenth-century woodwork in courtrooms, lavish terra-cotta ornamentation, stone carvings, statuary, terrazzo and mosaic floor designs, and, lastly, the craftsmanship and murals of the WPA era.

Surviving Old Courthouse Buildings

A NUMBER OF OLD COURTHOUSES that have been replaced by newer ones still survive in various forms and uses. In some instances I have used the photograph of the old courthouse because I like it more than the new courthouse and we have space for only one. I have found reports of thirty-two such buildings. Many of them are listed in the National Register of Historic Places and are worth a visit. Probably the oldest is the 1848 log courthouse of Navarro County, which still stands. The log courthouse for Comanche County was a residence in Cora before 1856, when it became the county seat. When the county seat was moved to Comanche, the building reverted to a residence and was operated as a museum for years until it was moved to the present courthouse square in Comanche. In Rio Grande City, Starr County, the first courthouse, originally built in 1854 as a trading post, is still used for city functions. The town of Zapata was flooded by the Falcon Dam, and the city was relocated on a new site. Among the buildings of the old city now under water is the old courthouse. This is the only courthouse in the United States requiring underwater gear to visit it.

The old Cameron County courthouse (1882) at 1131 East Jefferson Street in Brownsville was taken over by a Masonic Lodge. The old Medina County courthouse is now the city hall of Castroville, which used to be the county seat. The old Bandera County courthouse (1869) and the old Gillespie County courthouse (1882) at Fredericksburg are both listed in the National Register and serve as libraries. The old Brazoria County courthouse (1897), an Ital-

ian Renaissance-style building listed in the National Register, is also now a library. The old Collin County courthouse (1874) at McKinney has been restored and is part of a historic commercial district listed in the National Register. The old Maverick County courthouse (1885) at Eagle Pass, listed in the National Register, is now vacant and needs funds for restoration. The old Nueces County courthouse (1914), a Classical Revival building listed in the National Register, is unoccupied. The old Morris County courthouse (1882) at Daingerfield and the old King County courthouse at Guthrie now serve as museums.

The old Irion County courthouse (1901), a fine Second Empire relic listed in the National Register, became a community center in Sherwood after the county seat was moved to Mertzon. The old Reagan County courthouse (1911) at Stiles is listed in the National Register; the present courthouse is at Big Lake. The old Hidalgo County courthouse (1886), listed in the National Register, was built of handmade bricks by mason Juan Rios. It remains in Hidalgo; Edinburg, the new county seat, was moved to its present location, where it built a modern county courthouse for Hidalgo County. The original county seat of Karnes County was Helena, named after the founder's wife Helen Owens. This old courthouse, built in 1873, still stands and may be reached by FM 81 and Texas 80, but the county seat was moved to Karnes City in 1894. The old Stonewall County courthouse (1891), listed in the National Register, is used as a residence on Rayner's Ranch in Rayner, while the present county seat is now Aspermont. The old Taylor County courthouse and jail (1879) in Buffalo Gap, listed in the National Register, were built before the railroad bypassed Buffalo Gap and the county seat was moved to Abilene. It has served as a residence, a lodge, and a museum.

The former Oldham County courthouse at Tascosa is now a part of Farley's Boys' Ranch as the Julian Bivins Museum, while the present county seat is at Vega. The old Harrison County courthouse at Marshall (1900), listed in the National Register, has been preserved as a history museum, although a few county functions still remain in the building. The old Victoria County courthouse (1892), listed in the National Register, was replaced by a modern courthouse nearby. The first floor of the old courthouse of Kent County at Clairemont remains today as a community center, while the present county seat is in Jayton. The old Blanco County courthouse (1885) at Blanco was later used as a bank, a hospital, stood vacant, and now is being restored as a museum. A shooting occurred when, after a long controversy, the county seat was moved to Johnson City in 1890.[2]

2. Willard B. Robinson, *Texas Republic Buildings of the Nineteenth Century* (Austin: University of Texas Press, 1974), p. 232.

In Atascosa County, a replica of the original county court-house has been built to provide an office for the State Highway Patrol in Jourdanton.[3] The original Glasscock County courthouse was converted to a jail when the present courthouse was built in 1909. The old Frio County courthouse (1876), of Queen Anne style, is vacant and privately owned. The old Upton County court-house at Upland stands abandoned since the railroad passed it by and the present courthouse was built in 1926 at Rankin. Worth listing among the old courthouses is the Capitol of the Republic of the Rio Grande, still standing as a museum on San Agustin Plaza in Laredo, which in 1840 housed a short-lived government, whose national flag was the seventh banner under which Laredo has served.

Old County Jails

COURTHOUSE VISITORS will also encounter many old county jails. Before the jail could be constructed in some newly organized counties, the prisoners were chained to a tree. The jail was sometimes built before the courthouse. Some counties bragged that they had no criminals and never used their jails; however there was much lawlessness, and Texas produced its share of western bad men, such as King Fisher, Ben Thompson, John Wesley Hardin, and Doc Holliday.

Jail construction usually followed the architectural style of the courthouse. The first jails were of logs or stone, but after 1870, more elaborate jails were built. Sometimes the jail provided residence for the jailer, and his wife would cook for the prisoners, as well as for her family. Most jails were freestanding buildings located on the courthouse square or nearby. A few jails were housed in the courthouse building and had special passages to bring prisoners to the courtroom. These jails and courthouses were at their prime when crime was less frequent. County citizens handled their own criminals and administered justice swiftly, including death by hanging, and many counties had their own gallows built inside the jail. I remember as a boy when murderers were executed by hanging in Paris and in Clarksville. On one occasion my father was summoned, the same as for jury duty, to witness an execution in Paris. It was a depressing experience for the county, and especially for my father and others involved in the process.

Some old jails are still in use (Shackelford County is example). Some have been converted to county museums, thereby preserving some of the fine architectural structures which are listed on the National Register. An outstanding example is the

3. Ray Miller, *Eyes of Texas, San Antonio/Border Edition*, 1989, p. 85.

ornate, red brick jail-museum at Bellville, Austin County. Other jail museums include those in Milam, Freestone, Martin, and Throckmorton counties. A few jails are information centers or libraries, while others are locked up and decaying or have been demolished.

Courthouses

Anderson County
(48,024)
County Seat: Palestine (18,042)

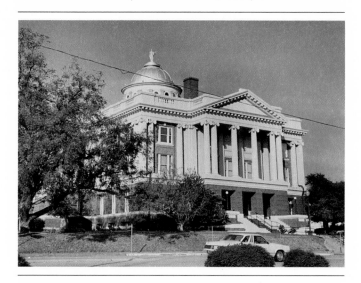

COURTHOUSES: four; 1847, 1856,
1886, 1914

STANDING: 1914 brick courthouse de-
signed by C. H. Page and Brothers, Austin,
Texas, in Renaissance Revival style.

LOCATION: Palestine: south of Lacy
Street, between Dechard and Fannin
streets.

NOTES: Named for Kenneth Lewis Ander-
son, vice-president of Texas from 1844 to
annexation, Anderson County was orga-
nized in 1846. Houston, the original
county seat, was abandoned in favor of
Palestine because Houston was two miles
off-center. The 1886 courthouse (designed
by W. C. Dodson) was burned to destroy
incriminating documents. The 1914 court-
house was remodeled in the 1980s. Nearby
at 1007 North Perry Street is the Howard
House Museum.

Palestine obtained its name from Pilgrim
Church minister Daniel Parker, who named
it for Palestine, Illinois.

Andrews County
(14,338)
County Seat: Andrews (10,678)

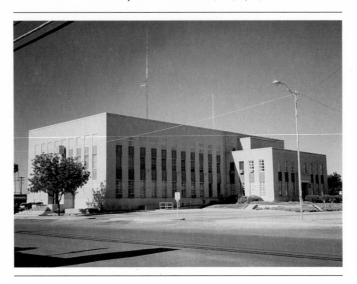

COURTHOUSES: two; 1911, 1939

STANDING: 1939 Moderne-style court-
house built of brick with several subse-
quent additions. W. T. Strange was the
architect.

LOCATION: Andrews: on North Main
(U.S. 385), between NW Avenue A and NW
Avenue B.

NOTES: Named for Richard Andrews, the
first man to fall in the Texas Revolution.
He was killed in 1835 in the Battle of Con-
cepción. Andrews County was organized
in 1910.

Angelina County
(69,884)
County Seat: Lufkin (30,206)

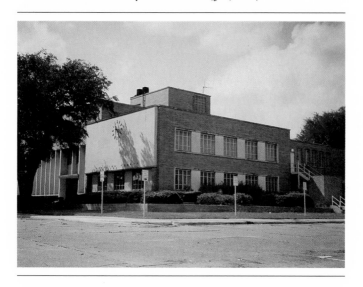

COURTHOUSES: six; 1847, 1849 (Marion), 1873 (Homer), 1892 (Lufkin), 1903, 1955

STANDING: 1955, designed in Modern style, and built of brick, limestone, and steel. It was designed by Wilbur Kent.

LOCATION: Lufkin: southwest corner of Third Street and Frank Avenue (Texas 94).

NOTES: Angelina ("Little Angel") County was organized in 1846 and named for a young Indian girl who eagerly embraced the faith of Franciscan missionaries. There were three courthouses at the Lufkin site, plus additional buildings at earlier county seats (Homer and Marion). Of related interest is the Historical and Creative Arts Center (Second and Paul streets) with a local history room. The Texas Forestry Museum (1905 Atkinson Drive) is also nearby.

Railroad engineer E. P. Lufkin is the namesake of the county seat.

Aransas County

County Seat: Rockport (4,753)

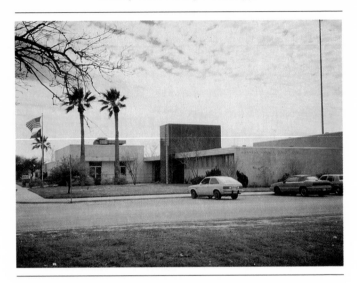

COURTHOUSES: two; 1889, 1956

STANDING: 1956 courthouse in Modern "motel" style, built of brick and steel, designed by Lynn A. Evans. The county constructed an addition in 1983.

LOCATION: Rockport: southeast corner of Mimosa and Church streets.

NOTES: The name Aransas came from the Rio Nuestra Señora de Aranzazu, which has its origin in an estate in Spain. The county, established in 1871, was an important shipping point for cattle from inland ranches.

Rockport's name is geographically descriptive and refers to a ledge of rock near the Gulf.

Archer County

(7,973)

County Seat: Archer City (1,748)

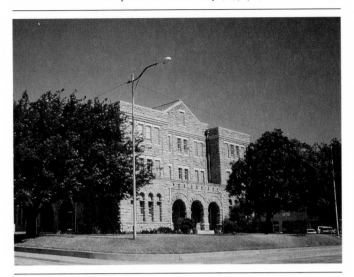

COURTHOUSES: two; 1880, 1892

STANDING: 1892 courthouse designed by
A. N. Dawson in Romanesque Revival
style and built of sandstone. A central
tower was removed in 1928. The roof has
been altered, and there have been other
changes over the years; a National Register
Property.

LOCATION: Archer City: southeast corner
of Main (Texas 25) and Center (Texas 79).

NOTES: The county was named for
Branch Tanner Archer, Texas revolutionary
and congressman. It was organized in
1880. The Archer County Historical
Museum (in the old jail) is one block
northeast of the courthouse.

Armstrong County

(2,021)

County Seat: Claude (1,199)

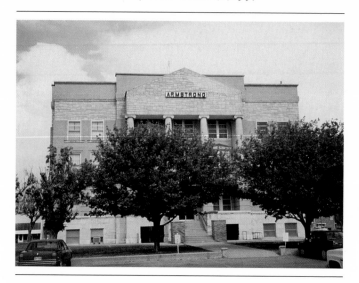

COURTHOUSES: two; 189 ——, 1912

STANDING: 1912 courthouse was designed by Elmer George Withers in Classical Revival style sometimes referred to as Texas Renaissance. Built of brick and stone.

LOCATION: Claude: off U.S. 287, intersection of Trice and Second streets.

NOTES: Armstrong County was obviously named for someone named Armstrong, but no one knows who. The name antedates the organization of the county in 1890 and most likely honors one of several Texas pioneers with that surname. Claude Ayres, the engineer who brought the first train through the area, lent his name to the county seat.

Claude was also the site of the filming of *Hud,* the movie version of Larry McMurtry's *Horseman, Pass By.*

Atascosa County

(30,533)

County Seat: Jourdanton (3,220)

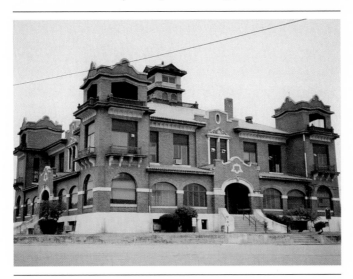

COURTHOUSES: four; 1856 (Amphion), 1857 (Pleasanton), 188 —, 1912

STANDING: 1912 courthouse is a pleasant Mission-style building of brick and stone, designed by Henry T. Phelps. Possessing towers and Spanish-tiled roofs and balconies, Mission-style courthouses are somewhat rare in Texas. Originally the lower floor was open for storage of cord wood.

LOCATION: Jourdanton: off Texas 16, Circle Drive on Main Street.

NOTES: Atascosa is Spanish for an impediment to travel—such as a bog, mud, etc. Jourdan Campbell, local land promoter, gave his name to the county seat.

Austin County

(19,832)

County Seat: Bellville (3,378)

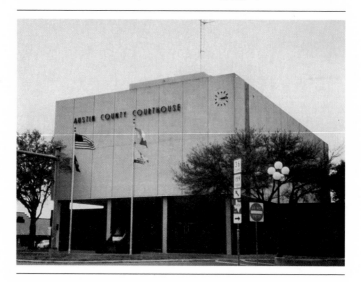

COURTHOUSES: four; 1837, 184 —,
1888, 1960

STANDING: 1960 courthouse designed in
Modern style by Wyatt C. Hedrick and
built of granite and concrete.

LOCATION: Bellville: on Main Street
(Texas 36), between Holland and Bell
streets.

NOTES: San Felipe de Austin was the origi-
nal county seat until 1848. Bellville has
been the county seat since then. Austin
County was named for Stephen F. Austin
and organized in 1836. One of the old
three hundred of Stephen F. Austin's first
colony, Thomas B. Bell settled in the area,
and the county seat acquired his name.

Bailey County
(7,064)
County Seat: Muleshoe (4,571)

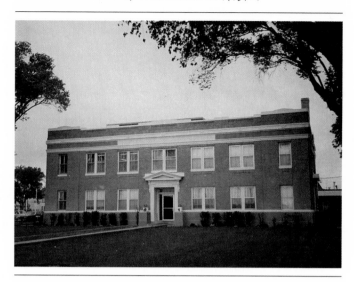

COURTHOUSES: two; 1917, 1925

STANDING: 1925 Classical Revival build-
ing constructed of brick. The architect was
M. C. Butler.

LOCATION: Muleshoe: west corner of
Avenue C and First Street (U.S. 70).

NOTES: Named in honor of Peter James
Bailey, a Kentucky lawyer who died at the
Alamo, Bailey County was not organized
until 1918. Muleshoe was named for the
ranch of the same name.

Bandera County

(10,562)

County Seat: Bandera (877)

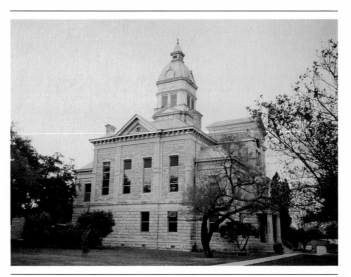

COURTHOUSES: two; 1869, 1890

STANDING: 1890 National Register Property designed in Renaissance Revival style by B. F. Trester and built of native limestone. The 1869 courthouse on Maple Street is of limestone blocks and now serves as a library.

LOCATION: Bandera: southeast corner of Main (Texas 173/Texas 16) and Pecan Street.

NOTES: Bandera (Spanish for flag or banner) is named for a range of hills and the famous Bandera Pass—site of a couple of desperate battles between Texas Rangers and Comanches.

The railroad never came to Bandera, thus sparing the county the economic roller coaster of the nineteenth century and helping to ensure the survival of the county's charming courthouse. The county was organized in 1856.

Bastrop County
(38,263)
County Seat: Bastrop (4,044)

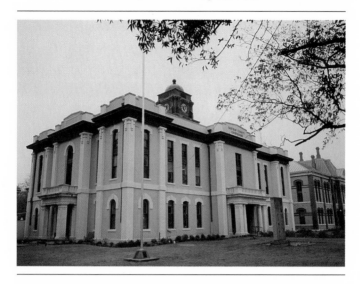

COURTHOUSES: three; 1832, 1852, 1883

STANDING: 1883 brick Renaissance Revival–style building designed by Jasper N. Preston and F. E. Ruffini; a National Register Property.

In 1923, the brick was plastered over. Many of the ornate Victorian details were removed, and the clock tower was reduced in size to make the building more "contemporary." The years 1953 and 1989 saw additions to the courthouse. A "hanging" hook was discovered in 1989, along with evidence of an overhead bridge between the jail and the courthouse.

LOCATION: Bastrop: southwest corner of Pine and Pecan streets.

NOTES: Organized in 1837, Bastrop was named in honor of Felipe Enrique Neri Baron de Bastrop, land commissioner of Austin's colony and member of the Congress of Coahuila y Texas.

Bastrop County Historical Society Museum is at 702 Main Street.

Baylor County
(4,385)
County Seat: Seymour (3,185)

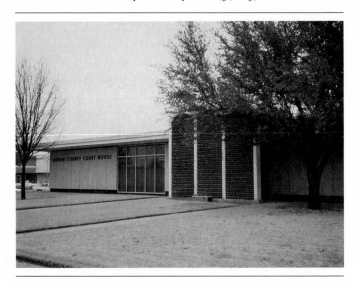

COURTHOUSES: two; 1879, 1968

STANDING: 1968 Modern courthouse built on the site of the old 1879 structure. Pierce, Norris & Pace were the architects.

LOCATION: Seymour: northwest corner of Main (U.S. 183/U.S. 283/U.S. 277) and Reiman Street.

NOTES: Dr. Henry W. Baylor, Indian fighter, Ranger captain, and veteran of the Mexican War, was the namesake of this county, which was organized in 1879. Seymour Munday, local cowboy, lent his name to the county seat.

The Baylor County Historical Museum is located in the 1880s E. R. Morris home at 200 West McLain.

Bee County

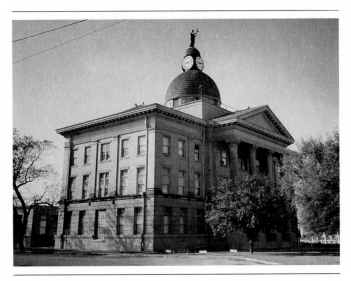

COURTHOUSES: three; 1861, 1879, 1912

STANDING: 1912 Beaux-Arts–style brick structure with a dome, clocks, and classic porticoes. It was designed by Whitney and Heldenfelds.

LOCATION: Beeville: corner of U.S. 59 and U.S. 181 (516).

NOTES: Bernard E. Bee, South Carolina nullificationist, opposed the annexation of Texas to the United States and left the state in 1846. Nevertheless, while in Texas, he served as secretary of state and war, and this county was named in his honor in 1858.

Bell County
(191,088)
County Seat: Belton (12,476)

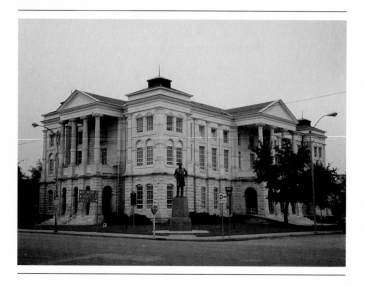

COURTHOUSES: three; 1851, 1858, 1884

STANDING: 1884 sandstone structure designed by Jasper N. Preston and Sons in Renaissance Revival style; a National Register Property. The building has been altered and remodeled several times over the years.

LOCATION: Belton: southeast corner of Main Street (Texas 317) and Central Avenue (Texas 253).

NOTES: Battle of San Jacinto veteran, Mexican War veteran, Texas Ranger, governor, congressional representative, and later a colonel in the Confederacy, Peter Hansborough Bell lent his name to this county when it was organized in 1850. The county seat is most likely a contraction of Bell and town.

Bexar County

(1,185,394)

County Seat: San Antonio (935,933)

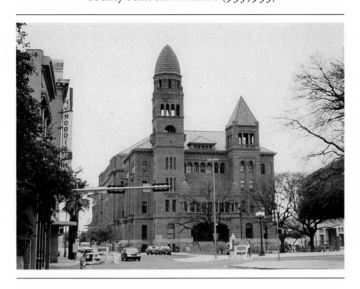

COURTHOUSES: four; 1837, 1850, 1882, 1892

STANDING: 1892 Romanesque Revival masterpiece by J. Riely Gordon; red granite. A National Register Property with a unique beehive tower. Numerous additions dating from 1928.

LOCATION: San Antonio: I-10/U.S. 81, Exit 155B to Durango Street, north on Dwyer Avenue; northwest corner of Dwyer and Nueva.

NOTES: Of course, San Antonio has a wealth of historic sites, many dating back to the eighteenth century. Bexar County, organized in 1836, was named for the Duke of Bexar, who lent his name to the presidio of San Antonio de Bexar. The city of San Antonio owes its name to the fact that a missionary expedition stopped to rest here on the feast day of Saint Anthony.

The Bexar County courthouse of 1892 was the result of a competition for a $1,000 first prize and a $500 second prize. Over twenty-five designs arrived from ten states pursuing these prizes. Since both prizes went to San Antonio architects, objectivity may have been lacking.

45

Blanco County
(5,972)
County Seat: Johnson City (932)

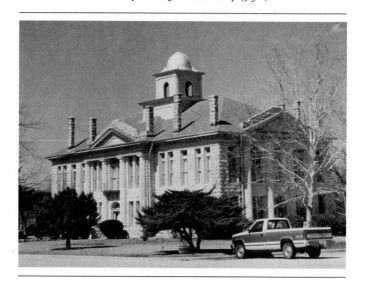

COURTHOUSES: three; 1885 (Blanco), 1860 (Blanco), 1916 (Johnson City)

STANDING: 1916 stone building designed by Henry T. Phelps in Classical Revival style. The 1885 courthouse in Blanco, designed by F. E. Ruffini, still survives in its Second Empire style, as well.

LOCATION: Johnson City: on the square between Sixth and Seventh and Avenue G and Avenue H.

NOTES: Blanco (Spanish for white) County was organized in 1858, and for many years Blanco was the county seat. Beginning with secession and the Civil War, a series of divisions resulted in new county boundaries and a new county seat. Johnson City got its name from early settlers of the same name. Blanco was the original county seat until the seat moved to Johnson City as the result of an 1890 county seat election.

The stonework of the courthouse was constructed by stonemason James Waterston, a Scottish immigrant, who also worked on the Texas Capitol and Old Main at Southwestern University, Georgetown.

46

Borden County
(799)
County Seat: Gail (202)

COURTHOUSES: two; 1890, 1939

STANDING: 1939 Moderne-style court-
house built of brick. David S. Castle Com-
pany was the architectural firm.

LOCATION: Gail: corner of U.S. 180 and
FM 669.

NOTES: Organized in 1890, Borden
County was named for Gail Borden, Jr.,
civic promoter, Baptist missionary, news-
paper publisher, and inventor.

The Borden County Historical Museum is
also in Gail.

Bosque County

(15,125)

County Seat: Meridian (1,390)

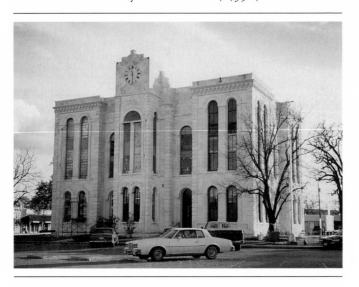

COURTHOUSES: four; 1854, 1860, 1875, 1886

STANDING: 1886 building built of local limestone and designed by J. J. Kane, a Fort Worth architect; a National Register Property. WPA alterations in the mid-1930s shaved the peaked corner towers and obliterated the original clock tower. The decorative elements of this much-altered Romanesque Revival structure were also removed or changed.

LOCATION: Meridian: off Texas 6, intersection of Texas 22 and Main streets.

NOTES: Organized in 1854, Bosque (Spanish for woods or forest) County lay on the Chisholm Trail. Surveyor George Bernard Erath laid out Meridian on the ninety-eighth meridian.

John A. Lomax, one of the foremost collectors of American folk music, was born near Meridian.

Bowie County

(81,665)

County Seat: New Boston (5,057)

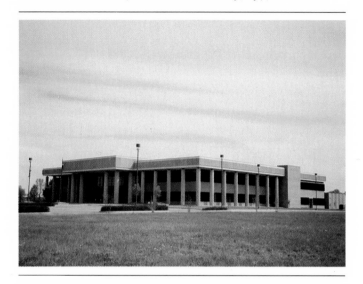

COURTHOUSES: three; 1841, 1889, 1985

STANDING: 1985 Modern-style court-
house designed by Thomas and Embeton
Associates, Texarkana.

LOCATION: New Boston: off U.S. 82,
intersection of South Merrill and Runnels
streets.

NOTES: Named for the fabled martyr,
James Bowie, Bowie County has had three
county seats: Boston (now Old Boston),
Texarkana, and New Boston. Boston refers
to an early settler, W. J. Boston.

The old courthouse (1889) was com-
pletely gutted by a fire (1987) after sitting
idle for several years.

Brazoria County
(191,707)
County Seat: Angleton (17,140)

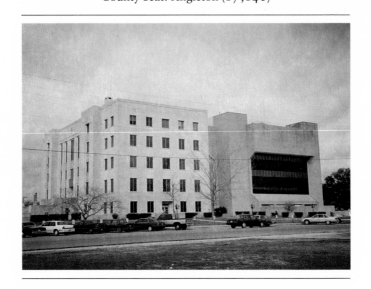

COURTHOUSES: four; 1839 (Brazoria), 1897 (Angleton), 1940, 1976

STANDING: 1940 and 1976 buildings, which are joined, more or less, into one building of brick and stone. The 1940 building was designed in Moderne style by Wyatt Hedrick, and built of Indiana granite and limestone. The 1897 Italian Renaissance–style courthouse, designed by Eugene T. Heiner, is now a library. Originally it had a ninety-foot tower.

LOCATION: Angleton: southwest corner of Chenango and East Live Oak.

NOTES: Organized in 1836, Brazoria County had the city of Brazoria as county seat until 1897, when it was moved to Angleton. Angleton, a railroad town, got its name from Mrs. George Angle, wife of the railroad's general manager.

The Brazoria County Historical Museum is in the courthouse.

Brazos County

(121,862)

County Seat: Bryan (55,002)

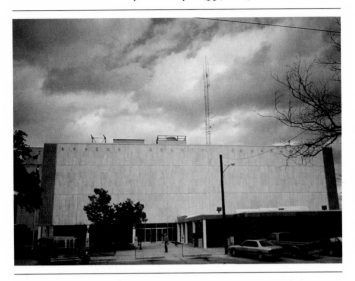

COURTHOUSES: six; 1843 (Boonville), 1846, 1853, 1871 (Bryan), 1892, 1955

STANDING: 1955 steel, brick, and marble Modern courthouse designed by Caudill, Rowlett & Scott. Significant additions have been included in recent times.

LOCATION: Bryan: corner of North Texas Avenue (Texas 6) and Twenty-fifth Street.

NOTES: Organized in 1843 and named after the longest river in Texas—originally the Brazos de Dios (Arms of God, in Spanish), Brazos County has had two county seats: Boonville and Bryan. William Joel Bryan, early Texas revolutionary, planter, and landowner is the namesake of the county seat.

Brewster County

(8,681)

County Seat: Alpine (5,637)

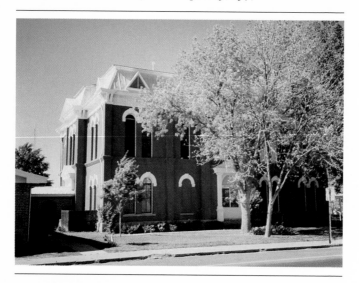

COURTHOUSES: one; 1887

STANDING: 1887 Second Empire red brick courthouse, which is a National Register Property; the architect is unknown.

LOCATION: Alpine: corner of Avenue E and Seventh Street.

NOTES: Brewster County was named for lawyer Henry Percy Brewster and was organized in 1887. Alpine is a descriptive name referring to the Davis Mountains. Alpine has had two other names: Osborne and Murphyville. The county seat's present name is an improvement.

Briscoe County

(1,971)

County Seat: Silverton (779)

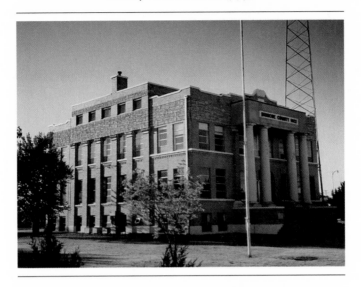

COURTHOUSES: two; 1892, 1922

STANDING: 1922 brick and concrete courthouse designed in Classical Revival style and remodeled in 1954. The architectural firm was Smith & Townes of Amarillo.

LOCATION: Silverton: corner of Main Street and Lone Star.

NOTES: Andrew Briscoe, Texas patriot and veteran of San Jacinto, was the namesake chosen, upon the organization of Briscoe County in 1892. Silverton came by its name innocently enough: Mrs. T. J. Braidfoot, a local land developer, optimistically named the community Silverton. Other stories speak of a silvery sheen on one of the local lakes which inspired Mrs. Braidfoot. Perhaps both are true.

Brooks County
(8,204)
County Seat: Falfurrias (5,788)

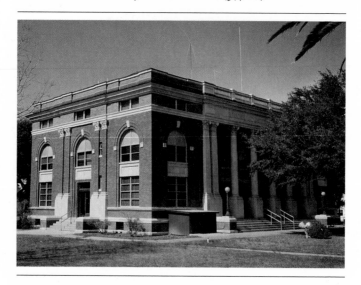

COURTHOUSES: one; 1914

STANDING: 1914 Classical Revival brick courthouse designed by Alfred Giles.

LOCATION: Falfurrias: southeast corner of South St. Mary's (U.S. 281) and Miller streets.

NOTES: Named for a local Ranger captain, judge, and legislator, James Abijah Brooks, Brooks County was organized in 1912. The Heritage Museum is located in Falfurrias. Falfurrias is supposed to be Lipan Apache for a native flower, the "heart's delight." Another possible origin is mangled Spanish for skirts, *falduras*.

Brown County

(34,371)

County Seat: Brownwood (18,387)

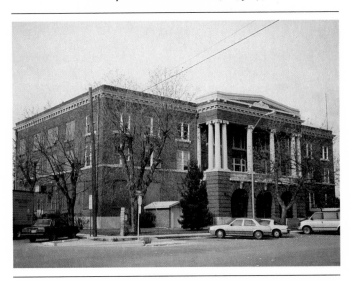

COURTHOUSES: four; 1858, 1876, 1884, 1917

STANDING: 1917 Classical Revival brick courthouse is technically a "repair," or re-modeling, of the 1884 courthouse. However, the 1884 courthouse was so thoroughly repaired that only the vault from the 1884 building survived.

LOCATION: Brownwood: corner of North Center Avenue and South Broadway.

NOTES: Henry Stevenson Brown, this county's namesake, was an early Texas merchant and Indian fighter. Brownwood is also named for Henry S. Brown.

Burleson County
(13,625)
County Seat: Caldwell (3,181)

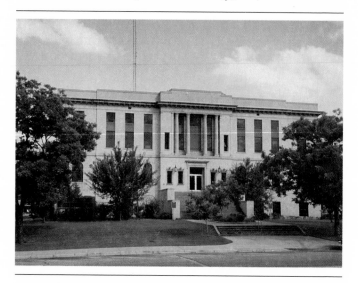

COURTHOUSES: four; 1846–47, 185 —,
1890, 1927

STANDING: 1927 brick and concrete
Classical Revival courthouse. J. M. Glover,
of Houston, was the architect.

LOCATION: Caldwell: corner of Main
Street and Fox.

NOTES: Organized in 1846, Burleson
County was named for Gen. Edward Bur-
leson of Battle of San Jacinto fame.
Mathew Caldwell, an early Texas revolu-
tionary leader, is honored by this county
seat and also Caldwell County.

The Burleson County Historical Museum
is in the courthouse.

Burnet County

(22,677)

County Seat: Burnet (3,423)

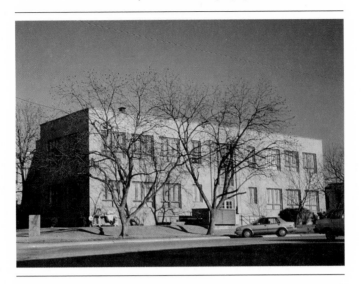

COURTHOUSES: three; 1854 (Hamilton), 1874, 1936

STANDING: 1937 Moderne-style granite courthouse constructed in part with WPA funds. Built with the same locally produced granite as the capitol, the courthouse was designed by Willis Environmental Engineering of Marble Falls.

LOCATION: Burnet: on the square, Main Street and Washington.

NOTES: David G. Burnet, the first provisional president of the Republic of Texas, was honored by the naming of this county. The city of Burnet was originally called Hamilton. The name was changed because of another Hamilton in the county. The county was organized in 1854. The 1854 courthouse was presumed burned by cattle thieves to destroy brand records.

Caldwell County
(26,392)
County Seat: Lockhart (9,205)

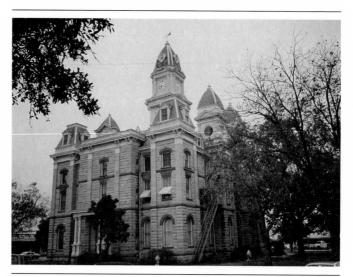

COURTHOUSES: three; 1848, 1858, 1894

STANDING: 1894 Second Empire master-piece designed by Alfred Giles and built of Muldoon blue limestone trimmed with Pecos red sandstone; a National Register Property.

LOCATION: Lockhart: on the square at Main Street and San Antonio (Texas 142).

NOTES: Organized in 1848, Caldwell County was named for Mathew Caldwell, one of the signers of the Texas Declaration of Independence and military commander during numerous engagements against Mexican forces. Byrd Lockhart, early local landowner, gave his name to the county seat.

Calhoun County

(19,053)

County Seat: Port Lavaca (10,886)

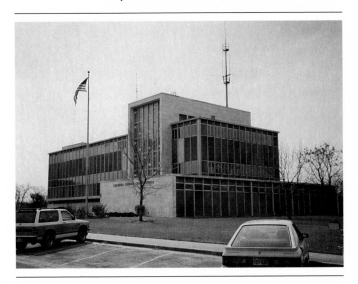

COURTHOUSES: four; 1846, 185 — (Indianola), 1887 (Port Lavaca), 1959

STANDING: 1959 courthouse, designed in Modern style by Rusty and Martin of Houston. It is built of concrete, steel, and aluminum.

LOCATION: Port Lavaca: corner of Leona and Benavides streets.

NOTES: The county is named for prominent national politician John C. Calhoun of South Carolina. The county seat started out in Port Lavaca in 1846, then moved to Indianola for thirty years and, upon the destruction of that city, returned to Port Lavaca. *La vaca,* a Spanish term, means "the cow"; Port Lavaca was an early cattle shipping point.

The Jail Museum is on Bowie Street and dates from 1896.

Callahan County

(11,859)

County Seat: Baird (1,658)

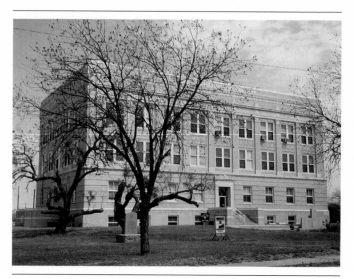

COURTHOUSES: four; 1877 (Belle Plain),
1883 (Baird), 1884, 1929

STANDING: 1929 Texas Renaissance–
style building of brick, designed by
Voelcker and Dixon, Inc.

LOCATION: Baird: corner of Fourth (U.S.
80) and Market streets.

NOTES: Callahan County, organized in
1877 and named for James Hughes
Callahan, who fought for Texas indepen-
dence and survived the Goliad Massacre,
had as its original county seat Belle Plain
until 1883, when the seat was moved to
Baird. Matthew Baird was one of the rail-
road officers when the line came through
Callahan County in the 1870s.

The Callahan County Pioneer Museum is
at Fourth and Market streets in Baird.

Cameron County

(260,120)

County Seat: Brownsville (98,962)

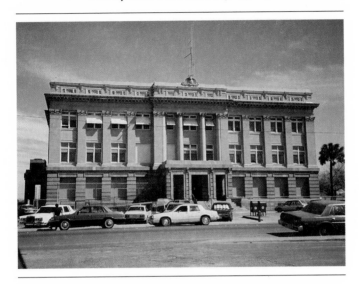

COURTHOUSES: two; 1882, 1912

STANDING: 1882 (now a Masonic Lodge)
and 1912 buildings. The 1912 building is
a Texas Renaissance structure with Classi-
cal Revival elements and was designed by
Atlee B. Ayres. The courthouse has a dome
and rotunda, which are not obvious from
the outside.

LOCATION: Brownsville: International
Boulevard (Texas 4), on East Tyler, corner
of East Ninth and East Tyler streets.

NOTES: Cameron County was organized
in 1848 and named for Scot Ewen Cameron
of the Texas Revolution and the infamous
Black Bean Affair of the Mier Expedition.
Cameron got a white bean but was shot by
Santa Anna on the way to Mexico in 1843.
Brownsville honors Maj. Jacob Brown,
who died while defending the fort in the
early days of the Mexican War.

The original county seat was Santa Rita;
doubtless there were more courthouses
than the two listed.

Camp County
(9,904)
County Seat: Pittsburg (4,007)

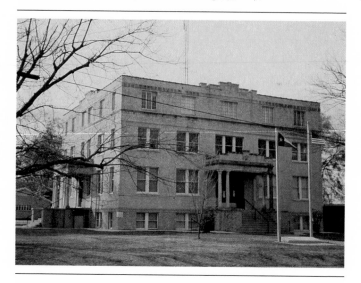

COURTHOUSES: two; 187 —, 1928

STANDING: 1928 Texas Renaissance
structure with Classical Revival elements,
designed by Smith and Praeger, Paris,
Texas. There is a columned porch at the
entrance.

LOCATION: Pittsburg: corner of Mt.
Pleasant (Spur 238) and Church streets.

NOTES: John Lafayette Camp, lawyer,
judge, colonel of the Confederate Army,
and state senator, lent his name to Camp
County when it was created from Upshur
County in 1874. W. H. Pitts, an early set-
tler from Georgia, gave his name to the
early settlement.

Carson County

(6,576)

County Seat: Panhandle (2,353)

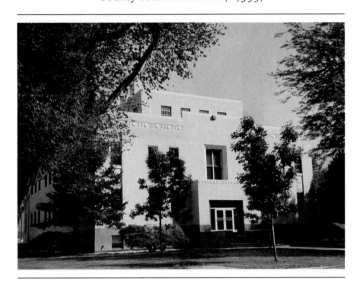

COURTHOUSES: three; 1888, 1909, 1950

STANDING: 1950 Moderne-style concrete, brick, and steel courthouse designed by J. C. Berry, Kerr and Kerr. There is an intriguing relief, or frieze, over the entrance doors depicting Carson County's economic strengths.

LOCATION: Panhandle: west corner of Main and Fifth streets.

NOTES: Organized in 1888, Carson County was named in honor of Samuel P. Carson, statesman of Texas and of the United States. Panhandle was originally named Carson City and was the terminus of the Santa Fe Railroad. The name was changed to Panhandle in 1887 because of its location.

The Carson County Square House Museum is at Fifth and Elsie streets.

Lonely cowboys used to come to dances held on the top floor of the old 1888 courthouse. The razed 1909 courthouse was very similar in appearance to the Franklin County courthouse (1912).

Cass County
(29,982)
County Seat: Linden (2,375)

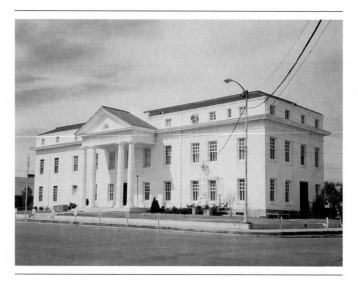

COURTHOUSES: one; 1861 (remodeled in 1900 and 1933)

STANDING: 1861 courthouse, a brick Classical Revival reincarnation originally designed by Charles Ames, county judge. This is the only antebellum courthouse surviving in Texas.

LOCATION: Linden: corner of Houston and Rush streets.

NOTES: Cass County, named for Lewis Cass, advocate of the annexation of Texas, was organized in 1846. The original county seat was Jefferson, but when Marion County was created out of Cass County in 1860, Linden became the new county seat. It was named for an early settler's former home in Tennessee.

Castro County

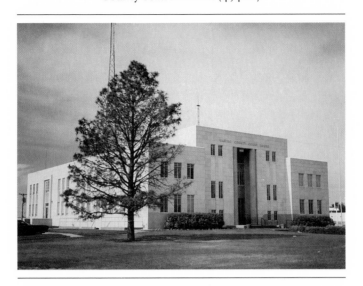

COURTHOUSES: three; 1892, 1906, 1940

STANDING: 1940 Moderne courthouse built of sandstone and designed by Townes & Funk.

LOCATION: Dimmitt: on the square, corner of Bedford (Texas 86) and Broadway streets.

NOTES: Organized in 1891, Castro County was named for Henri Castro, one of the notable pioneers and sturdy colonizers Texas attracted in abundance. His energy and enterprise were legendary; at one time Castroville rivaled San Antonio in hopes for the future. W. C. Dimmitt, an early promoter of the community, gave his name to the county seat.

The Castro County Historical Museum is located at 404 West Halsell Street.

Chambers County
(20,088)
County Seat: Anahuac (1,993)

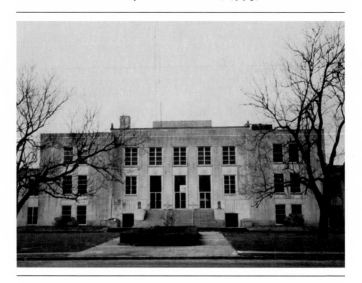

COURTHOUSES: four; 1858 (Wallisville), 1887, 1912 (Anahuac), 1936

STANDING: 1936 building of limestone designed in a Moderne, rather severe style, with the help of WPA funds. Cornell G. Curtis drew the plans for the courthouse.

LOCATION: Anahuac: west corner of Washington Avenue and Stonewall Street.

NOTES: Chambers County was formed from Jefferson and Liberty counties in 1858. Its namesake, Thomas Jefferson Chambers, was the first, and only, superior judge of Texas before the revolution. He was active in the provisional government and was one of the charter members of the Philosophical Society of Texas. Chambers was also a member of the Secession Convention. He died by assassination at his home in Anahuac. The name Anahuac, everyone agrees, is of Indian origin. There is no agreement, however, on what it means.

Anahuac is also the birthplace of Ross Shaw Sterling, noted Texas newspaper publisher, oilman, head of the Texas Highway Commission, and governor.

Cherokee County

(41,047)

County Seat: Rusk (4,366)

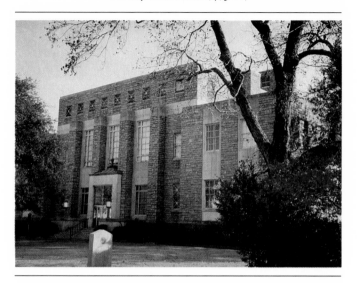

COURTHOUSES: five; 1846, 1850, 1859, 1889 (remodeled 1925), 1941

STANDING: 1941 stone courthouse (with 1955 annex across the street) designed by Gill and Bennett, Inc., in Moderne style and constructed with WPA funds.

LOCATION: Rusk: on the square at the corner of Main and Sixth streets.

NOTES: Cherokee County's name obviously came from the Indian tribe of the same name, which moved into the area in 1822. As the Republic of Texas refused to sanction any previous treaties, the Cherokees were forced to leave after a short, but intense, battle in 1839. The county was organized in 1846. Rusk, Texas, like Rusk County, is named for Thomas Jefferson Rusk.

Childress County

(5,953)

County Seat: Childress (5,055)

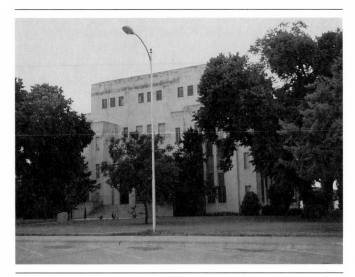

COURTHOUSES: three; 1887, 1891, 1939

STANDING: 1939 Moderne-style building designed by Townes & Funk of Amarillo, and built of stone.

LOCATION: Childress: on the square at Main Street and U.S. 287.

NOTES: The county was named for George Campbell Childress, author of the Texas Declaration of Independence. The county was organized in 1887 and was home of several large cattle companies.

Childress County Heritage Museum is on the courthouse square.

Clay County
County Seat: Henrietta (2,896)

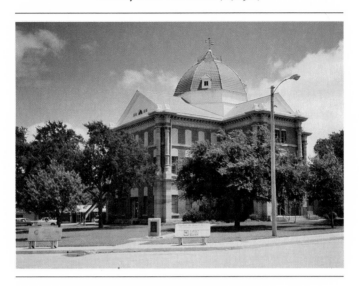

COURTHOUSES: one; 1884

STANDING: 1884 Italianate brick and sandstone structure has been altered by the removal of a prominent clock tower, roof alterations, and the building of a dome. The result is very different from what architects Wilson and Tozer designed; a National Register Property.

LOCATION: Henrietta: off U.S. 82, at the corner of North Bridge and Gilbert streets.

NOTES: Clay County was organized in 1861, but because of the Civil War and other circumstances, the settlers felt forced to give up the county. Reorganized in 1873, Clay County was named for Henry Clay. The county seat was named for the wife of Henry Clay.

An intense rivalry developed between Henrietta and New Henrietta for the county seat. New Henrietta was occasionally called Cambridge, New Town, or Pinhead. Henrietta was called worse. The Fort Worth and Denver Railroad settled the issue by building through Henrietta. New Henrietta was dismantled.

Cochran County

(4,377)

County Seat: Morton (2,597)

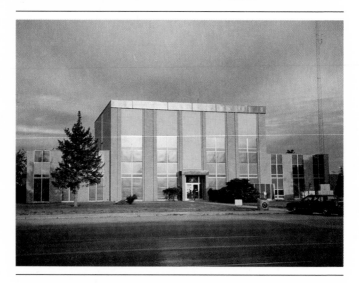

COURTHOUSES: one; 1926

STANDING: 1926 courthouse was originally a Texas Renaissance building designed by W. R. Kaufman and built of brick and steel. Remodeled and expanded in 1968, it is now a Modern building without any visual reminder of its previous life.

LOCATION: Morton: Northwest corner of Main (Texas 214) and Washington (Texas 114).

NOTES: Cochran County was organized in 1924 and named for New Jersey native Robert Cochran, who died in the Alamo siege. The C. C. Slaughter Ranch, one of the large and influential ranches of the region, had its headquarters near Morton. In fact, the county seat got its name from the selling agent for the Slaughter Ranch heirs, Morton Joe Smith.

Coke County
(3,424)
County Seat: Robert Lee (1,276)

COURTHOUSES: three; 1889, 1891, 1956

STANDING: 1956 Modern-style brick courthouse. Wyatt C. Hedrick and Harry Weaver drew the plans for the 1956 courthouse.

LOCATION: Robert Lee: on the square, Sixth and Seventh streets and Austin and Commerce streets.

NOTES: Named for Richard Coke, U.S. senator and governor of Texas, Coke County was organized in 1889, with Hayrick as the county seat. Robert Lee has been the seat of county government since 1890, and was named for the hero of the Confederacy, Robert E. Lee.

Coleman County
(9,710)
County Seat: Coleman (5,410)

COURTHOUSES: one; 1884

STANDING: 1884, but totally remodeled by Wyatt Hedrick in 1952 into a Modern brick-faced structure. The original stone courthouse, designed by W. W. Dudley, was buried within. The original courthouse had a Mansard roof and a central tower.

LOCATION: Coleman: north corner of Commercial Avenue and East Live Oak Street.

NOTES: Named for Robert Morris Coleman, Coleman County was organized in 1876. R. M. Coleman was a Virginia emigrant who fought in the Texas Revolution and was a signer of the Texas Declaration of Independence.

The Coleman Museum is in the city park in a replica of a building from Camp Colorado.

Collin County
(264,036)
County Seat: McKinney (21,283)

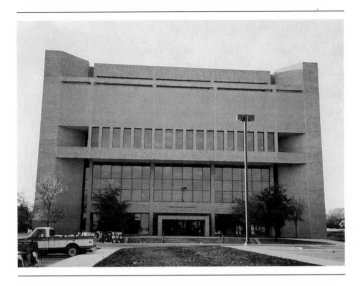

COURTHOUSES: six; 1846 (Buckner), 1848 (McKinney), 1856, 1874, 1927, 1979

STANDING: 1874, 1927, and 1979 buildings. The 1927 courthouse is a remodeling of the 1874 Second Empire, brick and stone building designed by Charles Wheeler (1874) and W. A. Peters (1927). The Modern steel, brick, and concrete courthouse was built in 1979.

LOCATION: McKinney: corner of Davis and Chestnut (off Texas 5 and Texas 121).

NOTES: Collin McKinney, for whom the county was named, was an early settler in the region and a signer of the Texas Declaration of Independence. The county was organized in 1846.

There is a museum of Collin County in the old post office, Chestnut at Virginia Street.

Collingsworth County

(3,573)

County Seat: Wellington (2,456)

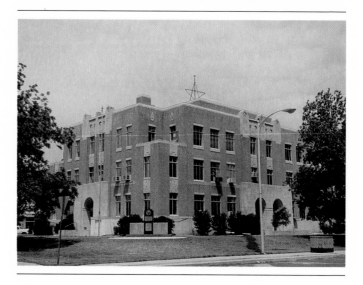

COURTHOUSES: two; 1893, 1931

STANDING: 1931, Texas Renaissance–
style courthouse of brick with stone ac-
cents. Berry & Hatch were the architects.

LOCATION: Wellington: on the square,
Fifth and Ninth, and East and West
avenues.

NOTES: The Collingsworth County Mu-
seum is at 1404 Fifteenth Street. Collings-
worth County was organized in 1890 and
named for James Colllinsworth, the first
chief justice of the Republic of Texas and a
signer of the Declaration of Independence.
There is a discrepancy between the spelling
of James Collinsworth and the county
named after him, Collingsworth. The rea-
son for the discrepancy goes back to an er-
ror in the legislation creating the county; it
has never been corrected, and so the county
named after James Collinsworth, isn't.

One of the tracts of the Rocking Chair
Ranch lay in Collingsworth County. The
ranch owner was an English peer, and the
Duke of Wellington served as inspiration
for the county seat's name.

Colorado County

(18,383)

County Seat: Columbus (3,367)

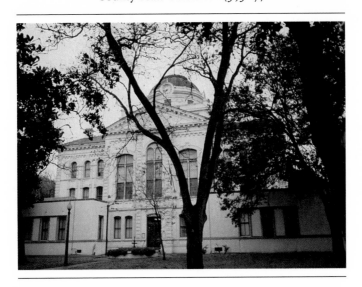

COURTHOUSES: four; 1836, 1847, 1855, 1891

STANDING: 1891 Renaissance Revival temple designed by Eugene T. Heiner, architect; a National Register Property. The courthouse has a stunning dome (originally silver) that was replaced with copper after a 1909 storm.

LOCATION: Columbus: southeast corner of Walnut (U.S. 90) and Milam streets.

NOTES: Colorado lies in an area traversed from the earliest times in Texas history. There are a variety of historic homes in Columbus, but one of the most interesting is long gone. Robert Robson, a Scot, built a concrete castle with moat, drawbridge, and rooftop gardens. Water was pumped from the Colorado River to a cistern on the roof and then through wooden pipes to the rooms of the castle; this early plumbing system may have been Texas' first. Colorado (Spanish for red), named after the Colorado River, was organized in 1837. The county seat's name comes from Columbus, Ohio—dear to an early settler.

Comal County
(51,832)
County Seat: New Braunfels (27,091)

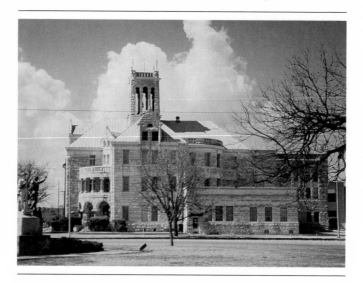

COURTHOUSES: two; 1860, 1898

STANDING: 1898 limestone palace built of local materials and designed in a Romanesque Revival style by J. Riely Gordon; a National Register Property.

LOCATION: New Braunfels: corner of East San Antonio and Seguin Avenue (Texas 46).

NOTES: Comal County (Spanish for flat saucer or pan) was named after the river, but no one is sure why the river was so named. The county was organized in 1846. The earliest permanent settlers, who came from Germany and established New Braunfels, were led by Prince Carl of Solms-Braunfels. Named for the prince, New Braunfels is a delight to visit.

Comal County officials met with architect Gordon about how to proceed with a courthouse. Ever shrewd, Gordon suggested that the county not have a design competition but rather hire an architect of "acknowledged ability." Since Gordon designed this courthouse, he evidently convinced the county that he had "acknowledged ability."

Comanche County

(13,381)

County Seat: Comanche (4,087)

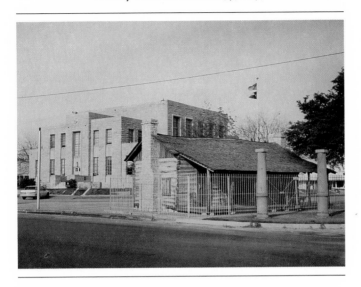

COURTHOUSES: four; 1856, 1874, 1890, 1939

STANDING: 1856 and 1939 buildings. The 1856 courthouse originally was in the community of Cora and was moved to its present location (Barks Museum) later. The 1939 Moderne-style courthouse is built of limestone and was a WPA project. Wyatt C. Hedrick designed this courthouse.

LOCATION: Comanche: on the square, Central Avenue (Texas 36/U.S. 67/U.S. 377) and Austin Street (Texas 16).

NOTES: Comanche County was created in 1856, and the county seat remained at Cora until 1859. Obviously named for the Indians, the new county seat at Comanche was created in 1858.

Concho County
(3,044)
County Seat: Paint Rock (227)

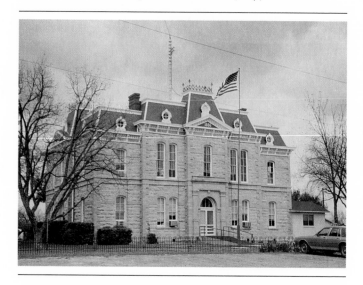

COURTHOUSES: two; 1879, 1883

STANDING: 1883 Second Empire stone courthouse with Mansard roof, designed by F. E. Ruffini; a National Register Property. Ruffini, sometimes working with his brother Oscar, designed several Second Empire buildings in Texas.

LOCATION: Paint Rock: on the square, Roberts Avenue (U.S. 83) and Moss Street (FM 380).

NOTES: Concho (Spanish for shell) is named after the river of the same name. The county was organized in 1879. Paint Rock, the county seat, was named for the many hundreds of paintings done by numerous tribes on a bluff nearby.

Cooke County

(30,777)

County Seat: Gainesville (14,256)

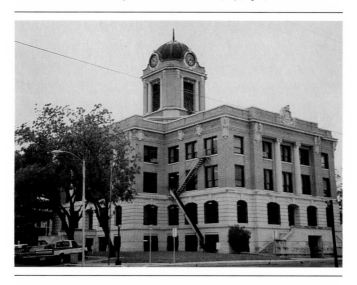

COURTHOUSES: four; 1850, 1853, 1878, 1911

STANDING: 1911 Beaux-Arts building of brick and stone designed by Lang and Witchell. Substantial interior work has been done to modernize the structure.

LOCATION: Gainesville: corner of Main and Commerce streets.

NOTES: Cooke County (organized in 1848) was named for William G. Cooke, captain of the New Orleans Greys at San Jacinto, member of the Santa Fe Expedition, secretary of war, and adjutant general. Edmund Pendleton Gaines, early Texas military leader, served as the inspiration for Gainesville.

The first courthouse, a log structure, was destroyed by a steer trying to evade pesky flies.

Coryell County

(64,213)

County Seat: Gatesville (11,492)

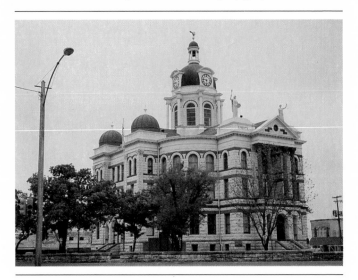

COURTHOUSES: three; 1868, 1872, 1897

STANDING: 1897 limestone and sandstone building in Beaux-Arts style with some Romanesque details. Designed by W. C. Dodson, another star among the nineteenth-century architects of Texas courthouses; a National Register Property.

LOCATION: Gatesville: corner of Main (U.S. 84/Texas 36) and Sixth Street.

NOTES: Named for James Coryell, this county was organized in 1854. James Coryell was a member of the Bowie Expedition in 1831. He joined Sterling C. Robertson's Ranger company in 1836 and later that year joined T. H. Barron's company. On May 27, 1837, while raiding a bee tree, Coryell and some companions were attacked by Indians, who shot and killed Coryell. Gatesville derived its name from old Fort Gates, which was about five miles from Gatesville, just outside present Fort Hood.

Cottle County

(2,247)

County Seat: Paducah (1,788)

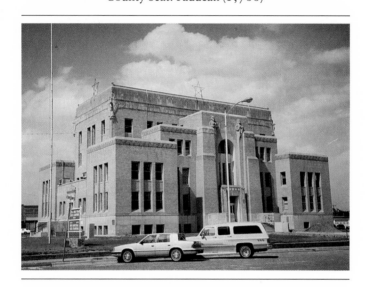

COURTHOUSES: two; 1893, 1930

STANDING: 1930 Moderne-style brick building with 1930s Art Deco and Classical details; the corners have apparent NRA eagles. Designed by the firm of Voelcker and Dixon.

LOCATION: Paducah: on the square, Ninth (U.S. 83) and Backus (FM 1037) streets.

NOTES: Named for Alamo defender George Washington Cottle, Cottle County was organized in 1892. Both of the surveyors of this county and some of its earliest settlers came from Paducah, Kentucky, and apparently they thought enough of their former home to name their new Texas home Paducah.

The Bicentennial City-County Museum is in the basement of the courthouse.

Crane County

(4,652)

County Seat: Crane (3,533)

COURTHOUSES: one; 1948

STANDING: 1948 building, but substantially remodeled in 1958 with a Modern brick exterior. The firm of Groos, Clift & Ball designed the courthouse.

LOCATION: Crane: on Sixth Street (Texas 329), between Sue and Alford streets.

NOTES: William Carey Crane lent his name to this county when it was organized in 1927. Crane was a Baptist preacher and longtime administrator of Baylor University from the days when it was located in Independence.

Crane County is somewhat remote; there are only 318 miles of road in the county. Despite the fact that there is but one community in Crane County, it boasts a surfboard manufacturing company. Since Crane County is not noted for surfing, we are left to soberly ponder the enterprise of Crane County residents.

Crockett County

(4,078)

County Seat: Ozona (3,181)

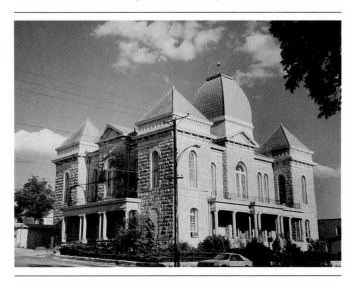

COURTHOUSES: two; 189——, 1902

STANDING: 1902 Second Empire lime-
stone building that had faux clock spaces
on the tower (they have since been re-
moved). Designed by Oscar Ruffini; a Na-
tional Register Property.

LOCATION: Ozona: corner of Avenue D
and Eleventh Street (U.S. 290).

NOTES: Crockett County was named for
Davy Crockett and organized in 1891.
Ozona, the only community in the county,
is still unincorporated and houses the
Crockett County Museum in a courthouse
annex. The origin of the name Ozona
hides in the shadows of history, but most
agree it came from promoters anxious to
emphasize the fresh air of the region. Since
Crockett County is a strong sheep ranch-
ing center, the ozone must be powerful
indeed.

Crosby County
(7,304)
County Seat: Crosbyton (2,026)

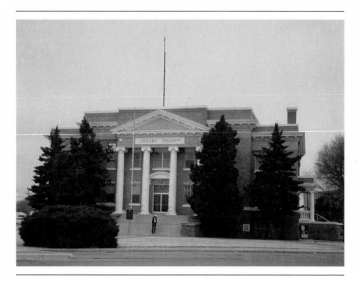

COURTHOUSES: three; 1887 (Estacado),
1891 (Emma), 1914 (Crosbyton)

STANDING: 1914 courthouse in Texas
Renaissance style with Classical columns
forming a portico; brick and concrete con-
struction. Crosbyton was planned in 1908
after previous courthouses existed in other
communities. The firm of M. H. Waller of
Fort Worth designed the courthouse.

LOCATION: Crosbyton: Southwest corner
of Berkshire Avenue and Aspen Street.

NOTES: Named for Texas Land Commis-
sioner Stephen Crosby, who was a member
of the Know-Nothing party, Crosby
County was organized in 1886.

The Crosby County Pioneer Memorial
Museum is at 101 Main Street.

Culberson County

(3,407)

County Seat: Van Horn (2,930)

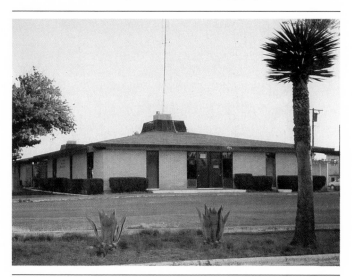

COURTHOUSES: two; 1912, 1964

STANDING: 1964 Modern brick, steel, and aluminum courthouse designed by Pierce, Norris, Pace and Associates.

LOCATION: Van Horn: intersection of La Caverna (Texas 54) and Third Street.

NOTES: David Browning Culberson was a Confederate officer and Texas legislator; Culberson County was named in his honor and organized in 1912. Col. James Judson Van Horn, U.S. Infantry, served with the Eighteenth Infantry in this area before the Civil War and lent his name to the county seat.

The old Clark Hotel on U.S. 80 houses the Culberson County Historical Museum.

Dallam County

(5,461)

County Seat: Dalhart (4,001)

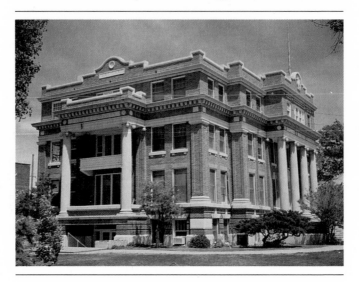

COURTHOUSES: three; 1876 (Texline), 1903, 1922

STANDING: 1922 Classical Revival courthouse built of brick; designed by Smith and Townes.

LOCATION: Dalhart: southeast corner of Denrock and Fourth streets.

NOTES: James Wilmer Dallam was a lawyer who compiled the digest of decisions of the Supreme Court of the Republic of Texas. The county was organized in 1891. Dalhart straddles the Dallam-Hartley County line; its name, reflecting the two counties, is derived from the first syllable of each.

This is XIT Ranch country, and the XIT Museum (across the street from the courthouse) is worth seeing. The museum is also supported by Hartley County.

Dallas County
(1,852,810)
County Seat: Dallas (966,168)

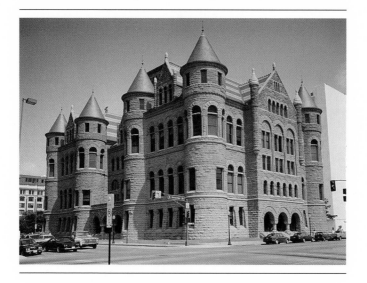

COURTHOUSES: five; 1851, 1855, 1872, 1892, 1966

STANDING: 1892 Romanesque Revival building of red granite and sandstone. Designed by Orlopp and Kusener, the old courthouse originally had a tower but due to structural weaknesses, the tower was removed about 1919. The new Modern courthouse (1966), which supplements its space, is of steel and concrete construction.

LOCATION: Dallas: corner of Jefferson Viaduct (Loop 354) and Jackson Street.

NOTES: Organized in 1846, the county was named for U.S. Vice-president George Mifflin Dallas.

Dawson County

(14,349)

County Seat: Lamesa (10,809)

COURTHOUSES: two; 1905, 1916

STANDING: 1916 brick courthouse was originally designed in Texas Renaissance style by Sanguinet and Staats. In 1952, the architectural firm of Allen and Allen built an annex and substantially remodeled the building.

LOCATION: Lamesa: on the square, Main and North and South First streets.

NOTES: The county was organized in 1905 and named for Nicholas Mosby Dawson, Texas revolutionary killed in the Battle of Salado. The county seat was originally called Chicago, but in the same year as the county's organization, the name was changed to Lamesa—Spanish for table—thus reflecting the flat countryside of the region.

The Lamesa–Dawson County Museum in Lamesa includes materials on the history of the county.

Deaf Smith County

(19,153)

County Seat: Hereford (14,745)

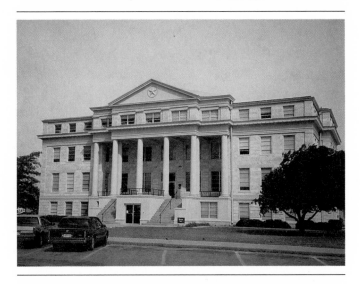

COURTHOUSES: two; 1890, 1910

STANDING: 1910 courthouse is a Classical Revival building in the Texas idiom with a Lone Star ornament. The building surface is marble. Chamberlin & Co. designed this building.

LOCATION: Hereford: south corner of Schley Avenue and Fourth Street.

NOTES: Erastus (Deaf) Smith came to Texas in 1821 and during the Revolution gained renown as a cool-headed scout and fighter. Organized in 1890, the county was named for this early Texas patriot. Since this was a ranching region, Hereford cattle inspired the name of the seat.

The Deaf Smith County Historical Museum is on Sampson Street in Hereford.

Delta County
(4,857)
County Seat: Cooper (2,153)

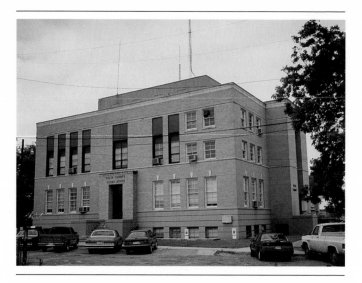

COURTHOUSES: three; 1881, 1900, 1940

STANDING: 1940 Moderne brick building designed by Hook Smith.

LOCATION: Cooper: northwest corner of First Street (FM 1528/Texas 24) and Dallas Avenue (Texas 24/154).

NOTES: Organized in 1870, Delta County got its name from its triangular shape, reminding creators of the same letter in the Greek alphabet. Sen. L. W. Cooper, who helped create this county, is memorialized in the county seat.

The Patterson Memorial County Library and Museum is at 700 West Dallas Avenue.

Denton County

(273,525)
County Seat: Denton (66,270)

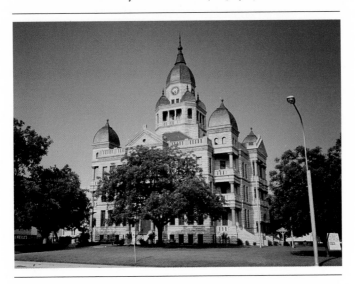

COURTHOUSES: four; 1851, 1858, 1877, 1896

STANDING: 1896 National Register Property designed by W. C. Dodson. Designed in an eclectic style, mixing Second Empire elements with Romanesque Revival, the courthouse is built of stone with eighty pink granite pillars.

LOCATION: Denton: on the square bounded by Fort Worth Drive (U.S. 377) and Dallas Drive (U.S. 77), Oak and Hickory.

NOTES: Organized in 1846, Denton County was named for John B. Denton, an early preacher and Indian fighter, who was killed in 1841 at the Battle of Village Creek.

There is a museum within the courthouse on the second floor.

DeWitt County

(18,840)

County Seat: Cuero (6,700)

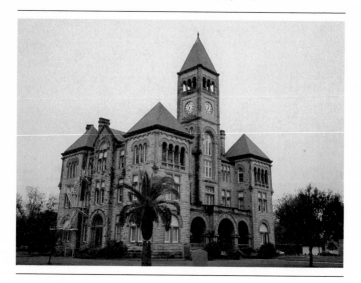

COURTHOUSES: three; 1847, 1858, 1897

STANDING: 1897 edifice built of sandstone in a distinctive Romanesque Revival style. A National Register Property, this courthouse was designed by A. O. Watson, who went bankrupt building it.

LOCATION: Cuero: Corner of Courthouse and Gonzalez streets.

NOTES: Green C. DeWitt, namesake of this county, established colonies and settlements in and around Gonzales. Cuero got its name from the local creek. The Spanish word *cuero* means hide; Indians and others skinned animals nearby.

DeWitt County was organized in 1846. The DeWitt County Historical Museum is in the historic Bates-Sheppard home.

Dickens County

(2,571)

County Seat: Dickens (322)

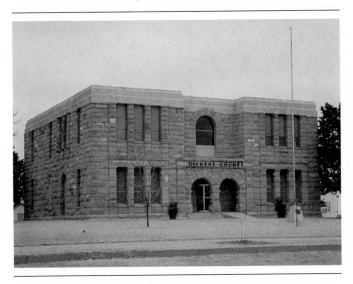

COURTHOUSES: one; 1893

STANDING: 1893 Romanesque Revival
building originally designed by E. L. Aiken
and built of stone. An addition was built
in 1936, and the courthouse has been re-
modeled at least twice, so it is very differ-
ent from its original design. As built, the
courthouse had a hipped roof and a sub-
stantial tower with stone chimneys; a Na-
tional Register Property.

LOCATION: Dickens: on U.S. 82.

NOTES: Organized in 1891, Dickens
County is named after an Alamo victim
variously recorded as James R. Demkins,
James R. Dimpkins, and J. Dickens.

Dimmit County

(10,433)

County Seat: Carrizo Springs (5,745)

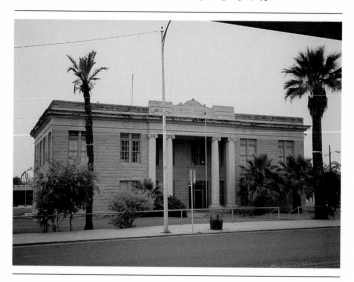

COURTHOUSES: two; 1880, 1884

STANDING: 1884 Classical Revival court-
house was originally an Italianate struc-
ture but was rebuilt or remodeled in 1927
to its present form. J. C. Breeding was the
original architect of this stone courthouse.

LOCATION: Carrizo Springs: corner of
Houston Street and Texas 85/FM 186.

NOTES: Philip Dimitt petitioned, as a
Mexican citizen (naturalized), for a league
of land. When the Texas Revolution be-
gan, he joined George Collinsworth's com-
mand and was among those who seized
Goliad. Dimmit County (misspelled in the
legislation) was organized in 1880 and
named for Dimitt.

Carrizo Springs is descriptive of what early
settlers found: a spring around which
reeds grew (*carrizo* is Spanish for reeds).

Donley County
(3,696)
County Seat: Clarendon (2,067)

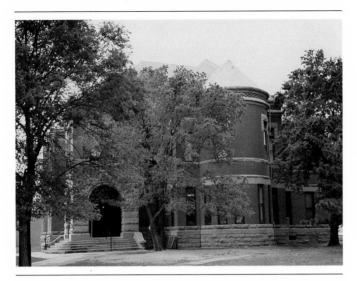

COURTHOUSES: one; 1894

STANDING: 1894 building designed by Bulger and Rapp in a Romanesque Revival style. Built of brick and stone, the courthouse used to have a tower; a National Register Property.

LOCATION: Clarendon: Corner of Jefferson and Third streets.

NOTES: Organized in 1882, Donley County was named in honor of Confederate veteran and Texas Supreme Court judge Stockton P. Donley.

Clarendon is a variation of Clara, the wife of an original settler.

Duval County

(12,918)

County Seat: San Diego (4,109)

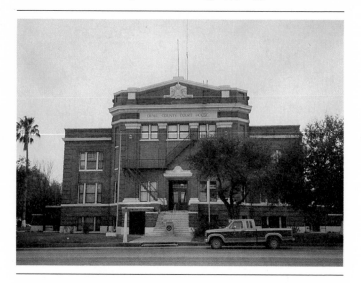

COURTHOUSES: two; 187 —, 1916

STANDING: 1916 Classical Revival court-house built of brick. The building has an annex constructed before World War II. The firm of Sanguinet, Staats & Gottlieb designed this courthouse.

LOCATION: San Diego: intersection of Travis (Texas 44) and Seguin streets.

NOTES: Duval County was organized in 1878 and named in honor of Burr H. Duval, captain of one of the companies in Fannin's command at Goliad, and killed in the massacre.

The county seat sits at the junction of San Diego and Rosita creeks, and favored San Diego for its name.

Eastland County

(18,488)

County Seat: Eastland (3,690)

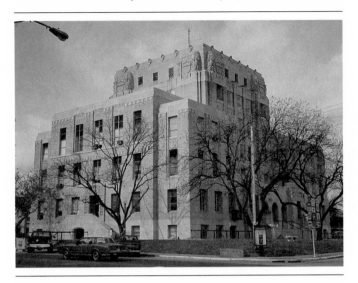

COURTHOUSES: four; 1874 (Merriman), 1875 (Eastland), 1897, 1928

STANDING: 1928 courthouse designed by architects Lang and Witchell, in a Moderne–Art Deco style with symbolic ornamentation; stone construction.

LOCATION: Eastland: intersection of Commerce and Lamar streets.

NOTES: Named for Capt. William Mosby Eastland (who drew the first black bean at Salado while on the Mier Expedition), Eastland County was organized in 1873.

Eastland County is the resting place of "Old Rip," the horned frog that survived in the old courthouse cornerstone for thirty years. Named "Old Rip" after Rip Van Winkle, the toad finally died, was embalmed, and placed in a casket in the courthouse.

Ector County

(118,934)

County Seat: Odessa (89,504)

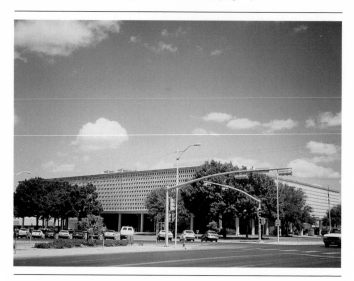

COURTHOUSES: three; 1904, 1938, 1964

STANDING: 1964 courthouse is actually the 1938 building, which was surrounded by the 1964 construction. Elmer Withers designed the 1938 structure. Peters and Fields were architects for the 1964 Modern concrete and steel courthouse.

LOCATION: Odessa: corner of Grant Avenue and Third Street.

NOTES: Ector County was named for Matthew Duncan Ector, who entered the Civil War as a private and rose to the rank of brigadier general in the Confederate army. There are many stories about the naming of Odessa, but the most prevalent is that the area suggested to early settlers the steppe breadbasket of Odessa, Russia.

The White-Pool Historic House at 112 East Murphy Street has information on Odessa's development.

Edwards County

(2,266)

County Seat: Rocksprings (1,339)

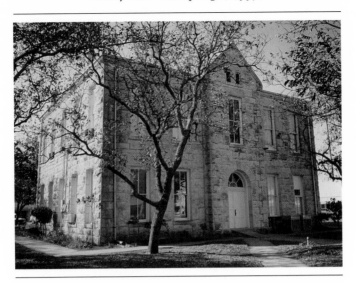

COURTHOUSES: two; 1883 (Leakey), 1891

STANDING: 1891 stone building designed by Ben Davey and Bruno Schott. The courthouse is in a vague Romanesque Revival style; a National Register Property.

LOCATION: Rocksprings: on the square, corner of Main and Sweeten streets.

NOTES: Named for early Texas colonizer Hayden Edwards of Nacogdoches, Edwards County was organized in 1883.

Rocksprings is the descriptive name for the springs that tumble from crevices in the rock of Llano Canyon.

Ellis County
(85,167)
County Seat: Waxahachie (18,168)

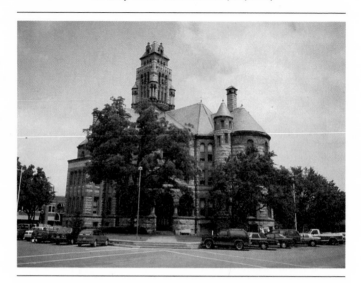

COURTHOUSES: four; 1850, 1854, 1873, 1896

STANDING: 1896 stunning red sandstone and granite Romanesque Revival building with massive tower. J. Riely Gordon designed the edifice, which still stands on the courthouse square; a National Register Property.

LOCATION: Waxahachie: corner of Main and Rogers streets.

NOTES: Organized in 1850, Ellis County was named for Richard Ellis, president of the Texas Constitutional Convention, 1836.

Waxahachie is a Tonkawa word referring to cow or buffalo creek; some say the word actually refers to cow chips. The town was named after the nearby Waxahachie Creek.

El Paso County
(591,610)
County Seat: El Paso (515,342)

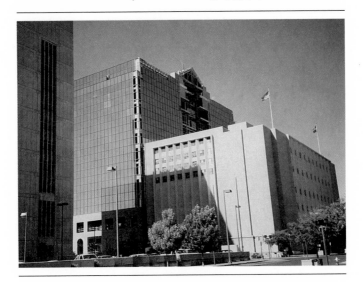

COURTHOUSES: seven; 1850 (San Elizario), 1866, 1871 (Ysleta), 1886 (El Paso), 1917, 1980, 1991

STANDING: 1991 shining new highrise building with flat surfaces covered by reflective glass. Still standing is the 1980 Modern steel and concrete building. The 1950s remodeling of the 1917 Classical Revival courthouse essentially destroyed it for the future.

LOCATION: El Paso: Paisano Drive (U.S. 62), north on South Campbell Street, to 500 San Antonio Avenue.

NOTES: El Paso (Spanish for the pass, originally El Paso del Norte—the pass of the north) was organized in 1850, but the county seat was Leakey and later moved to Ysleta. The seat changed to El Paso when that city won an exceptionally questionable ballot in 1883.

Erath County
(27,991)
County Seat: Stephenville (13,502)

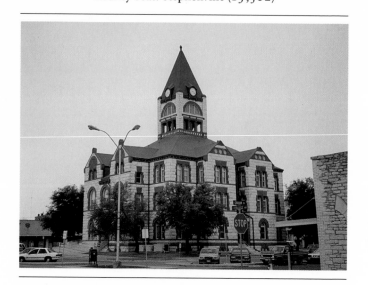

COURTHOUSES: three; 1856, 1876, 1892

STANDING: 1892 limestone courthouse is a Romanesque Revival building by noted architect J. Riely Gordon. It was restored in 1987; a National Register Property.

LOCATION: Stephenville: 100 block of West Washington Street, between College, Belknap, and Graham streets.

NOTES: Named for George Bernard Erath, who served with distinction during the Texas Revolution. Organized in 1856, the county land in Stephenville was donated by John Stephen, namesake of the county seat.

Falls County

(17,712)

County Seat: Marlin (6,386)

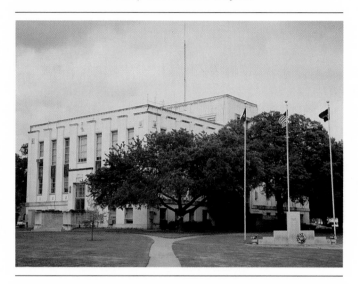

COURTHOUSES: five; 1851 (Adams),
1855 (Marlin), 1869?, 1878, 1939

STANDING: 1939 Moderne-style court-
house designed by Arthur E. Thomas and
constructed of concrete, brick, and stone.

LOCATION: Marlin: on the square be-
tween Bridge (Texas 7) and Fortune, and
Crank and Ward streets.

NOTES: Named for the Brazos River Falls,
Falls County was organized in 1850. The
courthouse burned in 1871, and the early
records were all lost. The original county
seat was Viesca, but no courthouse was
ever built. The 1851 courthouse was built
in Adams, or Adams Springs, which
changed its name to Marlin shortly after it
was named county seat. Marlin takes its
name from John Marlin, an early settler.

The Falls County Museum has materials
about the county.

Fannin County

(24,804)

County Seat: Bonham (6,686)

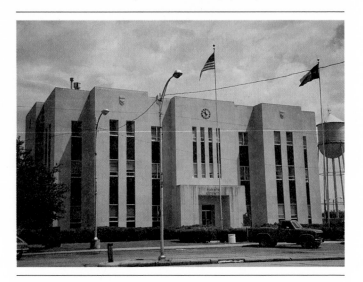

COURTHOUSES: five; 1839, 1843, 1854, 1860, 1889

STANDING: 1889 limestone courthouse was originally designed by the firm of W. C. Dodson and Dudley, architects. A 1929 remodeling removed the tower and the roof after a disastrous fire. The courthouse was rebuilt without the gables, roof, and tower. In 1965, the entire courthouse was remodeled into a Modern style. While it is still the 1889 building, it is impossible to tell from looking at it.

LOCATION: Bonham: on West Sam Rayburn Drive.

NOTES: Named for James W. Fannin, who was massacred with his soldiers at Goliad, Fannin County was organized in 1838. The third floor of the courthouse houses the Fannin County Museum.

Bonham took its name from James Butler Bonham, an Alamo defender.

Fayette County

(20,095)
County Seat: La Grange (3,951)

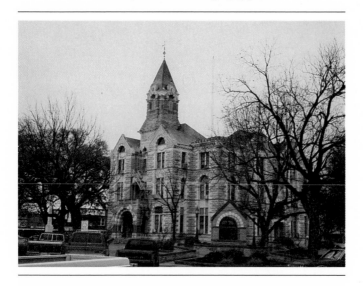

COURTHOUSES: four; 1838, 1848, 1855, 1891

STANDING: 1891 Romanesque Revival building made of rough and dressed stone, designed by J. Riely Gordon; a National Register Property.

LOCATION: La Grange: on the square between Main and Washington, and Travis (Texas 71) and Colorado streets.

NOTES: Named for the Marquis de Lafayette, the county was organized in 1838. La Grange was named for a previous settlement by early settlers.

The Fayette Heritage Museum and Archives is at 855 South Jefferson Street.

Fisher County
(4,842)
County Seat: Roby (616)

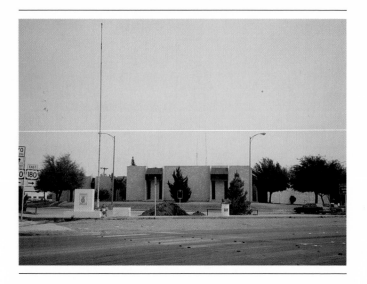

COURTHOUSES: three; 1886, 1910, 1972

STANDING: 1972 courthouse in Modern style, built of brick. The 1910 Classical Revival–style courthouse was razed, but the cornerstone is still present on the grounds. The present courthouse was built to designs by Lovett and Sellar and Associates of San Angelo.

LOCATION: Roby: intersection of U.S. 180 and Texas 70.

NOTES: Roby was named for local land-owners. Fisher County, organized in 1886, was named for Samuel Rhoads Fisher, secretary of the navy of the Republic of Texas.

Floyd County

(8,497)

County Seat: Floydada (3,896)

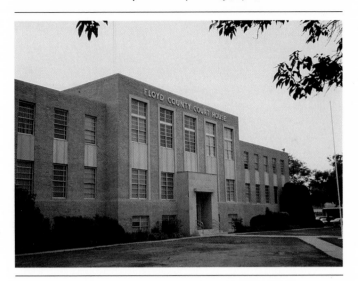

COURTHOUSES: three; 1892, 1911, 1950

STANDING: 1950 Modern-style building of masonry and steel, designed by architect Marvin Stiles of Lubbock.

LOCATION: Floydada: on Main Street between Missouri and California streets.

NOTES: Dolphin Ward Floyd died in the siege of the Alamo, and Floyd County, organized in 1890, honors his name. Floydada is a combination of Floyd and Ada (for Ada Price, a local resident). It was originally called Floyd City, but the duplication with another city of the same name prompted the invention of Floydada.

Foard County

(1,794)

County Seat: Crowell (1,230)

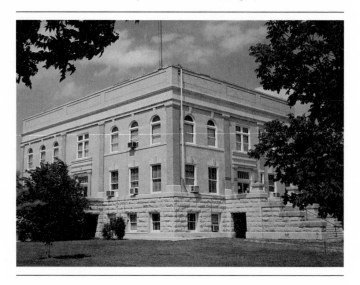

COURTHOUSES: two; 1891, 1910

STANDING: 1910 Texas Renaissance courthouse built of brick and stone, with classical details. In 1942 a tornado ripped the dome and porticoes from the building, and they were not replaced. The firm of McDonald Brothers of Fort Worth designed this courthouse.

LOCATION: Crowell: intersection of Main (Texas 6) and Commerce.

NOTES: Organized in 1891, Foard County was named in honor of Robert J. Foard, lawyer and Confederate officer. His law partner, who was in the Texas Senate, pushed the legislation through. Crowell was named for George T. Crowell, who owned the townsite.

The Foard County Courthouse Museum is inside the courthouse.

Fort Bend County
(225,421)
County Seat: Richmond (9,801)

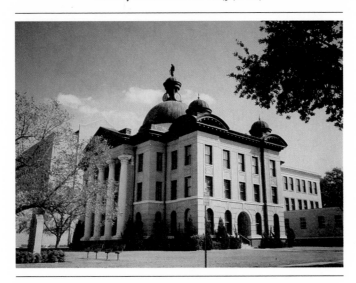

COURTHOUSES: four; 1842, 1871, 1887, 1908

STANDING: 1908 Beaux-Arts building designed by C. H. Page and Brother, architects. Built of brick with a lovely rotunda, this courthouse is virtually identical to the one in Hays County except that the Hays County courthouse does not have clocks. This is a National Register Property.

LOCATION: Richmond: corner of Jackson and Fourth streets.

NOTES: Fort Bend, organized in 1838, was named for a river bend where early colonists settled. Richmond, the county seat, harks back to the Virginia origins of early settlers.

Fort Bend County was home to Jane Long and Mirabeau B. Lamar. The Fort Bend County Museum is at 500 Houston Street.

Franklin County
(7,802)
County Seat: Mount Vernon (2,219)

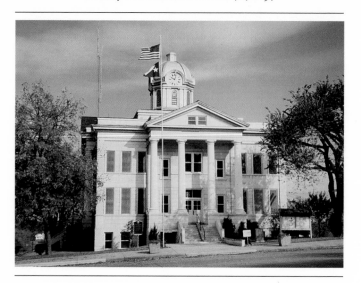

COURTHOUSES: two; 1875, 1912

STANDING: 1912 building is an attractive Classical Revival courthouse that is very similar to the vanished 1909 courthouse in Carson County—the details of the pediments on the cupola and fenestration are the chief distinguishing features. Both used pillared porticoes, gabled roofs, and clock towers. This courthouse was designed by L. L. Thurman, of Dallas.

LOCATION: Mount Vernon: off Texas 37, between Jackson and Dallas streets.

NOTES: Organized in 1875, the county was named for Benjamin Cromwell Franklin, the first judge of the Republic of Texas. In 1836, the armed Texas schooner *Invincible* captured the brig *Pocket,* owned by a U.S. citizen. Fearing reprisal, David Burnet hurriedly appointed Franklin to adjudicate the matter.

Mount Vernon was named in honor of George Washington's home. The community was originally named Lone Star.

Freestone County

(15,818)

County Seat: Fairfield (3,234)

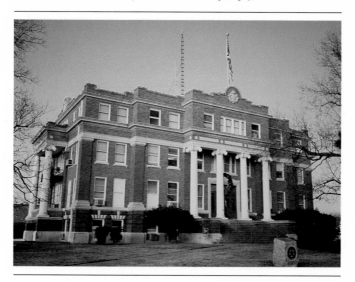

COURTHOUSES: four; 1851, 1855, 1891, 1919

STANDING: 1919 building is a Classical Revival design by W. R. Kaufman and executed in brick.

LOCATION: Fairfield: corner of Commerce and Mount streets.

NOTES: Organized in 1851, Freestone was named for the native stone of the county. Originally named Mount Pleasant, the county seat name was changed to Fairfield in sympathy with Fairfield, Alabama, the original home of early settlers.

The Freestone County Museum is on East Main.

Frio County
(13,472)
County Seat: Pearsall (6,924)

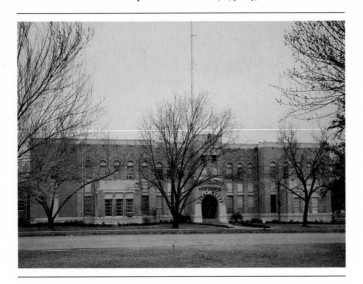

COURTHOUSES: four; 1871 (Frio Town), 1872, 1876 (Old Frio Town), 1904 (Pearsall)

STANDING: 1876 courthouse still stands abandoned in Old Frio Town on the Slaughter Ranch. The current courthouse, built in 1904 of brick, has Romanesque details but was much altered in 1937 and 1950. H. T. Phelps was the original architect.

LOCATION: Pearsall: on the square between East Leona and East San Antonio, and Cedar and Walnut streets.

NOTES: Organized in 1871, Frio (Spanish for cold) is named after the Frio River. Thomas Pearsall, director of the International–Great Northern Railroad, lent his name to the community, organized in 1880.

The old jail (1884) is the oldest building in Pearsall and houses a museum. The 1876 courthouse is down a dirt road on what was the old Slaughter Ranch. A flood levee separates the old courthouse from the jail; both have been taken over by hornets.

Gaines County
(14,123)
County Seat: Seminole (6,342)

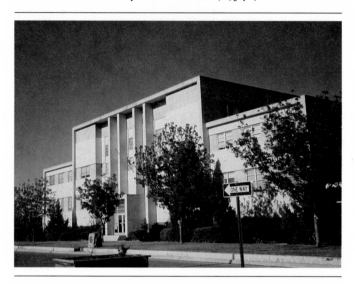

COURTHOUSES: three; 1906, 1922, 1955

STANDING: 1955 Modern concrete and limestone courthouse with a box-like mien. The 1922 courthouse, designed by Sanguinet & Staats, underwent extensive remodeling by Styles, Robert, Gee & Messersmith in 1955.

LOCATION: Seminole: corner of East Avenue A and Main Street.

NOTES: Named for Seminole Wells, some local water holes, Seminole, the county seat, grew rapidly after the arrival of the railroad in 1918.

Gaines County, organized in 1905, is named for James Gaines, a signer of the Texas Declaration of Independence.

Galveston County

(217,399)

County Seat: Galveston (59,070)

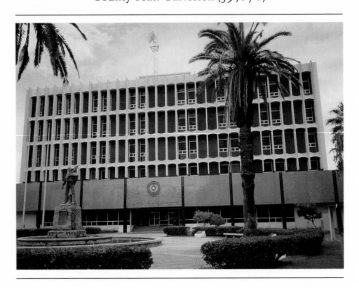

COURTHOUSES: six; 1838, 1856, 1875, 1892, 1898, 1966

STANDING: 1966 Modern concrete and steel building that seems odd for a city as steeped in history as Galveston. The columns of the 1892 courthouse are on the mall at Houston Baptist University. The present courthouse owes its design to Raymond R. Rapp, Jr., and Ben J. Koten & Associates.

LOCATION: Galveston: Broadway Avenue (U.S. 75/Texas 87), north on Twenty-first Street, corner of Twenty-first and Ball.

NOTES: Organized in 1839, Galveston (named for the Spanish governor of Louisiana, Bernardo de Galvez) drips with history. City government affairs have frequently overshadowed county concerns in Galveston. Since it is easily one of the most historically interesting cities in Texas, a visitor needs to allow sufficient time to enjoy the atmosphere of Galveston.

Garza County

(5,143)

County Seat: Post (3,768)

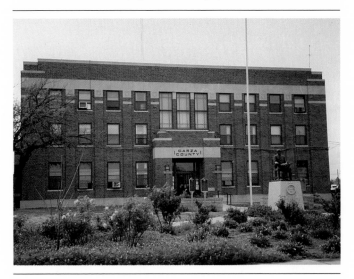

COURTHOUSES: two; 1908, 1923

STANDING: 1923 Texas Renaissance brick and concrete courthouse that was designed by C. A. Carlander.

LOCATION: Post: on center of Main Street between Avenue L and Avenue M.

NOTES: Industrialist C. W. Post founded the county seat as a sort of model city. Post also experimented with aerial dynamite explosions to induce rain and provide drought relief. He got the idea after reading that rain often accompanied the aftermath of artillery battles. Post's rain battles were said to be 40 percent effective— whatever that means.

Garza County (organized 1907) was named for a pioneer family. The Garza County Museum is in the old stone sanitarium constructed by C. W. Post.

Gillespie County
(17,204)
County Seat: Fredericksburg (6,934)

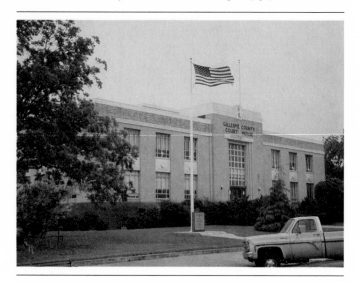

COURTHOUSES: three; 1854, 1882, 1939

STANDING: 1939 Moderne design by Edward Stein built of brick with tile accents.

LOCATION: Fredericksburg: corner of East Main and South Adams streets.

NOTES: Named for Texas Ranger captain Richard Addison Gillespie, the county was organized by German immigrants in 1848. They named the county seat after Prince Frederick of Prussia. The Pioneer Memorial Museum on West Main houses interesting lore of the early German settlers.

The 1882 courthouse, designed by Alfred Giles in an Italianate style and built of limestone, now serves as the library; it has always had a metal roof. In 1882, Giles was robbed en route to Fredericksburg by stage coach, where he was to supervise courthouse construction. One of only two who competed for a fifty-dollar prize for the Gillespie County courthouse, Giles refused the prize and asked that it go to his competitor, F. E. Ruffini, as an acknowledgement of Ruffini's talent.

Glasscock County

(1,447)

County Seat: Garden City (est. 300)

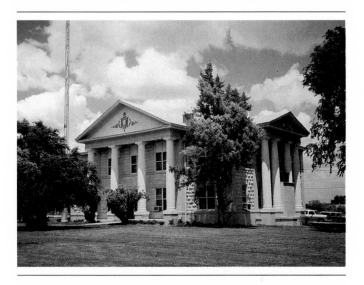

COURTHOUSES: two; 1893, 1909

STANDING: 1909 Classical Revival court-
house built of stone with columned porti-
coes. The 1894 jail is also on the court-
house square. The architects were Ed-
ward C. Hansford & Co.

LOCATION: Garden City: intersection of
Texas 158 and FM 33.

NOTES: George W. Glasscock was a flat-
boating partner of Abraham Lincoln in Illi-
nois before coming to Texas and fighting
for independence. Georgetown, as well as
this county, was named for him. The ori-
gin of Garden City is not so well known.
Perhaps it was named for an early mer-
chant named Gardner; perhaps it was an
alluring name from the original land pro-
moters. The county was organized in 1893.

Goliad County

(5,980)

County Seat: Goliad (1,946)

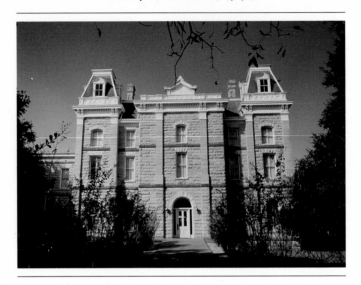

COURTHOUSES: four; 1847, 1855, 187 —, 1894

STANDING: 1894 courthouse is a Second Empire stone and brick building designed by Alfred Giles. Originally the courthouse had a soaring clock tower and a dome. A 1942 hurricane destroyed several of the towers, and they were never replaced; a National Register Property.

LOCATION: Goliad: center of End Street, between South Market and South Commercial streets.

NOTES: Organized as a county in 1836, Goliad was a strategic site for the Spanish, Mexicans, and Texans. Originally the name of the community was La Bahia, but in 1829 it was changed to Goliad, an anagram of Mexican patriot (H)idalgo. There are several museums in Goliad.

Gonzales County

(17,205)

County Seat: Gonzales (6,527)

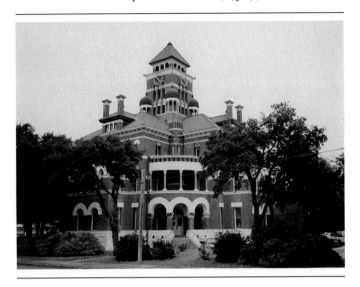

COURTHOUSES: two; 1858, 1894

STANDING: 1894 courthouse designed by
J. Riely Gordon in a Romanesque Revival
style. Constructed of red brick from St.
Louis and limestone from local quarries; a
National Register Property.

LOCATION: Gonzales: corner of St. Louis
and St. Paul streets.

NOTES: Named for the governor of Coa-
huila y Texas, Rafael Gonzales, the county
was organized in 1837. The Old Jail Mu-
seum, in a jailhouse designed by Eugene T.
Heiner, contains historical materials about
the county.

Gray County
(23,967)
County Seat: Pampa (19,959)

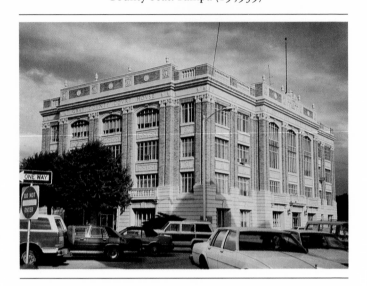

COURTHOUSES: two; 1902 (Lefors), 1928

STANDING: 1928 brick Texas Renaissance–style building designed by W. R. Kaufman. The first county seat was Lefors, but it was moved to Pampa in 1928.

LOCATION: Pampa: on Francis Avenue, between Russell and Frost streets.

NOTES: Gray county was organized in 1902 and named for Peter W. Gray, member of the first legislature, Texas Supreme Court justice, and member of the Confederate congress. The Spanish word *pampas* means plains.

Grayson County

(95,021)

County Seat: Sherman (31,601)

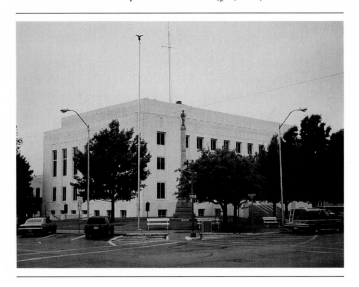

COURTHOUSES: three; 1847, 1859, 1936

STANDING: 1936 Moderne-style courthouse, built of concrete and limestone. Voelcker and Dixon, architects, drew the plans for this courthouse.

LOCATION: Sherman: on the square between Houston (Texas 56) and Lamar streets.

NOTES: Sidney Sherman, veteran of the Battle of San Jacinto, gave his name to this city, which incidentally, is also the site of the first interurban railway in Texas (1901). The naming of Grayson County honored Peter William Grayson, early Texas entrepreneur, diplomat, and government official.

Gregg County
(104,948)
County Seat: Longview (68,655)

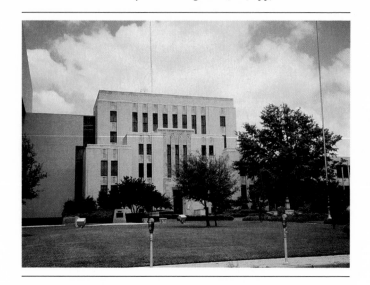

COURTHOUSES: three; 1879, 1897, 1932

STANDING: 1932 courthouse is in Art Deco style, designed by Voelcker and Dixon. The courthouse is built of brick, terra cotta, and marble. It has a Modern annex.

LOCATION: Longview: on the square, between Whaley and Methrin, and Center and Fredonia streets.

NOTES: Named in honor of Gen. John Gregg, secession convention delegate and Confederate officer. Longview was named by a group of surveyors in an apt description of what they surveyed.

The Gregg County Historical Museum is in the old Everett Building at the corner of Fredonia and Bank streets. The county was organized in 1873.

Grimes County
(18,828)
County Seat: Anderson (est. 320)

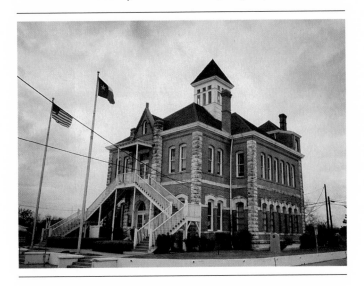

COURTHOUSES: five; 1838, 1849, 1850, 1891, 1893

STANDING: 1893 Italianate structure designed by F. S. Glover. Built of stone and brick, the courthouse is being restored at the time of this writing. This is a National Register Property.

LOCATION: Anderson: off Texas 90, on Main Street.

NOTES: Jesse Grimes signed the Texas Declaration of Independence, and for that he has been remembered geographically; this county was named in his honor in 1846. Kenneth Lewis Anderson, vice-president of the Republic of Texas, died at Fanthorp in 1845. The Fanthorp community changed its name to Anderson to honor him.

One of Clyde Barrow's gang was tried in this courthouse in the 1930s.

Guadalupe County

(64,873)

County Seat: Seguin (18,853)

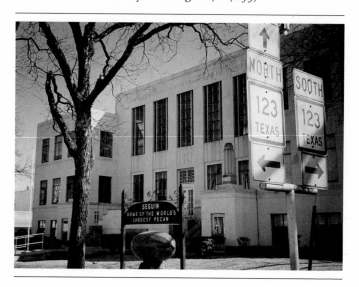

COURTHOUSES: two; 1858, 1935

STANDING: 1935 limestone courthouse designed in the Moderne style by architect L. M. Wirtz.

LOCATION: Seguin: corner of East Court Street and Austin Street (Texas 123).

NOTES: Named for the Guadalupe River and organized in 1846. The county seat, Seguin, was named for Juan Nepomuceno Seguín, a Texas revolutionary. It was Seguín who provided a proper military burial for the slain defenders of the Alamo.

Hale County
(34,671)
County Seat: Plainview (21,700)

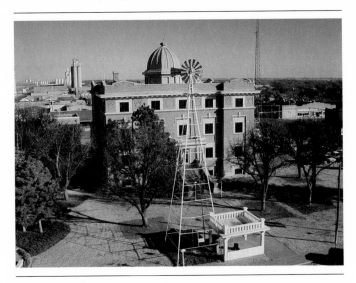

COURTHOUSES: three; 1888, 1890, 1910

STANDING: 1910 courthouse in the Texas Renaissance and Beaux-Arts styles and built of brick. A classic pediment with columns is at the entrance. This is a design by Martin, Byrnes and Johnston, architects. Bob L. Edwards, a professional photographer in Llano, Texas, graciously supplied the photograph of this courthouse.

LOCATION: Plainview: on Ash Street, between East Fifth and East Sixth streets.

NOTES: Organized in 1888, Hale County was named in honor of John C. Hale, who died at the battle of San Jacinto. Plainview was named because its location on high ground afforded a plain view of the surrounding countryside.

Hall County

(3,905)
County Seat: Memphis (2,465)

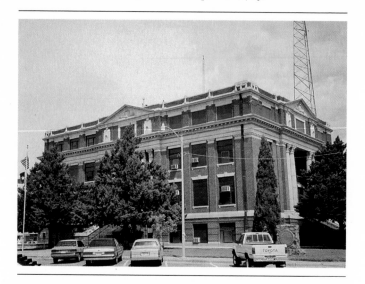

COURTHOUSES: three; 1890, 1892, 1923

STANDING: 1923 Texas Renaissance
building with classic columns and distinc-
tive stairs rising to the entrances. The court-
house was built of brick and concrete.

LOCATION: Memphis: corner of Noel
(Texas 256) and Fifth streets.

NOTES: A North Carolina lawyer, Warren
D. C. Hall, came to Texas on several occa-
sions before settling here permanently. He
served as secretary of war in the Republic,
and this county was named in his honor.
Organized in 1890, the county seat, Mem-
phis, got its name accidentally when mail
that should have gone to Tennessee, was
addressed to Memphis, Texas, instead.

Hamilton County

(7,733)

County Seat: Hamilton (2,937)

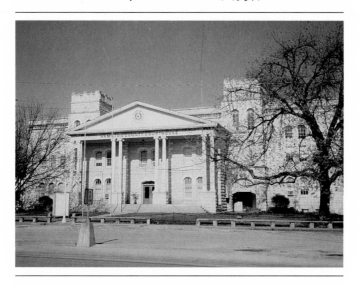

COURTHOUSES: three; 1860, 1878, 1886

STANDING: 1886 courthouse originally designed by Mason, Martin, Byrnes & Johnston as Second Empire limestone building. In 1931, under E. M. Miles, the courthouse was remodeled into a Classical Revival structure with crenellated towers flanking a large, columned portico; a National Register Property.

LOCATION: Hamilton: on square formed by Main (Texas 36), Rice (U.S. 281), Bell, and Henry streets.

NOTES: Both the county (organized in 1858) and the county seat were named to honor James Hamilton. Hamilton was governor of South Carolina and instrumental in the nullification crisis, but as that passed, he lost political influence and came to Texas as an advisor to President Lamar and diplomatic agent for the Texas Republic. On a trip back to Galveston in 1857, his ship was rammed, and he gallantly sacrificed himself by surrendering his life preserver to a woman and her child. The Hamilton County Museum is in the courthouse.

Hansford County

(5,848)

County Seat: Spearman (3,197)

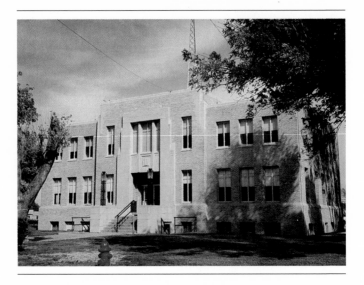

COURTHOUSES: two; 1889 (Hansford), 1931 (Spearman)

STANDING: 1931 Texas Renaissance courthouse with Moderne brick construction. An addition in 1958 displays the architectural skills of John P. Merk.

LOCATION: Spearman: junction of Kenneth Avenue and Bernice Street.

NOTES: Hansford County, named for John M. Hansford, judge and member of the Texas Congress, had as its original county seat the city of Hansford. However, when the Santa Fe Railway went through a recently erected city named after Thomas Spearman, an officer of the railroad, in 1929, Spearman became the county seat. The old county seat ceased to exist within a few years.

The Stationmaster's House Museum contains county history materials.

Hardeman County
(5,283)
County Seat: Quanah (3,413)

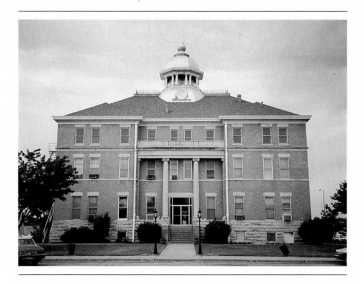

COURTHOUSES: three; 1885 (Margaret), 1890, 1908

STANDING: 1908 Beaux-Arts courthouse built of brick with a small dome. R. H. Stuckey was the architect.

LOCATION: Quanah: corner of Main and Fourth streets.

NOTES: Hardeman County was organized in 1884 and named in honor of Bailey Hardeman and Thomas Jones Hardeman, brothers and early Texas public servants. In 1890, the county seat moved from Margaret to the railroad town of Quanah (named after Quanah Parker, last chief of the Comanches). Inasmuch as residence in Quanah was defined by having one's clothes laundered there at least six times, the railroad crews had little trouble ensuring a big vote for Quanah as the new county seat.

The county historical museum is in the old stone jail built in 1891.

Hardin County
(41,320)
County Seat: Kountze (2,056)

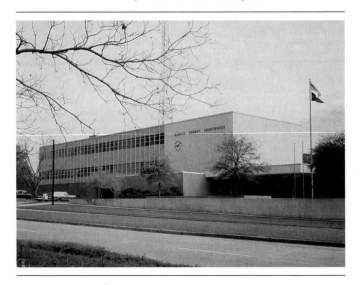

COURTHOUSES: four; 1859 (Hardin),
1872, 1904 (Kountze), 1959

STANDING: 1959 Modern edifice of steel
and masonry; designed by Dickson, Dickson & Associates.

LOCATION: Kountze: on Munro (Texas
326), between Second and Fourth avenues.

NOTES: Organized in 1858, Hardin
County was named in honor of a family
from Liberty, consisting of five sons and
their parents. The sons became prominent
in early Texas affairs.

The county seat was moved to Kountze
when the railroad bypassed Hardin; the
move occurred in 1887. Herman and Augustus Kountze worked for the railroad
and became operators of the commissary
in what became Kountze, Texas.

Harris County

(2,818,199)

County Seat: Houston (1,603,524)

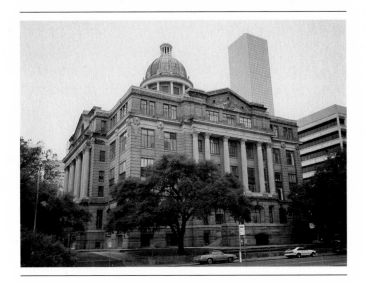

COURTHOUSES: five; 1838, 1851, 1883, 1910, 1952

STANDING: 1910 Beaux-Arts courthouse designed by Lang, Winchell & Barglebaugh. Built of granite and brick, it still serves as the Civil Courts building. The 1953 courthouse is of Modern architecture built of marble and granite, and looks nothing like the old courthouse. The 1910 structure is a National Register Property.

LOCATION: Houston: U.S. 59, north on Preston, corner of Preston and Caroline streets.

NOTES: John Richardson Harris lent his name to this county. As an early settler and merchant, he managed a small fleet of sailing vessels that traded on the Gulf Coast. Houston, of course, is named for Sam Houston.

Harrison County

(57,483)
County Seat: Marshall (23,682)

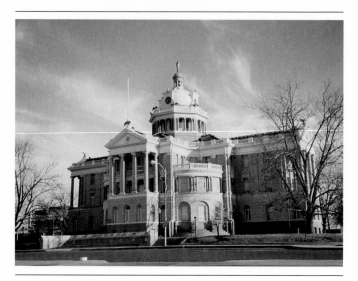

COURTHOUSES: five; 1839, 1848, 1889, 1900, 1964

STANDING: 1900 Renaissance Revival courthouse designed by J. Riely Gordon, with 1920 additions designed by C. G. Lancaster; built of granite, stone, and marble. Presently it serves as the county historical museum, and is a National Register Property. The 1964 courthouse is a Modern glass and masonry structure.

LOCATION: Marshall: corner of West Houston and Franklin streets.

NOTES: Organized in 1842, Harrison County commemorates the life of Jonas Harrison, an early settler and noted lawyer. Marshall was named for John Marshall, chief justice of the U.S. Supreme Court.

Hartley County
(3,634)
County Seat: Channing (277)

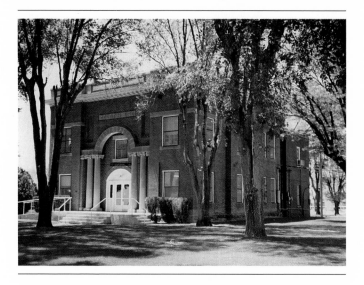

COURTHOUSES: two; 1891 (Hartley and Channing), 1906

STANDING: 1906 brick Texas Renaissance courthouse with Classical accents; there was an addition in 1935. The courthouse follows the designs of O. G. Rouquemore, architect.

LOCATION: Channing: intersection of Railroad (U.S. 385) and Ninth streets.

NOTES: Hartley County is named for Rufus K. and Oliver Cromwell Hartley, early Texas lawyers and codifiers of Texas law. Channing was named for a railroad employee. The original county seat, Hartley, missed the railroad. Channing was the headquarters of the XIT Ranch. An election in 1903 secured Channing as the county seat, and some XIT cowboys put the Hartley frame courthouse on wheels and towed it with horses to Channing. The county was organized in 1891.

The XIT Museum in Dalhart has exhibits and materials on both Dallam and Hartley counties.

Haskell County
(6,820)
County Seat: Haskell (3,362)

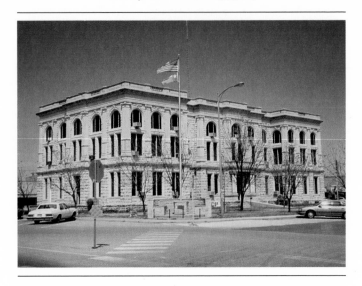

COURTHOUSES: three; 1885, 1891, 1906

STANDING: 1906 Italian Renaissance
courthouse designed by Larmour & Watson, and built of limestone. A renovation
in 1931 removed the roof and a large clock
tower.

LOCATION: Haskell: on Avenue E, between North First and South First streets.

NOTES: Organized in 1885, Haskell
County derived its name from one of the
Goliad victims, Charles Ready Haskell.
The county seat had an inauspicious beginning—a store selling groceries and
whiskey, and the Road-to-Ruin Saloon,
which also doubled as a church.

Hays County

(65,614)

County Seat: San Marcos (28,743)

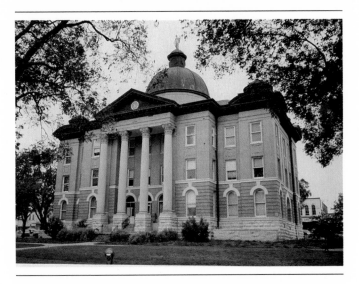

COURTHOUSES: four; 1861, 1869, 1882, 1908

STANDING: 1908 Beaux-Arts–style courthouse designed by C. H. Page & Bros., architects, is almost identical to the Fort Bend County Courthouse. Built of brick and limestone, the interior features wooden and iron beams; a National Register Property.

LOCATION: San Marcos: on the corner of Lyndon B. Johnson and Hopkins streets.

NOTES: Named for Capt. Jack Hays, a famous Texas Ranger, the county was organized in 1843. San Marcos is the abbreviated version of Villa de San Marcos de Neve, a name first given to the river on April 28, 1689 (Saint Mark's Day), by an early Spanish expedition.

Hemphill County
(3,720)
County Seat: Canadian (2,417)

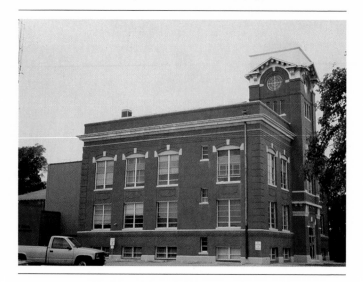

COURTHOUSES: two; 1887, 1909

STANDING: 1909 brick Texas Renaissance–style courthouse with Italianate accents on the tower. Gillcoat and Skinner were the architects.

LOCATION: Canadian: on Main Street, between Fourth and Fifth streets.

NOTES: Organized in 1887, Hamphill County was named in honor of Republic of Texas justice John Hemphill. Canadian was named for the nearby river. Hemphill County was the scene of the Buffalo Wallow Battle (1874), where two scouts and four soldiers held off a force of Comanches and Kiowas twenty times their number. The five survivors received the Medal of Honor from Gen. Nelson A. Miles. Frederic Remington's *Fight for the Water Hole* is reminiscent of the engagement.

Henderson County

(58,534)

County Seat: Athens (10,967)

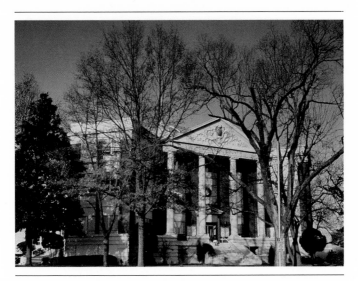

COURTHOUSES: three; 1850, 1887, 1913

STANDING: 1913 Classical Revival–style building of brick and stone, designed by L. L. Thurman.

LOCATION: Athens: on the square, bounded by Tyler (Texas 31), Corsicana (U.S. 175), Palestine (Texas 19), and Prairieville streets.

NOTES: Named for Gov. J. Pinckney Henderson, the county was organized in 1846. Athens, named either for the ancient Greek city or for Athens, Georgia, is the county seat.

Hidalgo County
(383,545)
County Seat: Edinburg (29,855)

COURTHOUSES: three; 1886 (Hidalgo), 1908, 1954

STANDING: 1886 Neoclassical brick courthouse. The 1954 courthouse is in Modern style of stone and marble.

The 1886 courthouse is in Hidalgo; the county seat moved to Chapin (later Edinburg) in 1908. Merle A. Simpson, an architect from Houston, did the renovation.

LOCATION: Edinburg: juncture of University Drive (Texas 107) and Closner Boulevard (U.S. 281).

NOTES: Named for Miguel Hidalgo y Costilla, leader of the independence movement in Mexico, the county was organized in 1852. John Young, of Edinburg, Scotland, began the community of Edinburg. The 1910 jail still exists in Edinburg.

Hill County
(27,146)
County Seat: Hillsboro (7,072)

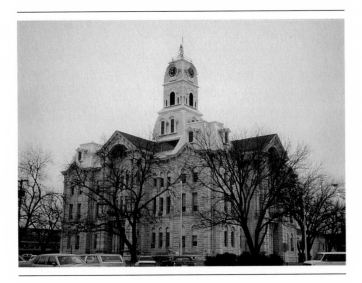

COURTHOUSES: three; 1854, 1874, 1890

STANDING: 1890 elaborate Second Empire–style courthouse designed by Wesley Clark Dodson. Built of limestone with a wooden frame and metal clock tower; a National Register Property. Hill County Courthouse is Dodson's most ornate Mansard-roofed design. Tragically, this magnificent structure was destroyed by fire in January, 1993, while this book was in press.

LOCATION: Hillsboro: on the square, bounded by Franklin, Elm, Covington, and Waco streets.

NOTES: Named for George W. Hill, a Republic of Texas official, Hill County was organized in 1853, with Hillsboro as the county seat.

Hockley County
(24,199)
County Seat: Levelland (13,986)

COURTHOUSES: two; 1921, 1928

STANDING: 1928 Classical Revival stone and concrete building; it was designed by Preston Lee Walker.

LOCATION: Levelland: on the square, bounded by Houston, Austin, Avenue G and Avenue H.

NOTES: George W. Hockley, commander of artillery at San Jacinto, received the honor of having Hockley County named after him. Levelland is another town with a geographically descriptive name.

The South Plains Museum contains materials on Hockley County.

Hood County
(28,981)
County Seat: Granbury (4,045)

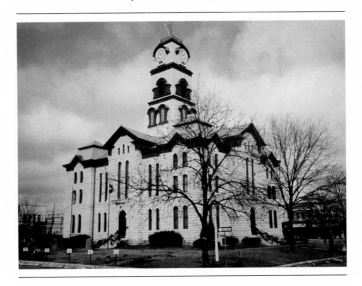

COURTHOUSES: three; 186 ——, 1876, 1890

STANDING: 1890 courthouse is part of a variety of nineteenth-century buildings built of limestone on the square. Designed by W. C. Dodson in a Second Empire style with Romanesque elements, the three-story courthouse served as inspiration for local preservation efforts; a National Register Property.

LOCATION: Granbury: corner of Houston and Bridge streets.

NOTES: Named for Confederate general John B. Hood, the county was organized in 1866. Settlers named Granbury for Hiram B. Granbury, Confederate general of the Texas Brigade.

The Hood County Museum and the Texas American Indian Museum have historic displays.

Hopkins County
(28,833)
County Seat: Sulphur Springs (14,062)

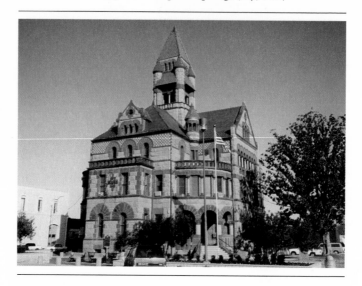

COURTHOUSES: three; 1854 (Tarrant), 1881, 1894

STANDING: 1894 Romanesque Revival courthouse designed by J. Riely Gordon, and built of granite and sandstone; a National Register Property. The courthouse is in the center of town.

LOCATION: Sulphur Springs: intersection of Jefferson (U.S. 67) and Church/Gilmer streets (Texas 154).

NOTES: The Hopkins County Museum and Heritage Park is on North Jackson Street. Organizers carved the county out of Lamar and Nacogdoches counties in 1846, with Tarrant as the original county seat. Moved in 1870, the county seat has been at Sulphur Springs since. The county was named in honor of the David Hopkins family, early settlers. Bright Star had its name changed to Sulphur Springs about the time the county seat came, in an effort to promote the area as one of healthful springs.

Houston County
(21,375)
County Seat: Crockett (7,024)

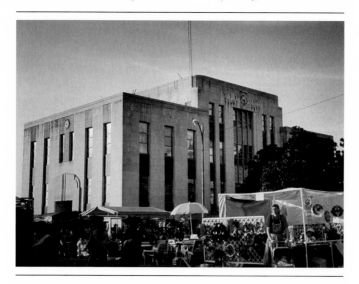

COURTHOUSES: five; 1838, 1851, 1869, 1883, 1939

STANDING: 1939 Moderne-style courthouse with some Art Deco design elements. The edifice was built of stone and owes its design to architect Blum E. Hester, of Houston.

LOCATION: Crockett: corner of Goliad (Texas 7) and Fourth (U.S. 287/Texas 19) streets.

NOTES: Houston County developed out of Nacogdoches County and was organized in 1837. Sam Houston is the county's namesake and David Crockett, Alamo victim, was the namesake of the county seat. Early records of the town were lost in a citywide fire.

Howard County
(32,343)
County Seat: Big Spring (23,093)

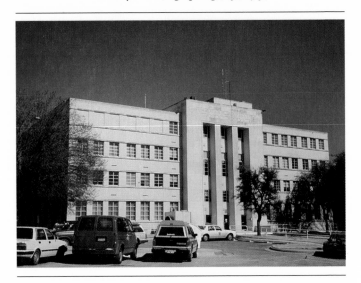

COURTHOUSES: three; 1884, 1908, 1953

STANDING: 1953 courthouse in Modern style is built of brick, tile, and concrete. Its design is the product of Puckett & French, architects.

LOCATION: Big Spring: corner of Third and Main streets.

NOTES: Organized in 1882, Howard County took its name from Volney Erskine Howard, Texas legislator and later member of Congress. The name of the county seat derived from a big spring that used to water herds of buffalo and mustangs. Heritage Museum, on Scurry Street, is devoted to local history.

Hudspeth County
(2,915)
County Seat: Sierra Blanca (est. 700)

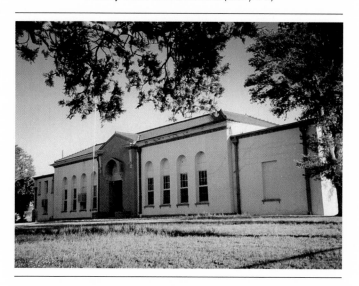

COURTHOUSES: one; 1919

STANDING: 1919 building is the only adobe courthouse in Texas and was designed by the firm of Buetell and Hardie in a Mediterranean style reminiscent of Renaissance Revival styles. The adobe walls are eighteen inches thick; a National Register Property.

LOCATION: Sierra Blanca: south of Interstate 10; second exit.

NOTES: Bradford Hardie also designed a two-story adobe business and office building in Sierra Blanca. The county seat was named for a nearby mountain peak. Claude Hudspeth, state senator and member of the U.S. Congress was the namesake for this county.

Hunt County
(64,343)
County Seat: Greenville (23,071)

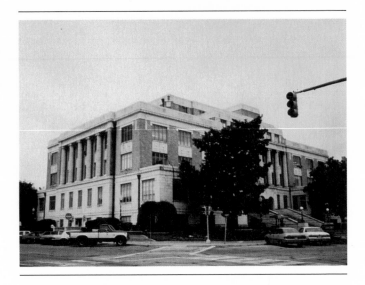

COURTHOUSES: six; 1847, 1853, 1859, 1881, 1885, 1929

STANDING: 1929 Moderne-style building designed by C. H. Page, Jr. and Bro., with Classical columns extending up from lower floors; constructed of brick and stone.

LOCATION: Greenville: corner of Lee (Business 67, Texas 302/24) and Stonewall (Business 69).

NOTES: Audie Murphy was a native of Hunt County, and there is material on him in the Public Library at 3716 Lee Street. Named for Memucan Hunt, Texas secretary of the navy, Hunt County was organized in 1846. Greenville was named after Gen. Thomas Green.

Hutchinson County
(25,689)
County Seat: Stinnett (2,166)

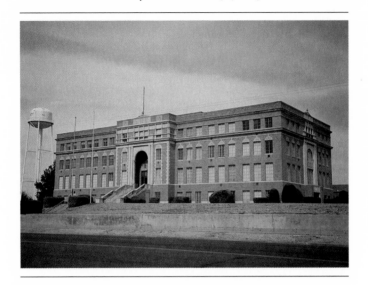

COURTHOUSES: three; 1901, 1926, 1927

STANDING: 1927 magnificent Texas Renaissance courthouse designed by William C. Townes and built of brick and concrete.

LOCATION: Stinnett: on Main Street (Texas 207).

NOTES: Named for pioneer jurist Anderson Hutchinson, the county was organized in 1901. The county seat was named for A. S. Stinnett of Amarillo. Hutchinson County is the site of the Battle of Adobe Walls, "Kit" Carson's last battle.

Irion County
(1,629)
County Seat: Mertzon (778)

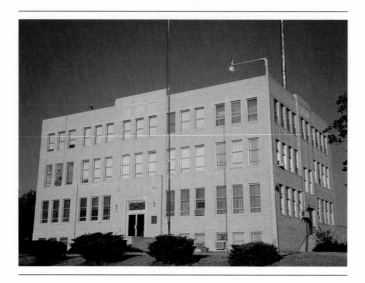

COURTHOUSES: two; 1901 (Sherwood), 1937

STANDING: 1901 courthouse, a Second Empire building, was designed by Martin & Moodie and built of limestone; a National Register Property located in Sherwood, the former county seat. The 1937 courthouse is a Moderne structure built of brick.

LOCATION: Mertzon: on the square, corner of Park View and Main Street.

NOTES: Organized in 1889 and named in honor of Robert Anderson Irion (early Texas legislator and secretary of state during the Republic), the county was the site of the famous (or infamous) Dove Creek Battle between Confederates and Texas militiamen, and the Kickapoo Indians.

M. L. Mertzon, director of the Kansas City, Mexico, and Orient Railroad, is the source of the county seat's name.

Jack County
(6,981)
County Seat: Jacksboro (3,350)

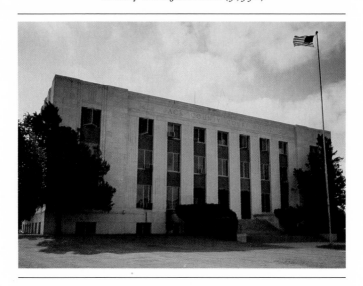

COURTHOUSES: four; 1858, 1871, 1886, 1940

STANDING: 1940 Moderne-style courthouse built of stone. The architectural firm of Voelcker and Dixon designed the building.

LOCATION: Jacksboro: on the square, corner of Belknap Street (U.S. 380) and U.S. 281.

NOTES: Organized in 1857, Jack County was named for brothers Patrick C. and William H. Jack, leaders in the Texas independence effort. The county's history includes frictions between Indians and settlers, including the so-called Salt Creek Massacre.

The city hall in Jacksboro was built with rock recycled from the 1886 courthouse.

Jackson County

(13,039)

County Seat: Edna (5,343)

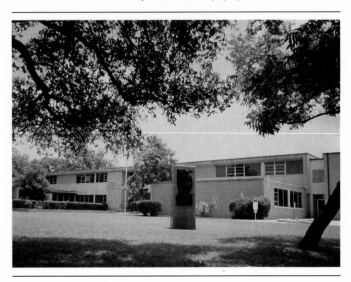

COURTHOUSES: three; 1836, 1884, 1954

STANDING: 1954 Modern design in brick, concrete, and stone by F. Perry Johnson.

LOCATION: Edna: on the square, corner of Main (U.S. 59) and Wells (Texas 111).

NOTES: Edna was named for the daughter of Joseph Talferner, a railroad executive. The county, organized in 1836, took Pres. Andrew Jackson as its namesake.

The Texana Museum on Texas 111 North, has information about Jackson County.

Jasper County
(31,102)
County Seat: Jasper (6,959)

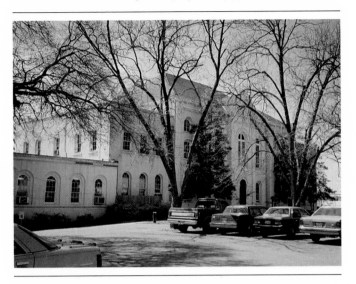

COURTHOUSES: three; 1837, 1854, 1889

STANDING: 1889 courthouse designed by Eugene T. Heiner. It has been altered extensively, stuccoed, and flanked with additions in 1934 and in 1960. Now a Neoclassical brick building, the original Renaissance Revival structure was crowned with a clock tower (removed in 1957). This is a National Register Property.

LOCATION: Jasper: corner of Main and Houston streets.

NOTES: Sgt. William Jasper, one of Francis Marion's regiment in the U.S. Revolution, gave his name to this county.

Jeff Davis County
(1,946)
County Seat: Fort Davis (1,212)

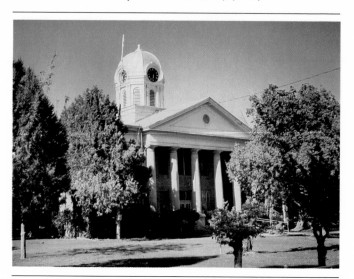

COURTHOUSES: two; 1880, 1910

STANDING: The 1910 Classical Revival courthouse has a Beaux-Arts clock tower and was built of stone and concrete. The architectural firm of L. L. Thurmon & Co. of Dallas, designed this edifice.

LOCATION: Fort Davis: off Texas 118/ Texas 17 and Court Street.

NOTES: Organized in 1887, Jeff Davis County was named for the president of the Confederacy. Fort Davis (the "Mile-high Town") was also named for Jefferson Davis — but earlier, when he was U.S. secretary of war before the Civil War.

There are several museums in Fort Davis: Neill Museum (about seven blocks west of the courthouse) is in the Trueheart House. Both the Overland Trail Museum and the Fort Davis Historic Site contain local history materials.

Jefferson County
(239,397)
County Seat: Beaumont (114,323)

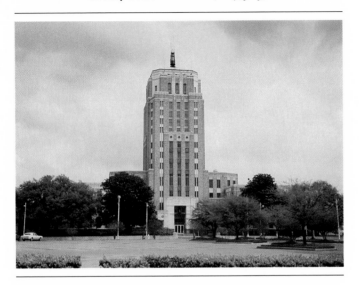

COURTHOUSES: four; 1838, 1855, 1893, 1932

STANDING: 1932 Moderne-style courthouse designed by Fred C. Stone & A. Babin. It has stone and brick veneer construction with Art Deco design elements; a National Register Property. An addition was built in 1981.

LOCATION: Beaumont: College Street (U.S. 90), south on Pearl Street, corner of Pearl and Franklin.

NOTES: Many believe Jefferson Beaumont was the source of names for both the county and the county seat. Others claim the county name came from Thomas Jefferson and the county seat name from the French, *beau mont* referring to a low rise nearby. Since the elevations around Beaumont have only slightly more variation than a billiard table, this seems doubtful. The county was organized in 1837.

153

Jim Hogg County
(5,109)
County Seat: Hebbronville (4,465)

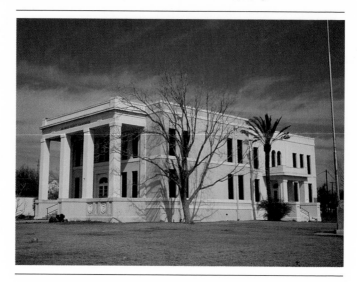

COURTHOUSES: one; 1913

STANDING: 1912 brick Texas Renaissance courthouse; later remodeled with Neoclassical stylistic elements. Architect H. T. Phelps of San Antonio produced the design.

LOCATION: Hebbronville: on the square, corner of Tilley Street and Smith Avenue (Texas 16).

NOTES: Named for Texas governor James Stephen Hogg, the county was organized in 1913. Established by W. R. Hebbron as a stop on the railroad, Hebbronville became the county seat when the county was organized.

Jim Wells County

(37,679)

County Seat: Alice (19,788)

COURTHOUSES: one; 1912

STANDING: 1912 Texas Renaissance courthouse designed by Atlee B. Ayers and built of concrete and brick. Wings were added in 1948.

LOCATION: Alice: corner of Second and North Almond streets.

NOTES: Alice King Kleberg lent her name to the community that became the county seat in 1912. James Wells was a prominent lawyer from Aransas Pass.

Johnson County
(97,165)
County Seat: Cleburne (22,205)

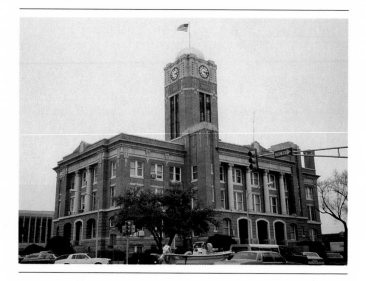

COURTHOUSES: four; 1854 (Wardville), 1857, 1882, 1913

STANDING: 1913 Texas Renaissance building designed by Lang and Witchell. Built of brick and concrete, the courthouse has Prairie-style details and a stunning interior with an atrium.

LOCATION: Cleburne: on the square, intersection of Main (Texas 174) and Henderson (U.S. 67) streets.

NOTES: Organized in 1854 and named for Col. Middleton Tate Johnson (Mexican War, the Confederacy), the county has had two county seats: Wardville and Cleburne. Cleburne honors Confederate general Pat Cleburne.

Jones County
(16,490)
County Seat: Anson (2,644)

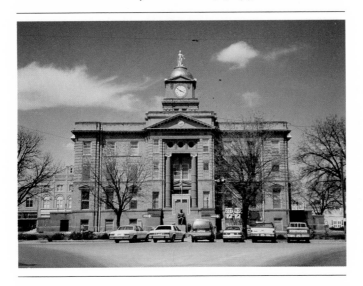

COURTHOUSES: two; 1882, 1910

STANDING: 1910 brick courthouse designed by Elmer George Withers in a Beaux-Arts style.

LOCATION: Anson: on South Commercial Street (U.S. 277), between Eleventh and Twelfth streets.

NOTES: Anson Jones, a pioneer Texas doctor, who was present at San Jacinto and was the last president of the Republic of Texas, is the honoree of both this county and its seat. Anson was originally named Jones City but was changed for reasons no one remembers.

Karnes County

(12,455)

County Seat: Karnes City (2,916)

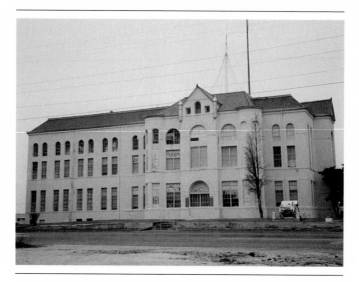

COURTHOUSES: three; 1854 (Helena), 1873 (Helena), 1894 (Karnes City)

STANDING: 1873 courthouse designed by John Jacob Riley. The 1894 Romanesque Revival design came from John Cormack only after lengthy and unseemly wrangling with other bids; bids had been accepted and rejected by contractors and architects alike.

LOCATION: Karnes City: corner of Panna Maria and Calvert.

NOTES: The Helena courthouse is now the Karnes County Museum. The county seat was moved in 1894. Named for Henry Wax Karnes, a participant in several battles and scouting expeditions during the Texas Revolution, Karnes County was organized in 1854.

Kaufman County

(52,220)

County Seat: Kaufman (5,238)

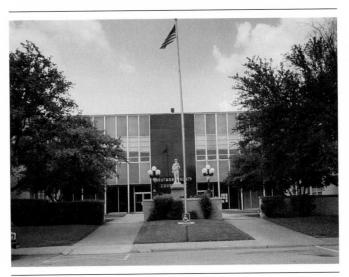

COURTHOUSES: four; 1851, 1861, 1887, 1956

STANDING: 1956 Modern steel, aluminum, and marble courthouse. The firm of A. Warren Morey and McGill of Dallas, designed the present courthouse.

LOCATION: Kaufman: on the square, corner of Grove and Washington streets.

NOTES: David Spangler Kaufman is the namesake of this county, which was organized in 1848. Kaufman came from Pennsylvania, fought with the Texans against the Cherokee Indians, and was the first man from Texas seated in the U.S. House of Representatives.

Kendall County
(14,589)
County Seat: Boerne (4,274)

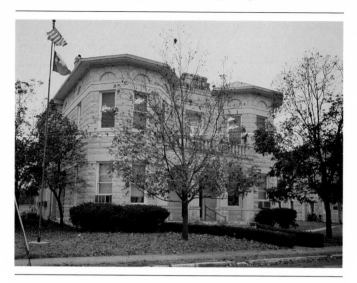

COURTHOUSES: one; 1870

STANDING: 1870 courthouse designed by Philip Zoeller and S. F. Stendeback. Charles Buckel then designed the second floor in 1886, and Alfred Giles designed the facade in 1909–10. It is in Italianate style and is the second oldest courthouse in Texas. Built of limestone, this is a National Register Property.

LOCATION: Boerne: on Saunders Street, between Blanco Road and San Antonio Avenue.

NOTES: Named in honor of George Wilkins Kendall, journalist, sheep raiser, and member of the Santa Fe Expedition, Kendall County was organized in 1862. German poet and historian Ludwig Boerne, was a political refugee in the early 1850s, and local settlers used his name for the county seat.

Kenedy County
(460)
County Seat: Sarita (est. 1 8 5)

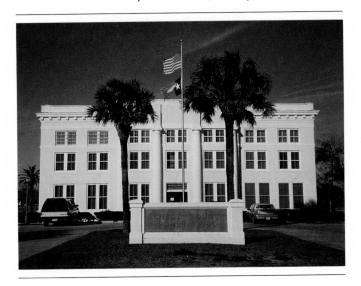

COURTHOUSES: one; 1921

STANDING: 1921 brick courthouse in
Texas Renaissance style was designed by
H. S. Phelps, an architect from San Antonio.

LOCATION: Sarita: on the square, corner
of Turcotte and La Parra streets.

NOTES: Sarita was named for the grand-
daughter of Mifflin Kenedy, riverboat cap-
tain, adventurer, and partner with Richard
King in a variety of enterprises. Among the
last counties to be organized in 1921, the
name Kenedy honors Mifflin's memory.

Kent County
(1,010)
County Seat: Jayton (608)

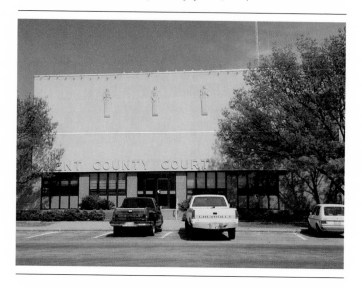

COURTHOUSES: two; 1893 (Clairemont), 1957 (Jayton)

STANDING: 1893 courthouse at Claire-mont is of sandstone construction in an Italianate style, and was designed by Martin, Byrnes, and Johnston.

The 1957 building in Jayton was designed by Wyatt Hedrick in a Modern style and built of concrete, stone, and steel.

LOCATION: Jayton: on Texas 70.

NOTES: Andrew Kent, who died at the Alamo, is honored by this county, which was organized in 1892. Jayton (named for two local promoters, James B. and R. A. Jay) became the county seat after the railroad bypassed Clairemont.

The Clairemont building once had two floors; it is now a community building.

Kerr County

(36,304)

County Seat: Kerrville (17,384)

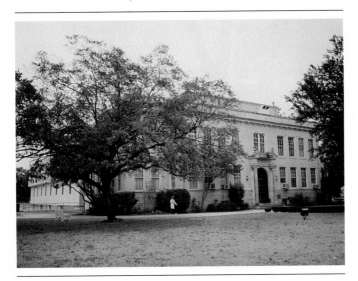

COURTHOUSES: five; 1856 (Kerrville), 1861 (Comfort), 1876 (Kerrville), 1886, 1926

STANDING: 1926 Beaux-Arts courthouse designed by Adams and Adams, architects, and built of brick and concrete.

LOCATION: Kerrville: on the square, corner of Main (Texas 27) and Sidney Baker (Texas 16).

NOTES: Kerrville has been the county seat during the entire life of this county, with the exception of two years (1860–62), when Comfort was the county seat. Both the county and its seat were named for James Kerr, one of the signers of the Texas Declaration of Independence and one of the first American settlers on the Guadalupe River.

Kimble County
(4,122)
County Seat: Junction (2,654)

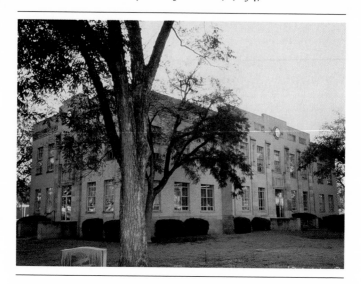

COURTHOUSES: three; 1878, 1885, 1929

STANDING: 1929 courthouse in Moderne style with Art Deco ornament. Built of brick, the courthouse was designed by Henry Phelps. An addition was built in 1974.

LOCATION: Junction: Main Street (U.S. 83) and College Street.

NOTES: George C. Kimbell (or Kimball or Kimble) died at the Alamo. Organized in 1876, Kimble County honors his memory.

Kimbleville was the first county seat, but it lasted only a few months. The community at the junction of the North and South Llano rivers became the county seat and took its name from its geographic circumstances.

The Kimble Historical Museum is located at Fourth and College streets.

King County

(354)

County Seat: Guthrie (est. 160)

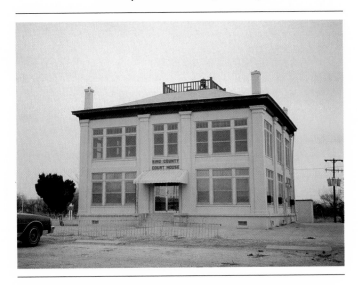

COURTHOUSES: three; 1891, 1914, 1982

STANDING: 1982 courthouse Modern brick structure designed by the Tushia Company with architect T. Renfro. The 1914 Texas Renaissance courthouse built of concrete and steel is now a museum.

LOCATION: Guthrie: U.S. 82.

NOTES: Named for William King, who died at the Alamo, King County is ranch country—the 6666 being the largest. Guthrie, which has the same population as it did in the 1890s, has been the county seat since organization in 1891. Guthrie was named for W. H. Guthrie, a stockholder in a land and cattle company prominent in the area.

Kinney County
(3,119)
County Seat: Brackettville (1,740)

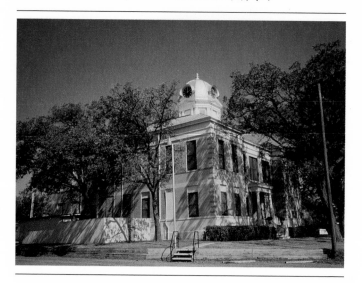

COURTHOUSES: three; 1869, 1879, 1910

STANDING: The 1910 Beaux-Arts court-
house is built of brick and reflects the de-
signs of L. L. Thurman of Dallas, architect.

LOCATION: Brackettville: intersection of
James and Ann streets.

NOTES: Henry L. Kinney, founder of Cor-
pus Christi and a state constitutional con-
vention member, is remembered by this
county. The county seat was named after
Oscar B. Brackett who was a supplier to
Fort Clark.

Kleberg County

(30,247)

County Seat: Kingsville (25,276)

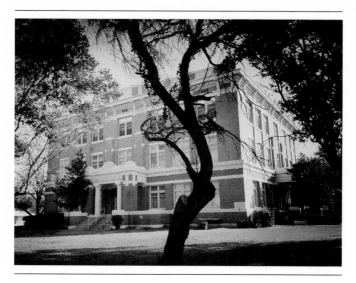

COURTHOUSES: one; 1914

STANDING: 1914 Texas Renaissance building with some Classical ornament in brick, tile, and concrete. Atlee B. Ayres was the architect.

LOCATION: Kingsville: on East Kleberg Avenue between North Eleventh and North Twelfth streets.

NOTES: Organized in 1913, the county was named in honor of Robert Justus Kleberg, a pioneer German settler who fought at the Battle of San Jacinto. Kingsville was named in honor of Capt. Richard and Henrietta King.

The John E. Conner Museum, at Texas A&I University, has materials on the county.

Knox County
(4,837)
County Seat: Benjamin (225)

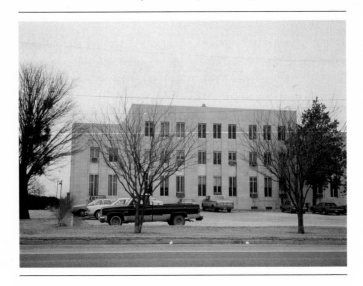

COURTHOUSES: three; 1886, 1888, 1935

STANDING: 1935 Moderne-style court-
house built of stone. Voelcker & Dixon,
Inc., were the architects.

LOCATION: Benjamin: corner of Texas 6
and U.S. 82.

NOTES: Organizers named this county for
U.S. secretary of war Gen. Henry Knox.
Benjamin was named for Benjamin Bed-
ford, a local landowner; it was made the
county seat when the county was orga-
nized in 1886.

Lamar County

(43,949)
County Seat: Paris (24,699)

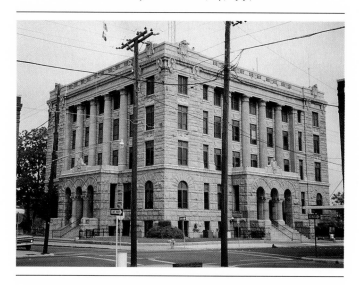

COURTHOUSES: six; 1841 (Lafayette),
1844 (Paris), 1847, 1873, 1896, 1917

STANDING: 1917 Classical Revival build-
ing with Romanesque details, designed by
Barry & Smith and Sanguinet & Staats. It
is constructed of marble and granite; the
granite is from the same quarries as the
state capitol.

LOCATION: Paris: corner of Lamar (U.S.
82) and North Main (U.S. 271).

NOTES: Mirabeau B. Lamar lent his name
to this county when it was organized in
1841. Originally called Pinhook, Paris has
been the county seat since 1844. Prior to
1844, both Lafayette (1841) and Mount
Vernon (1843) served as county seats;
no courthouse was ever built in Mount
Vernon.

Lamb County

(15,072)

County Seat: Littlefield (6,489)

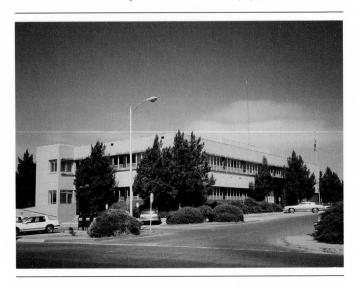

COURTHOUSES: three; 1908 (Olton), 1922, 1955 (Littlefield)

STANDING: 1955 Modern courthouse built of brick and concrete, and designed by Atcheson & Atkinson, architects. The 1922 Olton courthouse still stands, but the 1908 Olton courthouse burned.

LOCATION: Littlefield: corner of Sixth and Phelps streets.

NOTES: Maj. George W. Littlefield, who fought in numerous bloody Civil War battles and became a staunch benefactor to the University of Texas, founded Littlefield. Lamb County, organized in 1908, was named after George A. Lamb, who died at San Jacinto.

Olton, the first county seat (named for an early preacher), relinquished that seat in 1946.

Lampasas County

(13,521)

County Seat: Lampasas (6,382)

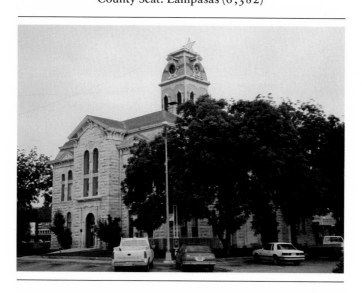

COURTHOUSES: two; 1856, 1883

STANDING: 1883 Second Empire lime-
stone courthouse designed by W. C. Dod-
son; a National Register Property.

LOCATION: Lampasas: on the square,
corner of Fourth (Spur 257) and Live Oak
streets.

NOTES: There may have been another
early courthouse, but the date of construc-
tion is unknown. Lampasas, it is generally
agreed, comes from the Spanish *lampazo*
and probably had reference to a local
plant. Lampasas used to be very popular
because of a natural spring. Now it is a
popular hunting center with an interesting
historic downtown.

La Salle County
(5,254)
County Seat: Cotulla (3,694)

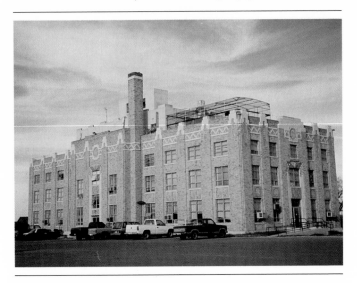

COURTHOUSES: four; 1884, 1897, 1904, 1931

STANDING: 1931 Moderne courthouse with Art Deco ornamentation in ceramic and terra-cotta. Built of brick and designed by Henry T. Phelps.

LOCATION: Cotulla: corner of Kerr and North streets.

NOTES: This county obviously derived its name from the French explorer Rene-Robert Cavelier Sieur de La Salle, who died in Texas. Cotulla was named for an early Polish settler, Joe Cotulla. The county was organized in 1880.

Lavaca County

(18,690)

County Seat: Hallettsville (2,718)

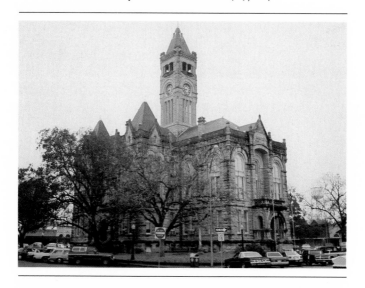

COURTHOUSES: five; 1847, 1850, 1852, 1875, 1897

STANDING: 1897 Romanesque Revival–style courthouse that dominates the city of Hallettsville. Eugene T. Heiner designed the building, and it was constructed of stone; a National Register Property.

LOCATION: Hallettsville: on North La Grange, one block from U.S. 90A.

NOTES: Lavaca, Spanish for cow, was organized in 1846. John Hallett's widow, Margaret, was honored when she gave the land for the town in 1852.

Lee County

(12,854)

County Seat: Giddings (4,093)

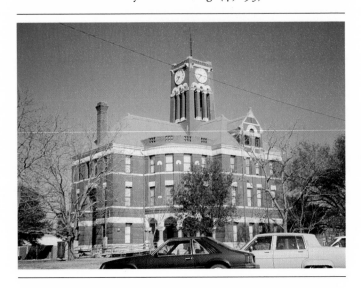

COURTHOUSES: two; 1878, 1897

STANDING: 1897 courthouse, designed by J. Riely Gordon, is built of brick in Romanesque Revival style; a National Register Property.

LOCATION: Giddings: on Main Street, between Hempstead and Richmond.

NOTES: Named for Confederate general Robert E. Lee, this county was organized in 1874. Jabez Deming Giddings, a stockholder in the Houston & Texas Central Railroad, was honored with the county seat as his namesake.

Lee County was one of the locations where Wends, a Slavic people from eastern Germany, settled.

Leon County
(12,665)
County Seat: Centerville (812)

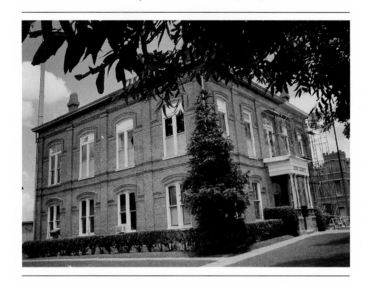

COURTHOUSES: three; 1847, 1858, 1886

STANDING: 1886 Renaissance Revival
building of brick with cast-iron columns.
The architect of this National Register
Property was William Johnson.

LOCATION: Centerville: on the square, in-
tersection of Commerce (Texas 75) and
Saint Mary's (Texas 7).

NOTES: Organized in 1846, Leon County
takes its name from either Martín de León,
an early Spanish business leader, or from a
yellow wolf, often known locally as a *león,*
Spanish for lion. Counties needed to have
their seats as close to the center as pos-
sible. There are several communities in
Texas with "center" as part of their name.

The contractor for the courthouse assumed
that the foundation was already in place.
The county commissioners assumed it was
part of the contract. Supplemental con-
tracts doubled the cost of the courthouse.

Liberty County
(52,726)
County Seat: Liberty (7,733)

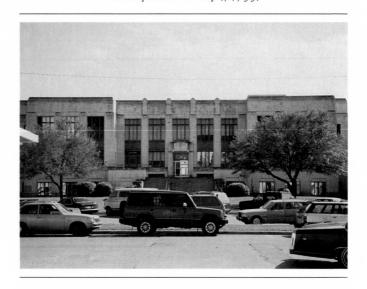

COURTHOUSES: seven; 1840, 1843, 1849, 1857, 1877, 1895, 1931

STANDING: 1931 Moderne concrete and brick building designed by architects Corneil G. Curtis and A. E. Thomas.

LOCATION: Liberty: on the square, corner of Main (Texas 146/FM 2684) and Sam Houston Street.

NOTES: The original community was named Villa de la Santísima Trinidad de la Libertad—shortened by the Anglos to Liberty. The county was organized in 1837.

The Sam Houston Regional Library has local history materials.

Limestone County
(20,946)
County Seat: Groesbeck (3,185)

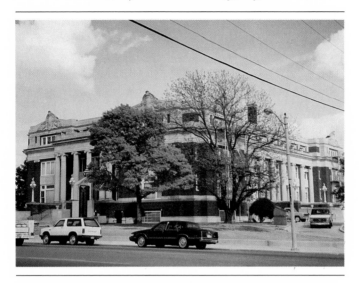

COURTHOUSES: five; 1847 (Springfield), 1856, 1878 (Groesbeck), 1892, 1924

STANDING: 1924 Classical Revival–style building constructed of brick, tile, marble, and concrete. R. H. Stucky was the architect.

LOCATION: Groesbeck: Ellis Street (Texas 14) between Brazos and State streets.

NOTES: Named for the indigenous rock, Limestone County was organized in 1846. Groesbeck, founded by the railroad, was named after one of the line's directors.

The original county seat was Springfield, a community bypassed by the railroad. Fort Parker State Park encompasses what was once Springfield. Limestone County Historical Museum is at 210 West Navasota in Groesbeck.

Lipscomb County

(3,143)

County Seat: Lipscomb (est. 45)

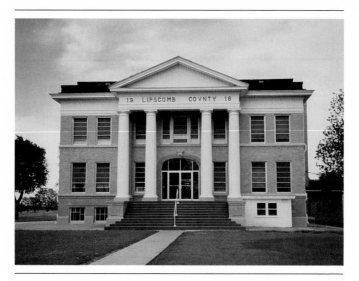

COURTHOUSES: two; 1887, 1916

STANDING: 1916 Classical Revival–style courthouse with a portico and doric columns; built of brick and concrete. W. M. Rice was the architect.

LOCATION: Lipscomb: on the square, corner of Main and Oak streets.

NOTES: Obviously, it is not hard to find the courthouse — or for that matter, anything else — in Lipscomb. A. S. Lipscomb, secretary of state of the Republic of Texas, was honored when this county was organized in 1887.

Live Oak County
(9,556)
County Seat: George West (2,568)

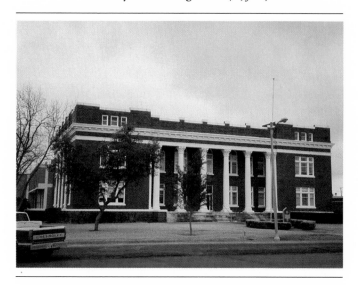

COURTHOUSES: three; 1857 (Oakville), 1888, 1919 (George West)

STANDING: 1919 Texas Renaissance courthouse of brick and concrete, with Corinthian columns, designed by Alfred Giles, architect. A modern annex by Wyatt Hedrick was built in 1956.

LOCATION: George West: on the square, on Main Street.

NOTES: George West was the founder of the community that bears his name which became the county seat in 1919. Prior to that time, Oakville had been the county seat. Live Oak County (named for its prominent trees) was the birthplace of J. Frank Dobie, Texas folklorist and writer.

Llano County

(11,631)

County Seat: Llano (2,962)

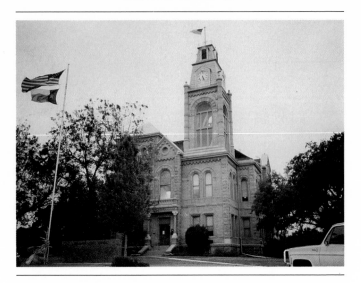

COURTHOUSES: four; 1856, 185 —,
1884, 1892

STANDING: 1892 Romanesque Revival–
style courthouse built of brick and granite.
Designed by A. O. Watson and Jacob Lar-
mour, this is a National Register Property.

LOCATION: Llano: on the square, corner
of Main (FM152) and Ford (Texas 16).

NOTES: Llano was named for the Llano
River. The Spanish word *llano* means
prairie or rolling plain, but this county's
name may have been a corruption of the
French name given to the Lipan Indians.

Llano County (organized in 1856) has
wonderful granite deposits that have been
used in buildings all over Texas and the
United States. The Llano County His-
torical Museum is in an old drugstore
on Bessamer.

Loving County
(107)
County Seat: Mentone (est. 50)

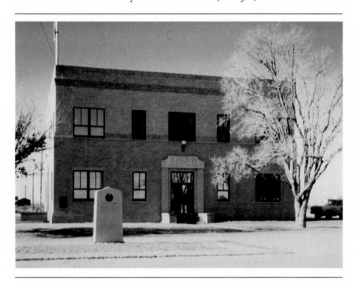

COURTHOUSES: two; 1931, 1935

STANDING: 1935 Modern brick court-
house with a telescoping second story.
Evan J. Wood designed this courthouse.

LOCATION: Mentone: on Texas 302.

NOTES: Loving County is named for
Oliver Loving, traildriver. It is the least
populated county in the state. Organized
in 1893, the county has only one town.
Mentone was named for another town in
the county, which some say was named by
a prospector from France. Mentone is only
a town in name; it has no city services, no
doctor, no lawyer, no newspaper.

Lubbock County

(222,636)

County Seat: Lubbock (186,206)

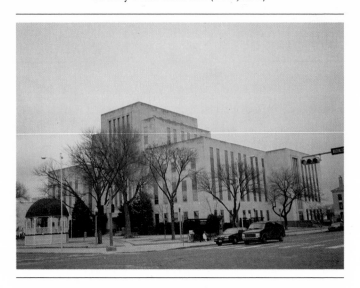

COURTHOUSES: three; 1891, 1915, 1950

STANDING: 1950 Modern-style building with a 1968 addition, of limestone and granite; Haynes & Kirby were the architects. The cupola on the original wood frame courthouse (1891) was removed to steady the building during windstorms.

LOCATION: Lubbock: on the square, corner of Avenue H and Broadway.

NOTES: Named in honor of one of the organizers of Terry's Texas Rangers, Col. Thomas S. Lubbock, the county was organized in 1891. The county seat was a compromise between rival entrepreneurs who decided to cooperate on the new site, rather than compete with rival townsites.

Lynn County
(6,758)
County Seat: Tahoka (2,868)

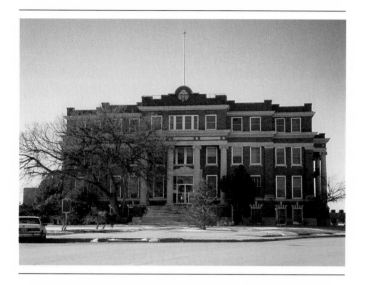

COURTHOUSES: two; 1903, 1916

STANDING: 1916 Classical Revival–style structure designed by W. R. Rice and built of concrete with a brick and terra-cotta veneer. This is a National Register Property.

LOCATION: Tahoka: on the square, corner of First and Main streets.

NOTES: Organized in 1903, Lynn County was named for Alamo victim G. W. Lynn, or G. W. Linn. Tahoka, Indian for deep or clear water, was named for the local lake of the same name.

McCulloch County

(8,778)

County Seat: Brady (5,946)

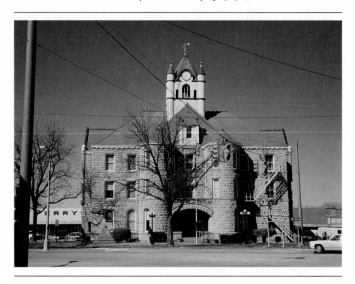

COURTHOUSES: two; 1878, 1899

STANDING: 1899 Romanesque Revival courthouse was designed by the architectural firm of Martin & Moodie. Built of sandstone, it has a clock tower, but no clock. The original contract also called for a well, cistern, and windmill; a National Register Property.

LOCATION: Brady: on the square, corner of Bridge (U.S. 377) and Commerce (U.S. 87).

NOTES: Ben McCulloch came to Texas and fought at San Jacinto. A legislator during the Republic and also during statehood, he died as a brigadier general of the Confederacy at the Battle of Pea Ridge in 1862. Peter Brady, one of the original surveyors of the county, was honored with this county seat. The county was organized in 1876.

The Heart of Texas Historical Museum is in the old 1910 jail.

McLennan County
(189,123)
County Seat: Waco (103,590)

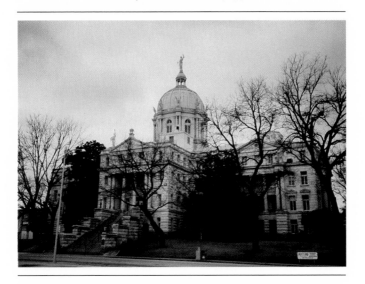

COURTHOUSES: four; 1850, 1856, 1877, 1901

STANDING: 1901 Beaux-Arts courthouse designed by J. Riely Gordon; it is built of steel-reinforced concrete, with granite at the base and a limestone facing above. W. C. Dodson supervised the project; a National Register Property. The architecture was said to have been inspired by Saint Peter's in Rome.

LOCATION: Waco: on the square, corner of North Sixth and Columbus streets.

NOTES: Organized in 1850, the county derived its name from Neil McLennan, who built the first dwelling in the county. The name of the county seat came from the nearby Waco Indians.

McMullen County
(817)
County Seat: Tilden (est. 500)

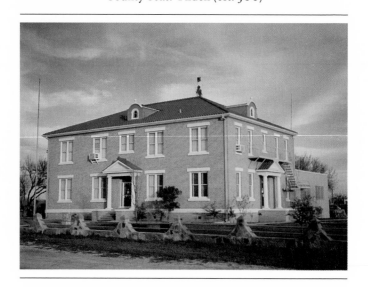

COURTHOUSES: two; 187 ——, 1930

STANDING: 1930 courthouse has Classical Revival elements. Built of brick and designed by W. C. Stephenson of Beeville.

LOCATION: Tilden: corner of River and Elm streets.

NOTES: This county derived its name from John McMullen, one of the Irish founders of San Patricio. The county organized in 1862 but was abandoned because of virulent bandit activity. It was not reorganized until 1877.

Tilden, named for Samuel J. Tilden, Democratic presidential candidate in 1876, had two previous names: Dog Town and Colfax.

The McMullen County Museum is on Texas 16.

Madison County

(10,931)

County Seat: Madisonville (3,569)

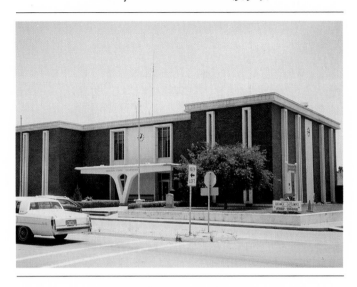

COURTHOUSES: five; 1854, 186 —,
187 —, 1896, 1970

STANDING: 1970 Modern concrete and
brick structure on the square. The archi-
tectural firm of Dickson, Dickson, Buckley
& Bullock designed this courthouse.

LOCATION: Madisonville: on the square,
corner of Main Street (Texas 21) and Elm
Street.

NOTES: Madison County took its name
from James Madison, U.S. president and
an author of the Constitution. The county
was organized in 1853.

Marion County

(9,984)

County Seat: Jefferson (2,199)

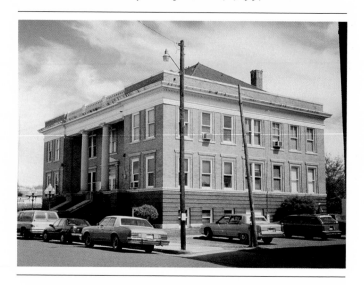

COURTHOUSES: two; 1874, 1912

STANDING: 1912 Texas Renaissance courthouse built of brick. Elmer George Withers, architect, also utilized Classical elements in his design.

LOCATION: Jefferson: on U.S. 59, between Dallas and Austin streets.

NOTES: The "Swamp Fox" of American Revolutionary fame, Francis Marion, provided the inspiration for this county. Jefferson, its seat, was named for the third president of the United States. Jefferson was a bustling river port in the early days, the first town to use gas lighting, and site of the first artificial icemaker in Texas, and, quite possibly, the first brewery. The county was organized in 1860.

The Jefferson Historical Museum is on West Austin Street.

Martin County

(4,956)

County Seat: Stanton (2,576)

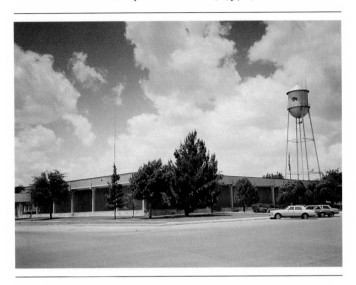

COURTHOUSES: three; 1886, 1908, 1975

STANDING: 1975 Modern concrete structure designed by Riherd & Huckabee. Twelve columns from the 1908 courthouse form a pergola, or gazebo, on the square.

LOCATION: Stanton: on the square, corner of Broadway and Saint Joseph.

NOTES: Named for Wylie Martin, a member of Austin's Colony and an early Texas patriot, Martin County was organized in 1884. Stanton (named for Abraham Lincoln's secretary of war) was originally named Mariensfield by early German Catholic settlers.

The Martin County Historical Museum on Broadway has historic exhibits.

Mason County
(3,423)
County Seat: Mason (2,041)

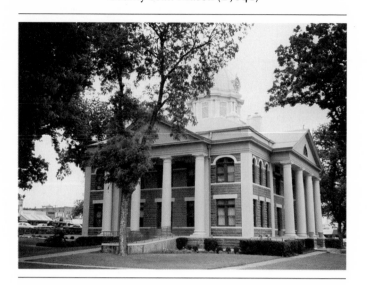

COURTHOUSES: three; 1875, 1878, 1909

STANDING: 1909 courthouse in Classical Revival style designed by E. H. Hosford & Co., architects, and built of granite. This is a National Register Property.

LOCATION: Mason: on the square on Spring Avenue between San Antonio (U.S. 87) and Fort McKavitt (Texas 29).

NOTES: Named for Fort Mason, this county was organized in 1858. The Mason County War of the mid-1870s was a vicious feud that began because of cattle thieving; several men were murdered. Rangers came to the county to keep the peace, but no one was ever convicted of the murders there.

Matagorda County
(36,928)
County Seat: Bay City (18,170)

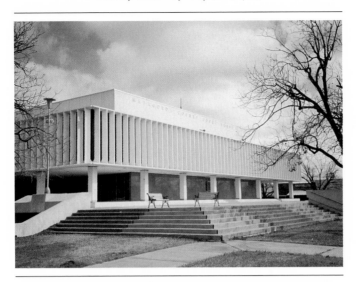

COURTHOUSES: three; 1849, 1895, 1965

STANDING: 1965 Modern reinforced concrete structure designed by Rusty, Martin & Vale.

LOCATION: Bay City: on the square, corner of Seventh (Texas 35) and Avenue F (Texas 60).

NOTES: Settled by Stephen F. Austin's colonists, Matagorda County was organized in 1837. In the old city hall on Sixth Street is the Matagorda County Historical Museum. *Mata* and *gorda* are two Spanish words meaning fat or thick plant, shrub, or plant growth, and had reference to canebrakes encountered by early colonists.

Maverick County
(36,378)
County Seat: Eagle Pass (20,651)

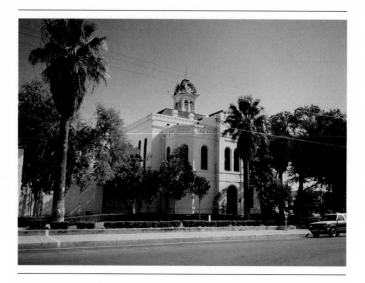

COURTHOUSES: two; 1885, 1979

STANDING: 1885 Romanesque Revival
courthouse built of brick and stone; de-
signed by the architectural firm of Wahren-
berger & Beckman. Presently, the old court-
house stands vacant, awaiting funds for
restoration. The 1979 Modern courthouse
replaced the 1885 building, which is a Na-
tional Register Property.

LOCATION: Eagle Pass: off Main Street,
corner of North Jefferson and Quarry
streets.

NOTES: Organized in 1871, Maverick
County was named for Sam Maverick,
Texas revolutionary, legislator, and signer
of the Texas Declaration of Independence
—whose name also became a synonym for
unbranded cattle. Eagle Pass was named
for a temporary military post, Camp Eagle
Pass, the name of which came from the
flight of an eagle back and forth from its
nest.

Medina County

(27,312)
County Seat: Hondo (6,018)

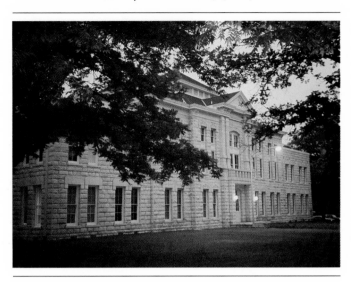

COURTHOUSES: two; 1854, 1892

STANDING: 1892 building was originally an Italianate structure, but it has been altered greatly. A National Register Property, this courthouse was designed by Martin, Byrnes & Johnston. Also standing is the 1854 courthouse in Castroville (now the city hall). Castroville used to be the county seat.

LOCATION: Hondo: on Sixteenth Street, between Avenue K and Avenue M.

NOTES: The 1892 courthouse originally had a tower with an ornamental clock; it was removed in 1941. Limestone for the 1892 courthouse and its additions came by donation from the Decker Ranch. The new wings were completed with WPA funds in 1942. The county was organized in 1848 and named for a local river. *Hondo* is Spanish for deep, another obvious reference to the river.

Menard County
(2,252)
County Seat: Menard (1,606)

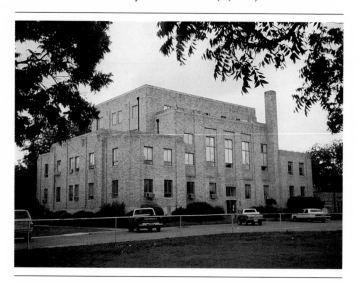

COURTHOUSES: three; 187 —, 1886, 1931

STANDING: 1931 concrete and brick Moderne-style building with Art Deco details. Withers & Thompson was the architectural firm.

LOCATION: Menard: corner of Tipton and Bowie streets.

NOTES: Organized in 1871, Menard was named for Michel B. Menard, founder of the city of Galveston, signer of the Texas Declaration of Independence, and member of the Texas Congress. The Menardville Museum is in the old Frisco Depot on U.S. 83 north of the San Saba River.

Midland County

(106,611)

County Seat: Midland (89,443)

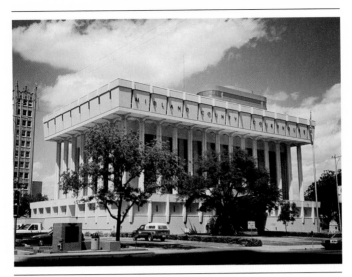

COURTHOUSES: three; 1886, 1906, 1930

STANDING: 1930 courthouse was origi-
nally designed by Voelcker and Dixon. A
1974 remodeling, designed by Dixon and
Staley, obliterated the original Art Deco–
style building and replaced it with a Mod-
ern structure.

LOCATION: Midland: on the square, cor-
ner of Wall Avenue and North Lorraine.

NOTES: Organized in 1858, Midland was
the railroad's halfway point between El
Paso and Fort Worth, hence its name. The
Midland County Historical Museum and
the Museum of the Southwest are both on
West Missouri, although somewhat distant
from each other. The Nita Stewart Haley
Memorial Library on West Indiana also
deserves a visit.

Milam County

(22,946)

County Seat: Cameron (5,580)

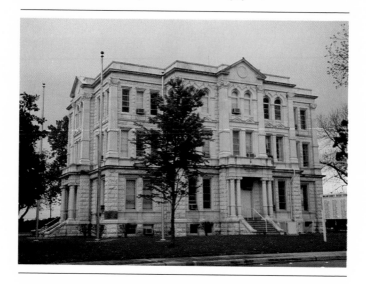

COURTHOUSES: six; 1841 (Caldwell), 1846 (Cameron), 1856, 1871, 1876, 1892

STANDING: 1892 building, a National Register Property, was originally designed by Larmour & Watson in Renaissance Revival style. Built of stone, it had a fenestrated tower with clocks and a statue, but the tower was torn down in 1938. The statue was stored, however. The roof was also substantially altered during this WPA-funded remodeling.

LOCATION: Cameron: corner of First and South Central Avenue.

NOTES: Benjamin Rush Milam fell at the Alamo and Milam County, organized in 1837, honored his memory. Cameron was named for Scot Ewen Cameron, a leader of the Mier Expedition who, although he drew a white bean, was shot anyway on the way to Mexico City. Milam has had three county seats: Caldwell, Nashville, and Cameron.

The Milam County Historical Museum is at Main and Fannin.

Mills County
(4,531)
County Seat: Goldthwaite (1,658)

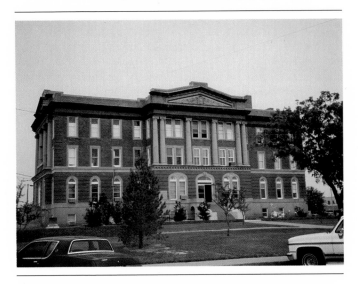

COURTHOUSES: two; 1890, 1913

STANDING: 1913 courthouse in Classical Revival style and built of brick, stone, and concrete, was designed by Henry Phelps.

LOCATION: Goldthwaite: on the square, between Fourth and Fifth and Fisher streets (U.S. 183).

NOTES: Organized in 1887 and named for John T. Mills, a judge during the Republic of Texas, Mills County claims to be the geographic center of Texas—a claim disputed by others. Joseph G. Goldthwaite was an official of the railroad that was built through the area in 1885, the same year the town was founded. The Mills County Historical Museum (Third and Fisher streets) has materials on the county.

Mitchell County
(8,016)
County Seat: Colorado City (4,749)

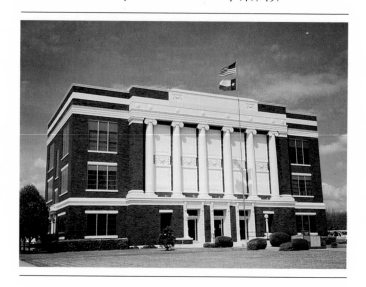

COURTHOUSES: three; 1883, 1885, 1924

STANDING: 1924 Classical Revival courthouse designed by David Castle and built of brick. The first two courthouses were both designed by Martin, Byrnes & Johnston. The 1883 courthouse was found to have been built in the middle of Oak Street rather than off of it, so it was demolished and rebuilt. It was copied from the courthouse in Bastrop.

LOCATION: Colorado City: on the square, corner of Pine and Third streets.

NOTES: Organized in 1881 and named for pioneer brothers Asa and Eli Mitchell, Mitchell County has an interesting museum on West Third Street featuring materials on Colorado City and the county. Colorado City is the oldest settlement between Weatherford and El Paso.

Montague County

(17,274)

County Seat: Montague (est. 400)

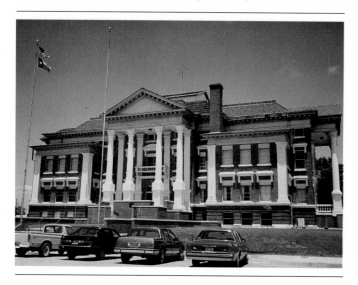

COURTHOUSES: four; 1858, 1879, 1885, 1912

STANDING: 1912 imposing Classical Revival–style courthouse designed by George Burnett and built of brick, steel, and concrete. As originally built, the courthouse had an impressive dome surrounded with columns and windows. Damaged during a 1941 wind storm, the dome was removed.

LOCATION: Montague: on Texas 59.

NOTES: Named for pioneer surveyor, Daniel Montague, the county was organized in 1858.

Montgomery County
(182,201)
County Seat: Conroe (27,610)

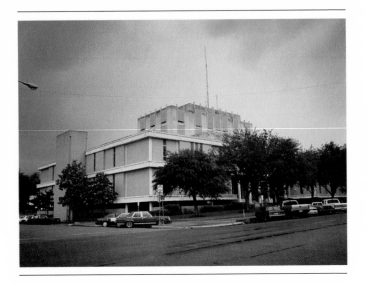

COURTHOUSES: five; 1838, 1842, 1855, 1891, 1936

STANDING: 1936 Moderne-style courthouse built of limestone has been obscured by a 1965 Modern remodeling. Joseph Finger, Inc., was the original architect of this building.

LOCATION: Conroe: corner of Davis (Texas 105) and Main streets.

NOTES: Organized in 1837, Montgomery County was named for American Revolutionary War general Richard Montgomery. Isaac Conroe, who operated a sawmill in the vicinity, gave the county seat its name.

Moore County

(17,865)

County Seat: Dumas (12,871)

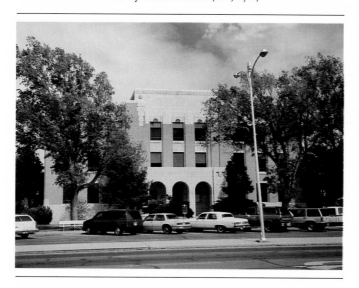

COURTHOUSES: two; 1893, 1930

STANDING: 1930 Moderne building with eagles as ornamentation; of brick and concrete construction. The designers were Berry & Hatch.

LOCATION: Dumas: on the square, between Seventh and Eighth streets and Dumas Avenue (U.S. 87/U.S. 287).

NOTES: Named in honor of the commodore of the Texas Navy, Edwin W. Moore, the county was organized in 1892. Louis Dumas was president of the land company that founded the town that bears his name. The Moore County Historical Museum is at Dumas Avenue and East Eighth.

Morris County

(13,200)

County Seat: Daingerfield (2,572)

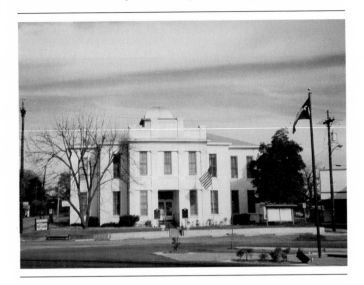

COURTHOUSES: two; 1882, 1973

STANDING: 1882 brick courthouse was designed by Peterson & Stuckey in an odd style with Classical elements. This is a National Register Property and is now a museum. The newer 1973 courthouse is a Modern structure designed by Pierce, Pace & Associates.

LOCATION: Daingerfield: on Broadnax (Texas 49/U.S. 259), between Truit and Union streets. The old courthouse is at 101 Linda Avenue.

NOTES: London Daingerfield, troop captain and early Indian fighter, was the source for the name of the county seat. Morris County, organized in 1875, was named for William Wright Morris, an early legislator and judge. The Morris County Historical Museum is open one day a week and has materials on the history of the county.

Motley County
(1,532)
County Seat: Matador (790)

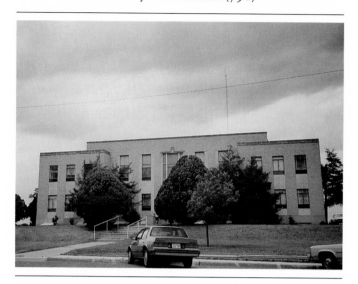

COURTHOUSES: three; 1891, 1904, 1948

STANDING: 1948 Moderne-style brick courthouse designed by Wyatt Hedrick. Both previous courthouses burned—the 1891 structure was incinerated in 1893 as the sheriff left town with the county's funds. That courthouse was fondly remembered for its sky blue privy out back.

LOCATION: Matador: on Main Street.

NOTES: Dr. Junius William Mottley (the legislation misspelled his name) is honored by Motley County. Mottley was a signer of the Texas Declaration of Independence. Matador got its name from the biggest ranch in the area. The county was organized in 1891.

Nacogdoches County
(54,753)
County Seat: Nacogdoches (30,872)

COURTHOUSES: four; 183 —, 1856, 1911, 1958

STANDING: 1958 unique Modern-style courthouse designed by J. N. McCammon; some writers have compared it to "early motel style."

LOCATION: Nacogdoches: corner of Main Street (Texas 21) and North Street (U.S. 59).

NOTES: This county, organized in 1837, was named for the town, which, in turn, was named for the Nacogdoches Indians. Both the Hoya Memorial Museum on La-nana Street and the Old Nacogdoches University Building at Mound and Hughes streets have local history materials.

Navarro County
(39,926)
County Seat: Corsicana (22,911)

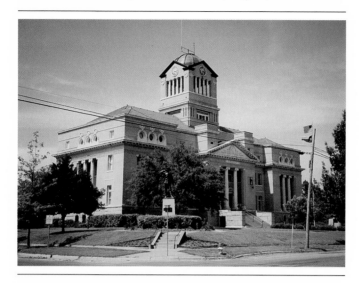

COURTHOUSES: five; 1848, 1851, 1858, 1880, 1905

STANDING: 1848 log courthouse still stands; the 1905 Beaux-Arts brick and marble temple of justice was designed by J. E. Flanders.

LOCATION: Corsicana: corner of West Third Avenue and Thirteenth Street.

NOTES: The Pioneer Village at 912 West Park Avenue has interesting exhibits on the county, which was organized in 1846 and named for Texas Republic leader José Antonio Navarro, who served as commissioner of the Santa Fe Expedition, a Constitutional Convention delegate (1845), and a member of the Texas Congress. Corsicana was named for Corsica, Navarro's place of birth.

Newton County
(13,569)
County Seat: Newton (1,885)

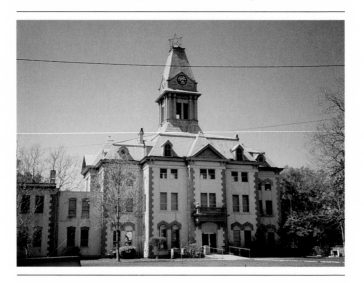

COURTHOUSES: three; 1848 (Burkeville), 1853 (Newton), 1902

STANDING: 1902 Second Empire courthouse designed by Martin and Moodie and built of brick. This is a National Register Property. A most unusual courthouse, in a style no longer fashionable at the turn of the century, this courthouse looks as if it had been built twenty or thirty years earlier.

LOCATION: Newton: on the square, corner of Court Street (U.S. 190/Texas 87/Loop 505) and Kaufman (Loop 505/Texas 87).

NOTES: Sgt. John Newton of the American Revolution is honored by this county. Newton has been the county seat twice, from 1846 to 1847, and again beginning in 1853. Burkeville was the county seat in between. The county was organized in 1846.

Nolan County

(16,594)

County Seat: Sweetwater (11,967)

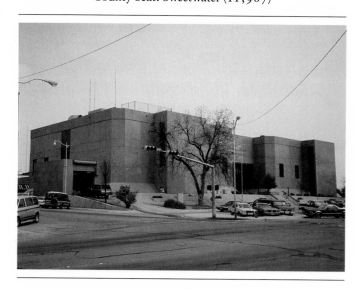

COURTHOUSES: four; 1882, 1892, 1917, 1977

STANDING: 1977 courthouse designed by Welch and Hampton in Modern style with a polished granite veneer.

LOCATION: Sweetwater: on the square, corner of Broadway (Texas 432) and Locust streets.

NOTES: The county was organized in 1881 and named for Philip Nolan, possibly the first Anglo to map Texas. A city and county museum is at 610 East Third Street. Sweetwater was the site of the Women's Airforce Service Pilots training base during World War II.

Nueces County

(291,145)

County Seat: Corpus Christi (257,453)

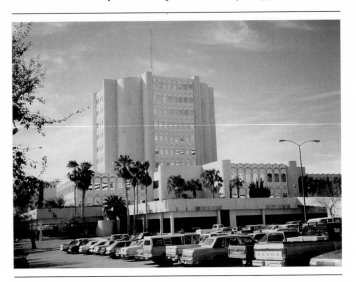

COURTHOUSES: five; 184 —, 1856, 1877, 1914, 1977

STANDING: 1977 Modern courthouse is used now, but the 1914 Classical Revival courthouse designed by Harvey L. Page is more interesting. The courthouse has had numerous additions: 1930, 1965, 1970. However, it is now vacant. A National Register Property built of reinforced concrete and brick, it is located at Mesquite and Belden streets.

LOCATION: Corpus Christi: on the square, off U.S. 181, between Belden and Power streets.

NOTES: *Nueces,* a Spanish word, means nuts and refers to the native pecan trees early explorers found. The county was organized in 1846, but the community of Corpus Christi (named for the festival day on which the bay was discovered) goes back many years before that.

The Corpus Christi Museum at 1900 North Chaparral is worth the visit.

Ochiltree County

(9,128)

County Seat: Perryton (7,607)

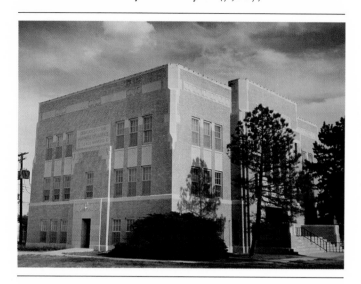

COURTHOUSES: two; 1890, 1928

STANDING: 1928 building with a 1974 addition; the whole is designed in Texas Renaissance style and built of brick, steel, and concrete. Mann & Co. were the architects.

LOCATION: Perryton: corner of Main Street (Texas 70/U.S. 83) and Southwest Sixth Street.

NOTES: William Beck Ochiltree was a Republic of Texas leader and member of the later secession convention. The county was organized in 1889 with Ochiltree as the county seat. Perryton (named for local settler George M. Perry) became the county seat in 1919.

The Museum of the Plains contains local history.

Oldham County

(2,278)

County Seat: Vega (840)

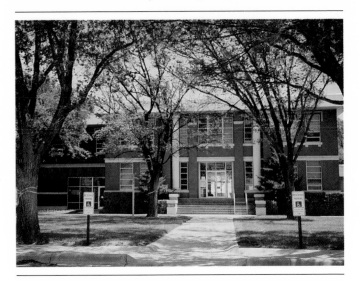

COURTHOUSES: two; 1884 (Tascosa),
1915 (Vega)

STANDING: 1884 farmhouse style court-
house built of sandstone is presently the
Julian Bivins Museum on Cal Farley's
Boys' Ranch near Tascosa (Ranch Road
1061), forty-two miles from Amarillo. The
1915 courthouse is an altered Classical Re-
vival courthouse. In 1967 the hipped roof
was removed. O. G. Roquemore was the
architect of the 1915 building.

LOCATION: Vega: corner of U.S. 385 and
Main Street.

NOTES: Organized in 1880, the county
was named for Williamson Simpson Old-
ham, lawyer, politician, editor, legislator.
Vega became the county seat in 1915 after
the railroad came. *Vega* is Spanish for
meadow.

Orange County
(80,509)
County Seat: Orange (19,381)

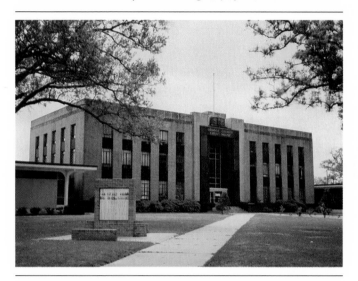

COURTHOUSES: three; 1853, 1884, 1937

STANDING: 1937 Moderne-style courthouse built of brick, limestone, and marble, with an addition in 1960. C. H. Page of Austin, was the architect.

LOCATION: Orange: corner of Seventh Street and Division.

NOTES: The county seat was originally called Madison, but the name was changed to Orange in 1858. Organized in 1852, the county takes its name from the fruit grown here since the time of the earliest settlers.

The Heritage House Museum contains materials on Orange County. The Stark Museum of Art is one of the best museums in Texas.

Palo Pinto County

(25,055)

County Seat: Palo Pinto (est. 350)

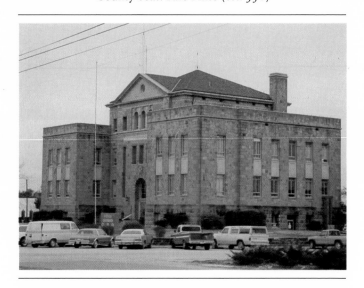

COURTHOUSES: three; 1857, 1882, 1940

STANDING: 1940 Texas Renaissance building with Classical elements and built of sandstone that was recycled from the 1882 courthouse. Preston M. Geren and M. A. Howell designed this courthouse.

LOCATION: Palo Pinto: on U.S. 180.

NOTES: Organized in 1857, Palo Pinto County derived its name from the spotted oak: *palo* being Spanish for trunk or post, and everyone knows what pinto is.

The Palo Pinto County Pioneer Museum is in the oldest building in the county, the jail.

Panola County

(22,035)

County Seat: Carthage (6,496)

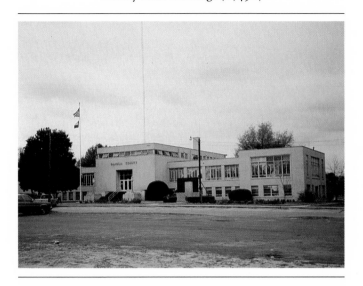

COURTHOUSES: five; 1848, 1850, 1853, 1885, 1953

STANDING: 1953 Modern concrete and brick courthouse; it was designed by Preston M. Geren. The 1885 courthouse looked the same as the Shelby County courthouse.

LOCATION: Carthage: corner of Sabine and Sycamore.

NOTES: Organized in 1846, the county originally had Pulaski as its seat. Carthage has been the seat of county government since 1848. Carthage was named for Carthage, Mississippi. Panola is an Indian word for cotton.

Parker County
(64,785)
County Seat: Weatherford (14,804)

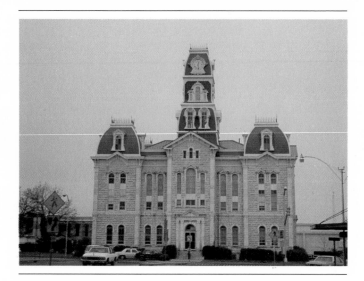

COURTHOUSES: four; 1856, 1858, 1878, 1885

STANDING: 1885 Second Empire courthouse designed by Dodson & Dudley, architects. The courthouse is built of limestone and is a National Register Property.

LOCATION: Weatherford: on the square, intersection of Palo Pinto/Fort Worth Street (U.S. 80) and Main Street (Texas 171/FM 51).

NOTES: Named for Isaac Parker, early Texas legislator, the county was organized in 1855. Weatherford was named for Texas senator Jefferson Weatherford. The Weatherford Depot Museum has exhibits on local history.

Parmer County
(9,863)
County Seat: Farwell (1,373)

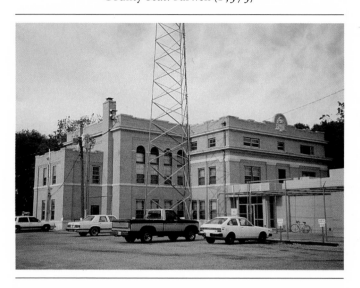

COURTHOUSES: two; 1907 (Parmerton), 1916 (Farwell)

STANDING: 1916 Texas Renaissance building designed by C. Risser, with an interesting Roman arched entrance. Built of brick, this is the second courthouse. The first (Parmerton) was towed to Friona, where it survived for fifty years until it burned in the late-1950s.

LOCATION: Farwell: on the square, corner of Third Street and Avenue C.

NOTES: Organized in 1907, Parmer County was named for Martin Parmer, the "Ringtailed Panther," as he was known, who was one of the signers of the Texas Declaration of Independence. Farwell was named for John V. Farwell, an officer in the land syndicate in the county.

Parmerton, the geographic center of the county, was the first county seat. In 1908, Farwell succeeded in wresting the county government from Parmerton.

Pecos County

(14,675)

County Seat: Fort Stockton (8,524)

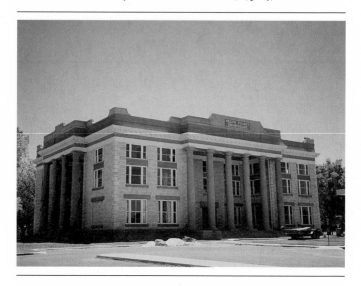

COURTHOUSES: one; 1883

STANDING: 1883 building is now in a Classical Revival style and built of stone. The 1883 structure was so substantially rebuilt in 1911–12 (adding a copper dome and a completely new facade) that for all intents, a new courthouse emerged. There are tentative plans to restore it. This courthouse lost its dome in the 1930s. Kenedy County courthouse is very similar to the one in Pecos.

LOCATION: Fort Stockton: on Callaghan Street, between Main and Nelson streets.

NOTES: Organized in 1872, the county was named for the Pecos River. Fort Stockton (named for Commodore Robert Field Stockton) was a military post established in 1859.

The Annie Riggs Memorial Museum has local history information.

Polk County
(30,687)
County Seat: Livingston (5,019)

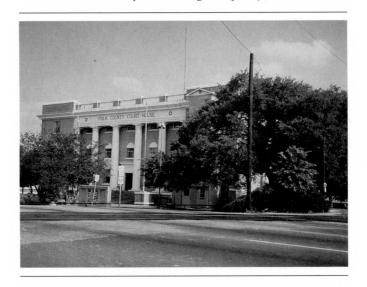

COURTHOUSES: three; 1846, 1854, 1923

STANDING: 1923 Texas Renaissance building of concrete and brick, designed by McLelland and Fink. The 1905 annex to the 1854 courthouse still survives as the Campbell-Forman Building.

LOCATION: Livingston: on the square, corner of Church Street (U.S. 190) and Washington Avenue (U.S. 59/Texas 35).

NOTES: James Knox Polk was president of the United States when Polk County was organized in 1846. Livingston was named for a town in Alabama.

The Polk County Memorial Museum has exhibits relating to local history.

Potter County
(97,874)
County Seat: Amarillo (91,502)

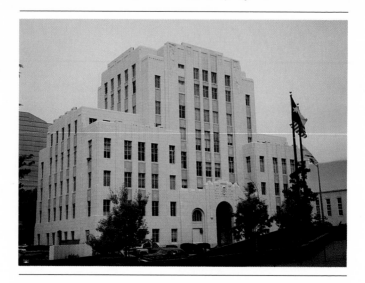

COURTHOUSES: three; 1887, 1906, 1932

STANDING: 1932 Moderne style courthouse built of terra-cotta and concrete. Townes, Lightfoot & Funk were the architects.

LOCATION: Amarillo: corner of Fillmore and Sixth Street.

NOTES: Amarillo was named for a nearby creek that Spaniards had named (*amarillo* is Spanish for yellow). Robert Potter served as secretary of the Texas Navy and as commander of the port of Galveston. The county, organized in 1887, was named for him.

Presidio County
(6,637)
County Seat: Marfa (2,424)

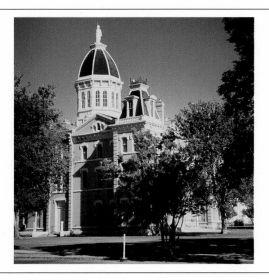

COURTHOUSES: one; 1886

STANDING: 1886 building is one of the best-preserved courthouses — people drive out of their way to see it. Alfred Giles was the architect of this Second Empire edifice of brick and stone; a National Register Property.

LOCATION: Marfa: on the square, corner of Lincoln Street and Highland Avenue (U.S. 67).

NOTES: El Presidio del Norte, Spanish for the fort of the north, is the origin of this county's name. It was organized in 1875. Marfa was named by the wife of a railroad president for the heroine of a Russian novel that she doubtless read on a long trip west.

Rains County

(6,715)

County Seat: Emory (936)

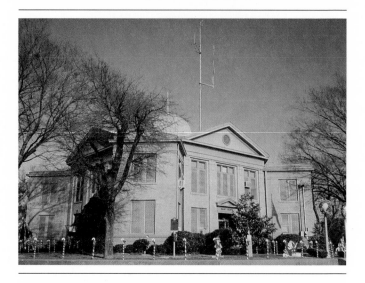

COURTHOUSES: three; 1871, 1884, 1908

STANDING: 1908 Texas Renaissance courthouse built of brick and concrete. Memory has it that the vault from the 1884 courthouse survived a disastrous fire in 1890. The new courthouse was built around the old vault. The 1871 courthouse also burned, in 1879.

LOCATION: Emory: on the square, corner of Texas 19 and Quitman.

NOTES: Both the county and the county seat were named for an early pioneer, Judge Emory Rains, who first represented the county in the state legislature. Before the county organized in 1870, Emory was known as Springville.

Randall County

(89,673)

County Seat: Canyon (11,365)

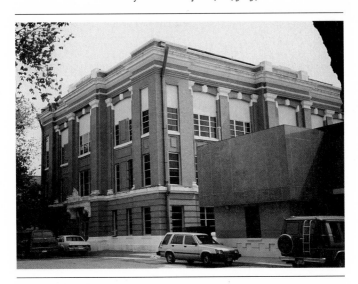

COURTHOUSES: two; 1892, 1908

STANDING: 1908 courthouse in the Texas Renaissance style, designed by Robert G. Kirsch. The original brick courthouse had a tower, which was removed during a 1945 remodeling. The county built an annex on the north side in 1957.

LOCATION: Canyon: on the square, corner of Fourth Avenue (Texas 217) and Fifteenth Street.

NOTES: Named for Horace Randal, erroneously spelled Randall County, was organized in 1889. Canyon is named for the Palo Duro canyon.

The Panhandle-Plains Historical Museum is at 2401 Fourth Avenue and contains a great store of materials on the area.

Reagan County

(4,514)

County Seat: Big Lake (3,672)

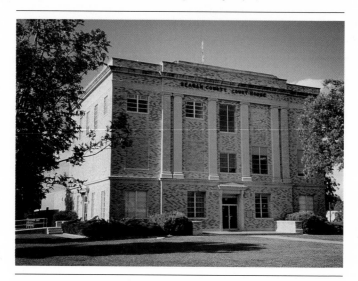

COURTHOUSES: three; 1904 (Stiles), 1911, 1927 (Big Lake)

STANDING: The 1911 Stiles courthouse (north of Texas 137 to the Centralia Draw) is still standing: a stone edifice with a central tower. The architect, if any, is unremembered, but the structure was built by William Martin; a National Register Property. The 1927 courthouse, a Texas Renaissance building, is of brick.

LOCATION: Big Lake: on the square, corner of Plaza Avenue and Third Street.

NOTES: John H. Reagan, lawyer, served in both the Texas and U.S. Congresses and was the first Texas Railroad Commissioner. Stiles, the first county seat, was bypassed by the railroad. In addition, the oil boom caused by Santa Rita favored Big Lake. The county seat moved to Big Lake in 1925 and a new courthouse arose in 1927. Big Lake got its name from a dry lakebed nearby.

Real County
(2,412)
County Seat: Leakey (399)

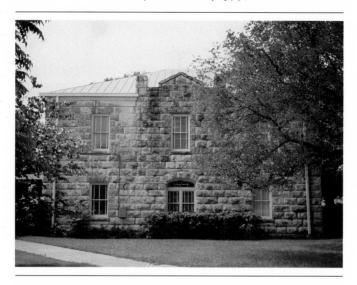

COURTHOUSES: two; 1913, 1917

STANDING: 1917 courthouse was designed by A. Reuter in a simple, pedimented Classical Revival style and built of local stone. During the 1970s, annexes were built.

LOCATION: Leakey: corner of U.S. 83 and Market.

NOTES: The county, organized in 1913, was named for prominent businessman and state senator, Julius Real. John Leakey, an early settler, provided the inspiration for naming the county seat.

Red River County
(14,317)
County Seat: Clarksville (4,311)

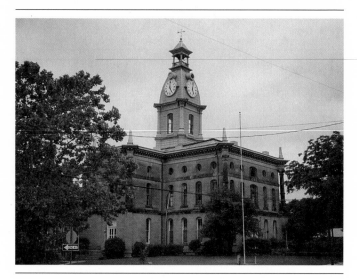

COURTHOUSES: four; 1830 (Jonesboro), 1838 (La Grange—present-day Madras), 1852 (Clarksville), 1884

STANDING: 1884 building designed by William H. Wilson, a stylistic mixture of Renaissance Revival and Second Empire. Built of limestone, with a 1910 addition, the courthouse has columns on the outside corners and a Mansard-roof clock tower. This is a National Register Property.

LOCATION: Clarksville: on the square, corner of Cedar (Texas 37) and Madison Street.

NOTES: The origin of this county's name is obvious. James Clark who settled near here in 1833 was the honoree for the naming of the county seat.

Sam Houston, as an agent of Pres. Andrew Jackson, first entered what later became Texas in Red River County in 1832. The county was organized in 1837.

Reeves County

(15,852)

County Seat: Pecos (12,069)

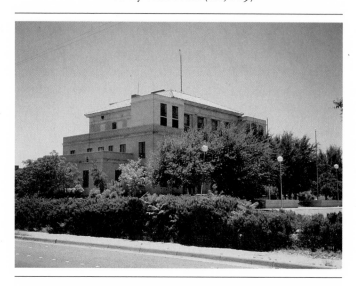

COURTHOUSES: two; 1886, 1937

STANDING: 1937 building is an interesting mix of Classical Revival and Mediterranean elements; built of brick.

LOCATION: Pecos: on the square, corner of Cedar (U.S. 285/Texas 27) and Fourth Street.

NOTES: Organized in 1884 and named for Confederate colonel and Texas speaker George R. Reeves. There are numerous stories of the origin of the name Pecos, but no one really knows.

The West of the Pecos Museum at the corner of Highway 285 and First Street has local history materials.

Refugio County

(7,976)
County Seat: Refugio (3,158)

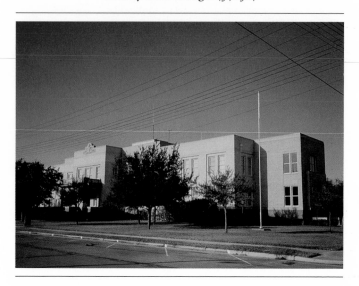

COURTHOUSES: five; 1840, 1856, 1874, 1880, 1919

STANDING: 1919 brick Texas Renaissance structure built with a severe angularity. Atlee B. Ayres was the architect.

LOCATION Refugio: on Commerce Street, between East Purisima and East Empresario.

NOTES: Named after the Indian mission, Nuestra Señora del Refugio, the county was organized in 1837. The story goes that employees of the courthouse burned the 1880 building when the county refused to build a new one, because "there was no need"; the employees reckoned that burning it down created a "need."

Roberts County
(1,025)
County Seat: Miami (675)

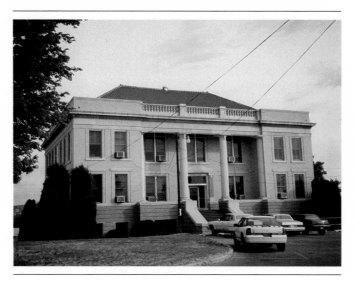

COURTHOUSES: two; 1889 (Oran, later Parnell), 1913

STANDING: 1913 Classical Revival courthouse built of brick and designed by Elmer George Withers.

LOCATION: Miami: corner of U.S. 60 and Kiowa Street.

NOTES: Roberts County, named for John S. Roberts, signer of the Texas Declaration of Independence, and Oran M. Roberts, Texas governor, was organized in 1889. Parnell was the county seat until 1898. Miami is said to be the Algonquin word for sweetheart, but no one knows whose.

Robertson County

(15,511)

County Seat: Franklin (1,336)

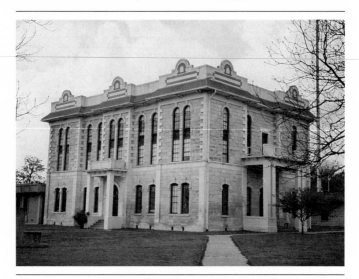

COURTHOUSES: four; 1837 (Old Franklin), 1850 (Wheelock), 1856 (Owensville), 1882 (Morgan, later Franklin)

STANDING: 1882 Second Empire courthouse designed by F. E. Ruffini and built of stone. Originally, this courthouse had a Mansard roof with towers. Sometime in the mid-1920s, the towers and Mansard roof were removed, and the odd Mission-style cap was built; a National Register Property.

LOCATION: Franklin: on the square, corner of Center and Decherd streets.

NOTES: Robertson County was named for Sterling Clack Robertson, colonizer and signer of the Texas Declaration of Independence. Franklin was named for Old Franklin, one of the five county seats of this county: Old Franklin, Wheelock, Owensville, Calvert, and Franklin.

The Hammond House in Calvert served as jail and possibly had court from time to time, but most authors believe the Calvert court was held in rented quarters.

228

Rockwall County
(25,604)
County Seat: Rockwall (10,486)

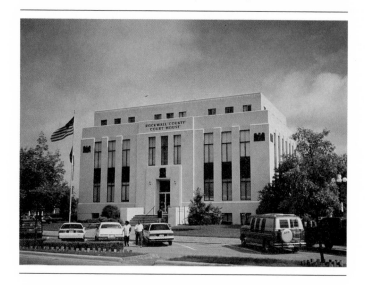

COURTHOUSES: three; 1878, 1892, 1940

STANDING: 1940 Moderne-style court-house built of stone.

LOCATION: Rockwall: on the square, corner of Rusk (Texas 66) and Goliad.

NOTES: Rockwall County was organized in 1873. Its name derives from a mostly subsurface wall of rock that runs through the county.

Runnels County

(11,294)

County Seat: Ballinger (3,975)

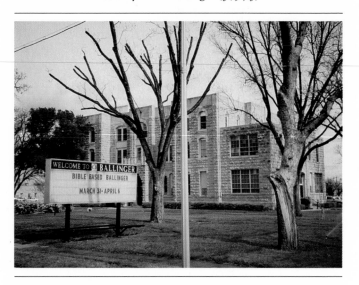

COURTHOUSES: two; 1880 (Runnels City), 1889 (Balllinger)

STANDING: 1889 Second Empire design by architect Eugene T. Heiner. The courthouse was built of stone; a 1941 renovation lopped off the original towers and Mansard roof.

LOCATION: Ballinger: corner of Hutchings Avenue (U.S. 67) and Broadway.

NOTES: Named for Hiram George Runnels (Brazos River planter and later legislator), Runnels County was organized in 1880. The first county seat, Runnels City, disappeared after the railroad passed it by. Ballinger (named for William Pitt Ballinger, a Galveston judge and Confederate official) became the seat of government in 1888.

Rusk County

(43,735)

County Seat: Henderson (11,139)

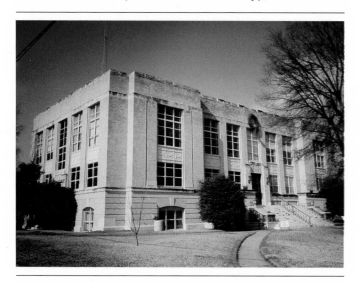

COURTHOUSES: four; 1845, 1854, 1878, 1928

STANDING: 1928 courthouse designed in Texas Renaissance style with some Moderne design elements. Architects were the firm of Curtis and Thomas, and A. C. Gentry. It is built of concrete and brick.

LOCATION: Henderson: corner of North Main Street and Fordall Street.

NOTES: Rusk was essentially an agricultural county until C. M. Joiner discovered oil in 1930 in what became the East Texas oil field. Population doubled in five years and the economic face of the county altered dramatically. Organized in 1843, Rusk was named for Thomas Jefferson Rusk, Texas military commander, early leader, and legislator. The county seat was named for James Pinckney Henderson, a contemporary of Rusk and early Texas diplomat, legislator, and governor.

Sabine County
(9,586)
County Seat: Hemphill (1,182)

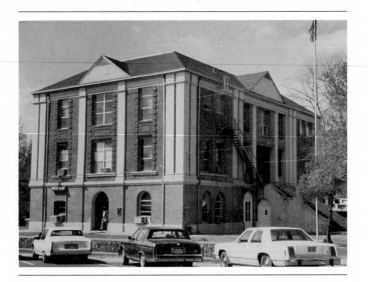

COURTHOUSES: There were known to be at least four courthouses, but fire destroyed all records prior to 1875.

STANDING: 1906 building was originally a Beaux-Arts masterpiece, with an inset portico flanked by columns and pilasters; pediments were on the ends of the building and a gracefully curving stairway swept up to the second floor entrance. A fire in 1909 partially destroyed this courthouse, and it was not completely rebuilt; the dome and clock tower were omitted. WPA funds enabled the completion of the upper floors in 1938. The architect of the original brick building was A. N. Dawson.

LOCATION: Hemphill: corner of West North Street (FM 83) and Oak Street.

NOTES: Sabine County (Spanish for cypress or cedar tree—the same as the English savin), organized in 1837. Hemphill was named for Texas Supreme Court justice John Hemphill.

San Augustine County

(7,999)

County Seat: San Augustine (2,337)

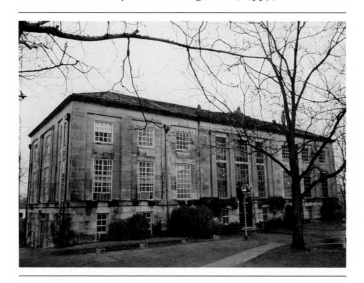

COURTHOUSES: three; 1840, 1855, 1927

STANDING: 1927 Classical Revival court-
house built of limestone and concrete.

LOCATION: San Augustine: corner of
Main (Texas 21) and Broadway (Texas
147).

NOTES: One of Texas' original counties,
organized in 1837 and named for a Mexi-
can community, San Augustine was the site
of many early Texas events, including the
Battle of Fredonia.

San Jacinto County
(16,372)
County Seat: Coldspring (538)

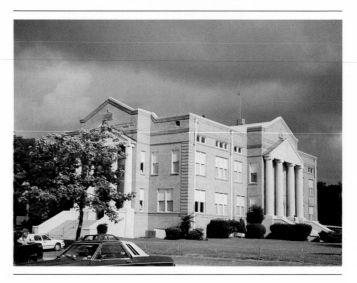

COURTHOUSES: two; 1877, 1917

STANDING: 1917 courthouse designed in Classical Revival style, and built of brick.

LOCATION: Coldspring: corner of Church and Byrd Street.

NOTES: Spaniards, noting the stream full of hyacinth, gave it the name Saint Hyacinth (San Jacinto). The county, organized in 1870, is located in part of the Big Thicket. Originally named Coonskin, then Fireman's Hill, Cold Spring, and finally Coldspring, the county seat has been in existence since the 1840s.

San Patricio County

(58,749)
County Seat: Sinton (5,549)

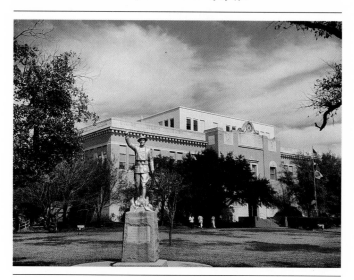

COURTHOUSES: six; 1837 (San Patricio), 1853, 1872, 1886, 1893 (Sinton), 1928

STANDING: 1928 courthouse in Texas Renaissance style was designed by Henry T. Phelps and built of brick.

LOCATION: Sinton: on the square, corner of West Sinton Street (U.S. 181/FM 881) and North Archer Avenue.

NOTES: San Patricio de Hibernia, Saint Patrick of Hibernia (Ireland), was the seat of an Irish colony, with John McMullen and James McGloin as empresarios. Sinton was named for David Sinton, a landowner with substantial holdings. The county was organized in 1837, and the county seat was San Patricio until 1893, when it moved to Sinton.

San Saba County

(5,401)

County Seat: San Saba (2,626)

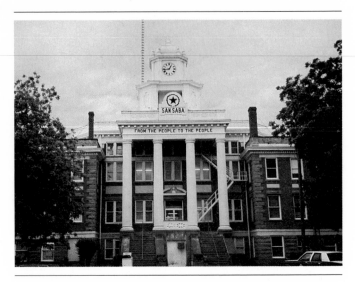

COURTHOUSES: three; 1857, 1878, 1911

STANDING: The 1911 courthouse was designed by the architectural firm of Chamberlin & Co. and built of brick and sandstone. Willard Robinson identifies this courthouse as the archetype of Texas Renaissance style, with its mixture of classic ornament mingled with Texas references.

LOCATION: San Saba: on the square, corner of Wallace Street (U.S. 190) and Live Oak.

NOTES: San Saba, county and town, were named for the local river. The county organized in 1856. The San Saba County Historical Museum is east of town on U.S. 190.

Schleicher County

(2,990)

County Seat: Eldorado (2,019)

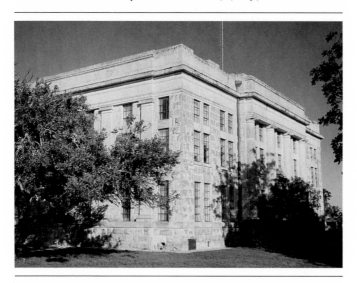

COURTHOUSES: two; 1902, 1924

STANDING: 1924 stone courthouse was designed by Henry T. Phelps in a stately Classical Revival style.

LOCATION: Eldorado: corner of U.S. 190 and U.S. 277.

NOTES: Organized in 1901, Schleicher County was named in honor of Gustav Schleicher, a German colonist, military commander, legislator, and lawyer. Eldorado, or El Dorado, was the name given to the community by land promoters. The Schleicher County Museum is at the junction of the Menard highway and U.S. 277.

Scurry County
(18,634)
County Seat: Snyder (12,195)

COURTHOUSES: two; 1886, 1911

STANDING: 1911 courthouse originally designed by Lang & Witchell in Texas Renaissance style and built of brick. A 1950 remodeling removed the tower. A 1972 remodeling buried the 1911 building in slabs of granite, giving it a Modern look. The architect of the 1972 remake was Joseph D. Hinton.

LOCATION: Snyder: on the square, corner of Twenty-fifth Street (U.S. 180/Spur 401) and College Avenue (Texas 350).

NOTES: Organized in 1884, Scurry County was named for the distinguished Confederate general William R. Scurry. W. H. Snyder first settled in the area and operated a trading post that attracted so many interesting characters it became known as Robber's Roost.

The Scurry County Museum had local history materials and is located on the campus of Western Texas College.

Shackelford County
(3,316)
County Seat: Albany (1,962)

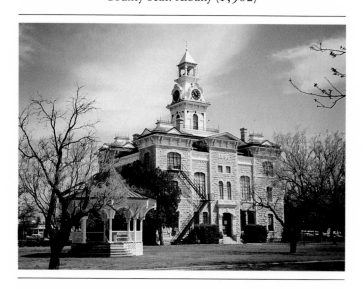

COURTHOUSES: two; 1875, 1883

STANDING: The 1883 courthouse is a lovely National Register Property designed by J. E. Flanders in Second Empire style. The building construction included native limestone.

LOCATION: Albany: corner of South Main Street and South Third Street.

NOTES: Organized in 1874, the county was named for Dr. John Shackelford, one of the few survivors of the Goliad massacre. Albany, the county seat, was named after the former residence of some early inhabitants, Albany, Georgia. The original, but temporary, county seat was Fort Griffin.

Shelby County

(22,034)

County Seat: Center (4,950)

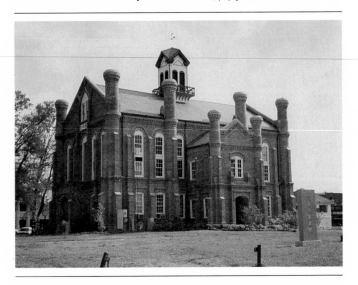

COURTHOUSES: three; 183 —, 1867, 1885

STANDING: 1885 courthouse in a picturesque Romanesque Revival style with turrets and a frame cupola. John Joseph Emmett Gibson designed this two-story brick courthouse; a National Register Property. Gibson was Irish, and he used castles in his native Ireland for inspiration.

LOCATION: Center: corner of Tenaha (Texas 87) and San Augustine (Texas 7).

NOTES: Originally called Tenaha, Shelby County got its final name from American Revolutionary War veteran Isaac Shelby when the county was organized in 1837. Shelbyville was the county seat until 1866, when the records were moved to Center.

The Shelby County Museum has local history materials.

Sherman County

(2,858)

County Seat: Stratford (1,781)

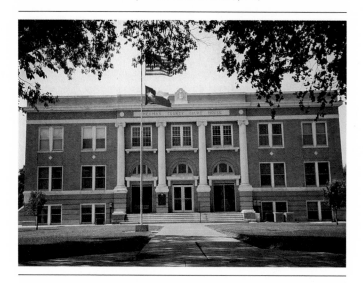

COURTHOUSES: three; 1889, 1901, 1922

STANDING: 1922 courthouse in Texas Renaissance style was designed by the architectural firm of Parker and Rittenberry. Built of concrete and brick, the courthouse boasts a handsome relief portico with Classical columns.

LOCATION: Stratford: on the square, corner of North Third and Fulton streets.

NOTES: Organized in 1889, this county honors Sidney Sherman, who commanded a cavalry wing at San Jacinto and commanded Galveston during the Civil War. The county seat was named by Englishman Walter Colton for Stratford-on-Avon, birthplace of William Shakespeare. Another story says that Colton named Stratford after Stratford, Virginia, birthplace of Robert E. Lee. Take your pick—no one knows for sure.

Smith County
(151,309)
County Seat: Tyler (75,450)

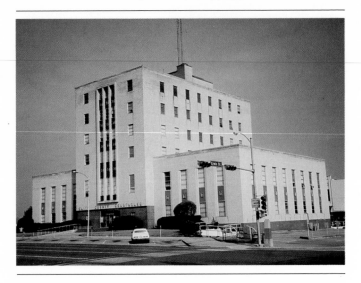

COURTHOUSES: five; 1846, 1848, 1851, 1910, 1955

STANDING: 1955 Modern-style courthouse built of concrete, brick, and stone. The courthouse was designed by the firm of Thomas Jameson & Merrell. The Statue of Justice survives from the 1910 courthouse.

It is difficult to distinguish between additions to the 1851 courthouse and what may have been not mere additions but replacement courthouses. Thus the number of courthouses may exceed the five listed.

LOCATION: Tyler: on the square, corner of Ferguson Street and Broadway Avenue South (U.S. 69).

NOTES: Organized in 1846, the county was named for Texas general James Smith, who was an active military commander during the Texas Revolution and the Regulator-Moderator War and who also served as a legislator. Tyler was named for Pres. John Tyler.

Somervell County

(5,360)

County Seat: Glen Rose (1,949)

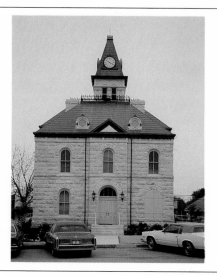

COURTHOUSES: two; 1882, 1893

STANDING: 1893 Romanesque Revival courthouse that originally had Second Empire influences. The original courthouse design came from John Cormack. The courthouse has been altered, however, particularly the roof and clock tower. This National Register Property is built of limestone.

LOCATION: Glen Rose: on Bernard Street (old U.S. 67) between Elm and Walnut streets.

NOTES: Named for the leader of a punitive expedition against Mexico, Somervell County was organized in 1875. Alexander Somervell also fought in the Battle of San Jacinto and was elected to the Texas Congress. The name of Glen Rose came from the imagination of Mrs. T. C. Jordan as she viewed a small glen overgrown with wild roses.

Starr County
(40,518)
County Seat: Rio Grande City (9,891)

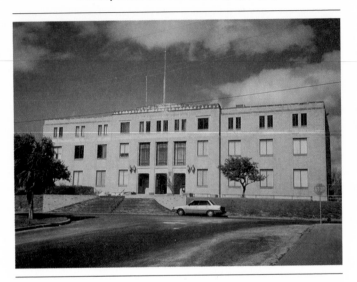

COURTHOUSES: three; 1854, 1886, 1939

STANDING: 1939 Moderne brick court-
house designed by Stanley Bliss. The origi-
nal 1854 courthouse was a warehouse
owned by Mifflin Kenedy; it still stands.

LOCATION: Rio Grande City: on the
square, corner of Fourth Street and Britton
Avenue.

NOTES: Organized in 1848, Starr County
derived its name from the highly efficient
and effective Texas secretary of the trea-
sury, James Harper Starr. Rio Grande City
was the western terminus of the Rio
Grande City Railroad, and its business dis-
trict hummed since it was located around
the river's wharves.

Stephens County

(9,010)

County Seat: Breckenridge (5,665)

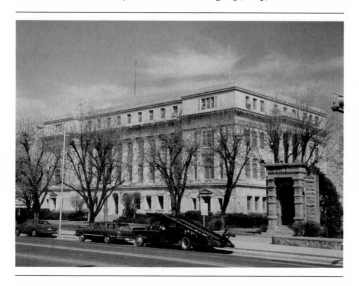

COURTHOUSES: three; 1876, 1883, 1926

STANDING: 1926 Classical Revival lime-
stone courthouse designed by David S.
Castle. The doorway of the 1883 court-
house survives on the grounds.

LOCATION: Breckenridge: corner of
Walker (U.S. 180) and Rose Avenue.

NOTES: Breckenridge was named for a
U.S. senator from Kentucky. Alexander
Stephens, the vice-president of the Confed-
erate States of America, was the namesake
of Stephens County when it was organized
in 1860; the county was reorganized in
1876.

The Swenson Memorial Museum of Ste-
phens County has local history exhibits.

Sterling County
(1,438)
County Seat: Sterling City (1,096)

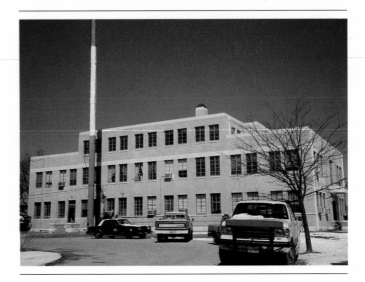

COURTHOUSES: three; 1891, 1905, 1938

STANDING: 1938 Texas Renaissance courthouse with Art Deco details is built of brick. David S. Castle served as the architect.

LOCATION: Sterling City: on the square, on Fourth Street (U.S. 87) between Main and Elm streets.

NOTES: Buffalo hunter and surveyor W. S. Sterling came to Sterling Creek in present-day Sterling County before the Civil War and camped and hunted in the area for over two decades. He later became a U.S. marshal in Arizona, where he was killed by Apaches near Fort Apache. The county and its seat were named for him when the county was organized in 1891.

Stonewall County
(2,013)
County Seat: Aspermont (1,214)

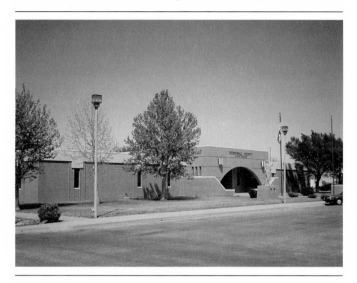

COURTHOUSES: five; 1889 (Rayner), 1891, 1900 (Aspermont), 1911, 1983

STANDING: 1891 (Rayner) courthouse was built of stone and designed by Elmer George Withers. It is now a private residence about seven or eight miles east of Aspermont on U.S. 380. The current courthouse is Modern and was built in 1983.

LOCATION: Aspermont: on 500 block of Broadway.

NOTES: T. J. "Stonewall" Jackson, a Confederate general, was the source of this county's name. Aspermont is a corrupted Latin expression for a rough hill.

The county seat was originally in Rayner but was moved to Aspermont in 1898 in a hotly contested election; Rayner ceased to exist.

Sutton County

(4,135)

County Seat: Sonora (2,751)

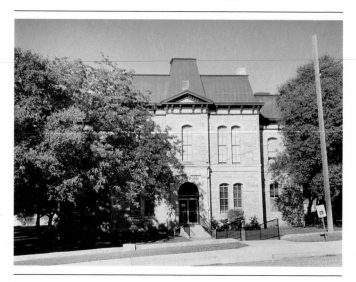

COURTHOUSES: one; 1891

STANDING: 1891 Second Empire–style courthouse built of limestone and dressed stone, with much handwork evident in the stonework. Oscar Ruffini was the architect of this National Register Property.

LOCATION: Sonora: on the square, corner of Poplar Street and Water Avenue.

NOTES: Sutton County, organized in 1890, claimed John S. Sutton as its namesake. He was a Texas Ranger, a soldier in the Mexican War, and a cavalry colonel who died in the Battle of Val Verde during the Civil War.

Swisher County

(8,133)

County Seat: Tulia (4,699)

COURTHOUSES: two; 1890, 1909

STANDING: The original 1909 courthouse was one of Elmer George Withers's Renaissance Revival–style edifices constructed of red brick, with sandstone columns and pediments. In 1962, this courthouse was completely remodeled by designs from the firm of Rittenberry and Rittenberry, and the old courthouse was encased, or entombed, in a modern brick veneer shell. Gone are the turret, dome, the pediments, roofs, and character.

LOCATION: Tulia: corner of Second Street and Austin Avenue.

NOTES: Named for James Gibbon Swisher, signer of the Texas Declaration of Independence, the county was organized in 1890. Tulia was named for a local creek. The Swisher County Museum has local history materials.

Tarrant County

(1,170,103)

County Seat: Fort Worth (447,619)

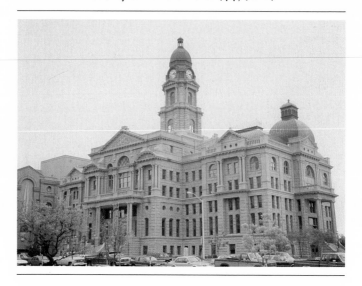

COURTHOUSES: six; 1849, 1856, 1860, 1876, 1878, 1895 (with additions)

STANDING: 1895 Renaissance Revival–style courthouse of majestic proportions and designed by the architectural firm of Gunn & Curtis. Built of red granite, this National Register Property received a complete restoration in 1983. A 1956 addition stands to the west.

LOCATION: Fort Worth: north off U.S. 30, corner of Houston and Weatherford Street.

NOTES: Organized in 1850, the county was named for Gen. Edward H. Tarrant, military commander and Texas Ranger. Fort Worth (named for William Jenkins Worth, a general in the Mexican War) had a variety of temporary courthouses before this magnificent structure.

Fort Worth has many local history collections—too many to list here—but they are easily found in guide books.

Taylor County
(119,655)
County Seat: Abilene (105,857)

COURTHOUSES: four; 1879 (Buffalo Gap), 1883, 1914, 1972

STANDING: 1914 Classical Revival courthouse built of brick with terra-cotta details. The courthouse design came from George L. Burnett.

The 1972 Modern design courthouse is across the street from the 1914 building. Tittle, Luther, Loving, Lee, architects, designed the new courthouse with massive concrete and pink granite structure. The 1879 courthouse at Buffalo Gap (designed by Martin, Byrnes & Johnston) still stands.

LOCATION: Abilene: on Third Street, between Chestnut and Oak streets.

NOTES: The Taylor brothers, Edward, James, and George, fought together and died together at the Alamo in 1836. This county was named in their honor when it was organized in 1878. Abilene, named by cattle producers and railroad officers, echoes Abilene, Kansas. Buffalo Gap was the original county seat. The railroad bypassed Buffalo Gap in 1880, and the seat was moved to Abilene.

251

Terrell County
(1,410)
County Seat: Sanderson (1,128)

COURTHOUSES one; 1906

STANDING: 1906 Mediterranean-style building with tile roof and details vaguely reminiscent of Moorish Spain. Built of brick and concrete, this courthouse has undergone remodeling twice: in 1930 and 1983.

LOCATION: Sanderson: Court House Square on Hackberry Street.

NOTES: Organized in 1905, this county honors Confederate officer and Texas legislator Alexander Watkins Terrell. Thomas P. Sanderson, a construction engineer, built the railroad roundhouse at Strawbridge. Local citizens changed the name of the town to correspond to Sanderson's roundhouse.

Terry County
(13,218)
County Seat: Brownfield (9,560)

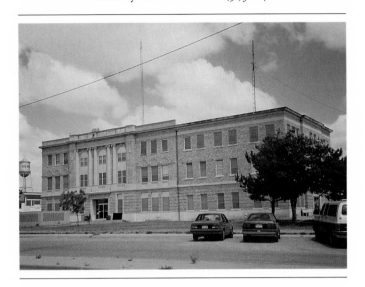

COURTHOUSES: two; 1906, 1925

STANDING: 1925 Texas Renaissance courthouse built of brick and concrete. An addition, in 1951, joins the courthouse to the east.

LOCATION: Brownfield: on the square, on Main Street between Fifth and Sixth streets.

NOTES: The Terry County Heritage Museum has exhibits about this county, which was organized in 1904. Named for the leader of Terry's Texas Rangers, Benjamin Franklin Terry, Terry County was the scene of early soldier and pioneer struggles. Lost Draw and Needmore are names that reflect some of these challenges. Brownfield was named for some local ranchers.

Throckmorton County

(1,880)

County Seat: Throckmorton (1,036)

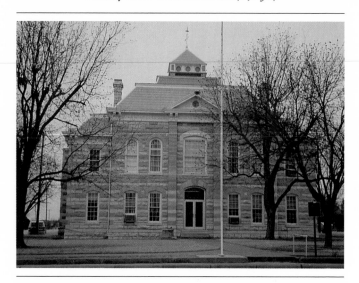

COURTHOUSES: two; 1879 (Williamsburg), 1890 (Throckmorton)

STANDING: 1890 Mansard-roofed Italianate design by the firm of Martin, Byrnes and Johnston. A similar courthouse was built in Rayner, Stonewall County, in 1888. Martin, Byrnes and Johnston contracted to build the old Rayner courthouse (now a ranch headquarters) and the Throckmorton courthouse. The Throckmorton courthouse is a National Register property and is built of stone. A 1938 annex also stands.

LOCATION: Throckmorton: corner of Chestnut Street (Texas 24) and U.S. 283 and U.S. 183.

NOTES: Dr. William Edward Throckmorton came to northern Texas in 1841 and was the father of Texas senator and later governor James W. Throckmorton. Organized in 1879, the county was named for the elder Throckmorton. Williamsburg, probably also named for him, was about six miles north of Throckmorton and was the original county seat.

Titus County

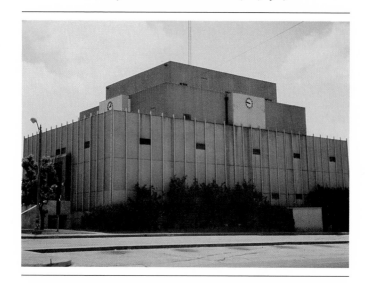

COURTHOUSES: five; 1846, 1851, 1859,
186 —, 1895

STANDING: 1895 courthouse that has
been substantially remodeled in 1940 and
1962, and again in 1990. The firm of
Eubanks-Harris "restored" the courthouse
to its 1940s appearance. Built in a Mo-
derne style of brick, the 1895 building is still
there, buried beneath several remodelings.

LOCATION: Mount Pleasant: on the
square, corner of West First Street and Ed-
wards Avenue.

NOTES: Andrew Jackson Titus came to
Texas from Tennessee. He fought in the
Mexican War and was a Texas legislator.
Named in his honor, Titus County was or-
ganized in 1846 with Mount Pleasant as
the county seat. Mount Pleasant derived
its name from the pleasing wooded hills.

Tom Green County

(98,458)

County Seat: San Angelo (84,474)

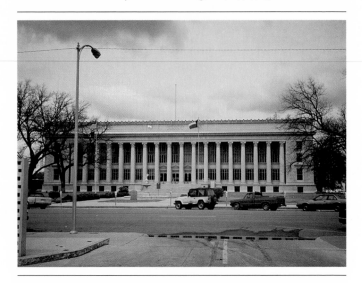

COURTHOUSES: four; 1876 (Ben Ficklin), 1882 (San Angelo), 1885, 1928

STANDING: The 1928 Classical Revival courthouse has a dignified Corinthian colonnade. Designed by Anton F. Korn, the courthouse is of brick and stone.

LOCATION: San Angelo: on the square, corner of Beauregard Avenue and Irving Street.

NOTES: Ben Ficklin was a pony express rider who settled in the area, and Col. F. C. Taylor named the first county seat for him. A flood in 1882 literally washed away the town of Ben Ficklin, and the seat was moved to San Angelo—a modification of Santa Angela, a name given by Bart DeWitt in honor of his Mexican sister-in-law. There are many other stories about the origin of the city's name, as well. Gen. Thomas Green was a veteran of the Battle of San Jacinto and a Confederate officer, who was killed during the Civil War. Fort Concho was nearby, and a museum on Burgess Street celebrates the fort's early role in the area.

Travis County
(576,407)
County Seat: Austin (463,178)

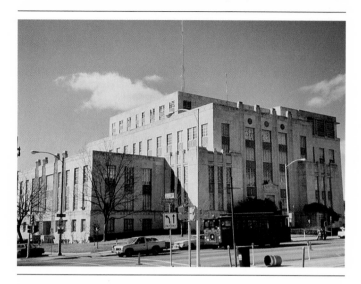

COURTHOUSES: three; 1855, 1876, 1930

STANDING: The 1930 courthouse came from the designs of Page Brothers and is in Moderne style, built of limestone, concrete, and steel. Additions in 1959 and 1962 have expanded the original courthouse.

LOCATION: Austin: on the square, corner of Eleventh Street and Guadalupe (FM 275).

NOTES: Organized in 1843 and named for the commander of the Alamo (William Barrett Travis), this county did not get around to building a courthouse until a dozen years after organization. Austin, of course, is named for Texas colonizer Stephen F. Austin and is the home of the largest state capitol building in the United States (naturally).

Trinity County
(11,445)
County Seat: Groveton (1,017)

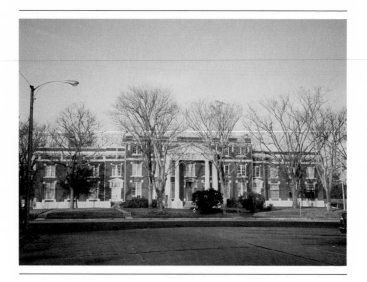

COURTHOUSES: five; 1850 (Sumpter), 1857, 1874 (Pennington), 1884 (Groveton), 1914

STANDING: 1914 Classical Revival courthouse built of brick. The architect was L. S. Green.

LOCATION: Groveton: on the square, on First Street (U.S. 287) between McGee and Devine streets.

NOTES: Sumpter, named for Gen. Thomas Sumpter of the American Revolution, was Trinity County's first county seat. Trinity was the second, but no courthouse was ever built. Pennington, named for a local resident, was the third. Groveton was a descriptive name derived from Trinity County's forests. The county, named for the river, was organized in 1850. Trinity County has an interesting and bloody history of feuds and violence and is linked with the likes of John Wesley Hardin. Lawlessness became the norm until the citizenry took the county back from its violators about 1905—but not before three courthouses burned.

Tyler County

(16,646)

County Seat: Woodville (2,636)

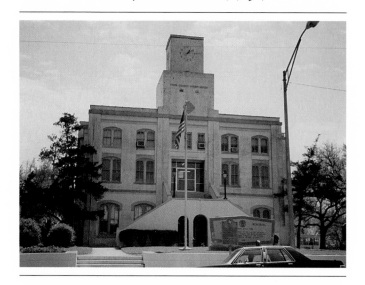

COURTHOUSES: three; 184 ——, 1856, 1891

STANDING: 1891 courthouse originally was an Italianate design by T. S. Hodges. The courthouse went through substantial alterations in the late 1930s: the tower and gabled roofs disappeared, thereby drastically changing the personality of the edifice.

LOCATION: Woodville: on the square, corner of Bluff (U.S. 190) and Magnolia (U.S. 69).

NOTES: George T. Wood, second governor of Texas, is the namesake of Woodville. Pres. John Tyler served as the inspiration for the county name.

Tyler County was created and organized twice: once in 1841, when it was declared unconstitutional, and later in 1846. Town Bluff, no longer extant, was the original county seat. The first courthouse was built between 1846 and 1849, but no record survives of the actual year.

Upshur County

(31,370)

County Seat: Gilmer (4,822)

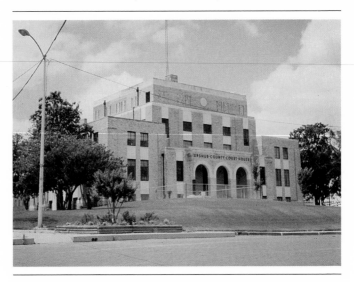

COURTHOUSES: five; 1846, 1848, 1871, 1889, 1933

STANDING: 1933 brick courthouse in Moderne style. Elmer G. Withers was the architect.

LOCATION: Gilmer: on Tyler Street (Texas 154), between Simpson and Davis streets.

NOTES: Secretary of state under Pres. John Tyler, Abel Pucker Upshur lent his name to this county when it was organized in 1846. U.S. secretary of the navy Thomas W. Gilmer provided the name for the county seat.

Upton County
(4,447)
County Seat: Rankin (1,011)

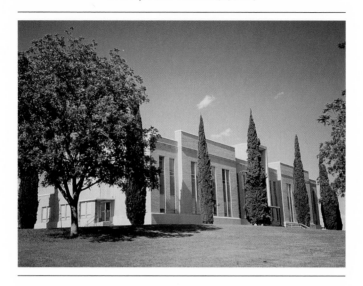

COURTHOUSES: two; 1911 (Upland), 1926

STANDING: 1926 brick courthouse of Moderne style was designed by David S. Castle.

Pieces of the old Upland courthouse still stand, but it has been abandoned for many years.

LOCATION: Rankin: on the square, on East Tenth Street between Grand and Rankin streets.

NOTES: Organized in 1910, Upton County obtained its name from two brothers who fought in the Civil War, William Felton Upton and John Cunningham Upton. The original county seat, Upland, began to decline when the railroad bypassed the community in favor of Rankin—named for F. E. Rankin, local landowner.

The Rankin Museum in the lobby of the old Yates Hotel on West Fifth Street has local history materials.

Uvalde County

(23,340)
County Seat: Uvalde (14,729)

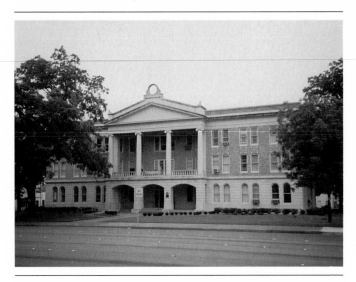

COURTHOUSES: three; 1877, 1890, 1927

STANDING: 1927 interesting Texas Renaissance–style building designed in the Classical manner by Henry T. Phelps; of brick and limestone.

LOCATION: Uvalde: on the square, corner of North Street (which becomes North Getty Street) and East Street (which becomes East Main Street).

NOTES: Uvalde has two very interesting museums: the John Nance Garner home (333 North Park Street) details not just the life of Speaker of the House and Vice-President Garner, but local issues as well. The Opera House Visitors Center traces Uvalde's history for several decades.

Juan de Ugalde, Spanish governor, knight, and soldier, is the source of this county's name. The county organized in 1853, and over the years Ugalde metamorphosed to Uvalde.

Val Verde County

(38,721)

County Seat: Del Rio (30,705)

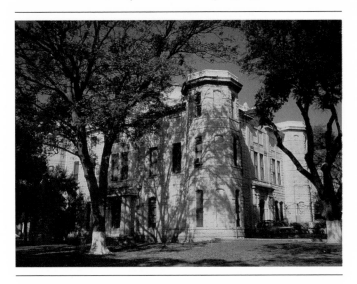

COURTHOUSES: one; 1887

STANDING: The firm of Larmour & Watson designed this Second Empire courthouse in stone. It is a National Register Property, but all the roofs (on the turrets and the Mansard towers) have been altered.

LOCATION: Del Rio: between Pecan and Mill, and Losoya and Greenwood streets.

NOTES: Organized in 1885, Val Verde is slightly corrupted Spanish for green valley, although the county obtained its name from a Civil War battle—the only Texas county with that distinction. San Felipe del Rio, the original name of the settlement, referred to the fact that the community's founding occurred on Saint Phillip's Day.

Van Zandt County

(37,944)
County Seat: Canton (2,949)

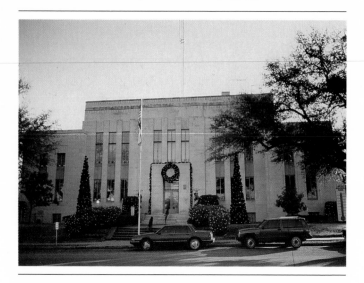

COURTHOUSES: five; 1848 (Jordan's Saline), 1850 (Canton), 1857, 1896, 1937

STANDING: The 1937 Moderne-style brick courthouse was designed by the architectural firm of Voelcker & Dixon.

LOCATION: Canton: on Dallas Street (Texas 64), between Buffalo and Capitol streets.

NOTES: Named for Isaac Van Zandt, an early Texas leader and attorney, this county was organized in 1848. Canton, styled after an earlier Texas community, struggled in the 1870s to be the county seat against rival Wills Point. Earlier county seats had been Jordan's Saline and Canton; Canton was successful.

The eagle on the lawn of the present courthouse was atop the 1896 courthouse.

Victoria County

(74,361)

County Seat: Victoria (55,076)

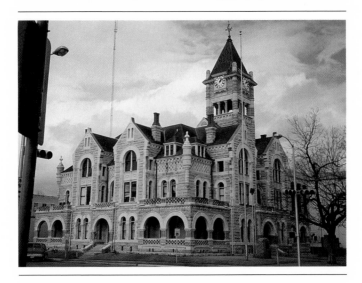

COURTHOUSES: three; 1849, 1892, 1967

STANDING: 1892 National Register Property designed by J. Riely Gordon in his enduring Romanesque Revival style. The 1892 courthouse is of limestone construction. Architect Gordon was fired during construction because he was not daily supervising the work. A 1967 Modern courthouse also exists.

LOCATION: Victoria: corner of Glass and Constitution streets.

NOTES: The McNamara House (502 North Liberty Street) has local history on exhibit from time to time. The county's original name was Nuestra Señora de Guadalupe de Jesus Victoria, later shortened to Guadalupe Victoria, and then to just Victoria. The county was first settled in 1824 and organized in 1837.

Walker County
(50,917)
County Seat: Huntsville (27,925)

COURTHOUSES: four; 1848, 1852, 1888, 1970

STANDING: 1970 Modern courthouse built of brick and steel after the 1888 courthouse burned. The firm of Joiner, Coburn & King designed the present courthouse.

LOCATION: Huntsville: on the square, corner of Eleventh Street (U.S. 190) and Sam Houston Avenue.

NOTES: Robert J. Walker first introduced legislation to annex Texas, and this county was named for him. Later, during the Civil War, Walker proved to be a Unionist. The Texas Legislature then changed the honoree to Samuel Walker, a Texas Ranger and a casualty of the Mexican War. Huntsville was named for Huntsville, Alabama, former home of Pleasant and Ephraim Gray, early settlers. Walker County was organized in 1846.

Waller County

(23,390)

County Seat: Hempstead (3,551)

COURTHOUSES: three; 1877, 1894, 1955

STANDING: 1955 Modern-style Herbert Voelcker design in brick and limestone.

LOCATION: Hempstead: corner of U.S. 290 and Ninth Street.

NOTES: Organized in 1873, Waller County derived its name from Edwin Waller, an early Texas leader. Hempstead was named for S. B. Hempstead, a relative of Richard Rogers Peebles, an early Texas physician and a Union sympathizer.

Ward County

(13,115)
County Seat: Monahans (8,101)

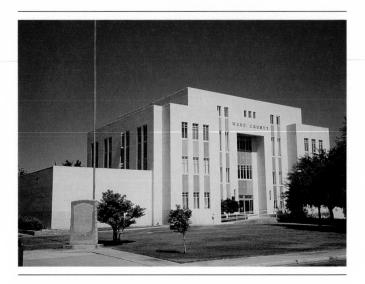

COURTHOUSES: two; 1893 (Barstow), 1940 (Monahans)

STANDING: 1940 Moderne-style courthouse designed by Townes & Funk in concrete and stone. The 1893 courthouse was razed about fifty years ago.

LOCATION: Monahans: on the square, corner of South Allen Avenue and East Fifth Street.

NOTES: Organized in 1892, Ward County honored Thomas William Ward, an early Texas warrior, postmaster, and land commissioner. In 1938 Monahans (on the railroad route) won the county seat from Barstow. Monahans was named for John Monahans who dug the first water well in the area.

Monahans Sandhills State Park and Museum (Interstate 20 at U.S. 80) has some local history exhibits.

Washington County
(26,154)
County Seat: Brenham (11,952)

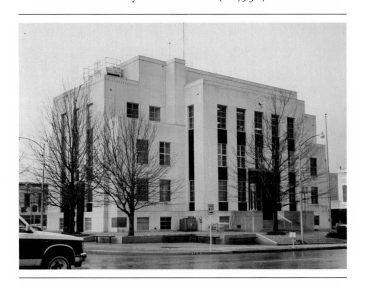

COURTHOUSES: four; 1844, 1852, 1883, 1939

STANDING: 1939 Moderne-style limestone courthouse, decorated with nationalistic eagles common to New Deal architecture, demonstrates the work of Travis Broesche, architect.

LOCATION: Brenham: on Alamo Street, between Park and Baylor streets.

NOTES: Dr. Richard Fox Brenham, a surgeon in the army of the Republic of Texas and a Mier Expedition victim, was honored with the name of this county seat. Washington-on-the-Brazos was the first county seat (1837–44) and intermittently was the capital of Texas. Washington County, possibly named for George Washington, was organized in 1837. Some have said it was named for Washington, Georgia, home of some early settlers.

Webb County

(133,239)

County Seat: Laredo (122,899)

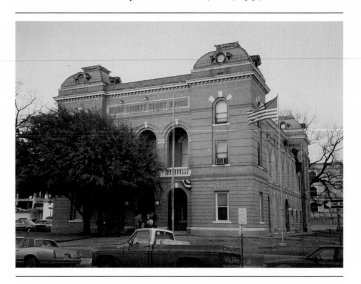

COURTHOUSES: three; 185 ——, 1882, 1909

STANDING: 1909 building designed by Alfred Giles and built of brick and concrete. It is in a Renaissance Revival style with Romanesque details; a National Register Property.

LOCATION: Laredo: west off Interstate 5/ U.S. 83, corner of Houston and San Augustin.

NOTES: Organized in 1848, the county was named for Republic of Texas leader James Webb, who served as secretary of state under President Lamar. Villa de San Agustín de Laredo (now Laredo) referred to a locale in Spain on the Bay of Biscay. City and county functions were not separate entities in Laredo during much of the nineteenth century.

The early history of Laredo, besides being interesting, is confusing. City and county functions were often mixed. The Nuevo Santander Museum at Laredo State University has local history materials.

Wharton County

(39,955)

County Seat: Wharton (9,011)

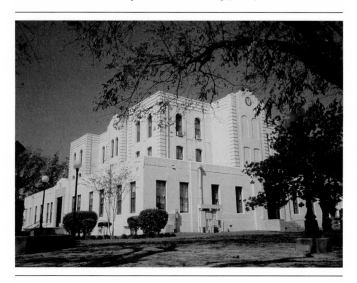

COURTHOUSES: two; 1851, 1889

STANDING: 1889 building is a Eugene T. Heiner design, originally in Second Empire style, but subsequently remodeled into a Moderne statement.

The original Mansard roof and clock tower were destroyed and the entire brick surface was stuccoed in 1935. The clock tower bell, it is said, is in the First Baptist Church. A move to demolish this courthouse is gaining strength.

LOCATION: Wharton: on the square, corner of Milam Street (Texas 60) and Houston Street.

NOTES: The county (organized in 1846) and county seat were named for brothers John Austin and William Harris Wharton. Both brothers practiced law and participated actively in the Texas Revolution.

The Wharton County Historical Museum has local history materials.

Wheeler County

(5,879)

County Seat: Wheeler (1,393)

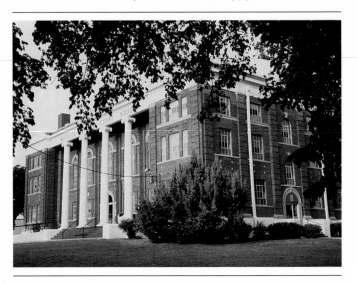

COURTHOUSES: three; 1880, 1907, 1925

STANDING: 1925 Classical Revival courthouse built of brick.

LOCATION: Wheeler: on the square, on Main Street between Texas Avenue and Oklahoma Avenue.

NOTES: The first county seat was Mobeetie, an Indian word for sweetwater. A storm in 1898 destroyed much of Mobeetie, and in 1906, the county voted to move the seat to Wheeler—a much less distinctive name. Organized in 1879, Wheeler County obtained its name as a memorial to Royal T. Wheeler, an early Texas lawyer and jurist.

The Old Mobeetie Museum in Wheeler has local history exhibits.

Wichita County
(122,378)
County Seat: Wichita Falls (96,259)

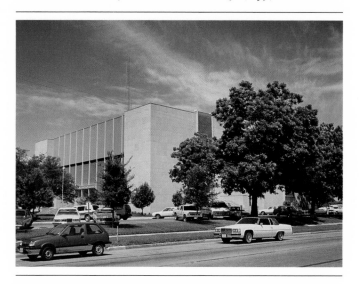

COURTHOUSES: three; 1883, 1886, 1916

STANDING: 1916 building, but it does
not appear that old. The Classical Revival
courthouse of 1916 gracefully endured re-
modeling in 1961. A subsequent remodel-
ing in the 1980s completely buried the old
courthouse under slabs of stone, glass, and
concrete. The columns and porticos are
gone, and the original design by Fields &
Clarkson and Sanguinet & Pate is no
more. Michael Koen did the recent remodel-
ing and annex and left an original court-
room charmingly ensconced on the fourth
floor.

LOCATION: Wichita Falls: corner of
Seventh and Lamar streets.

NOTES: Organized in 1882, Wichita
County was named for the river, and
present-day Wichita Falls developed at the
site of the falls (five or six feet high).

The Wichita Falls Museum and Art Center
at Two Eureka Circle has local history
exhibits.

Wilbarger County
(15,121)
County Seat: Vernon (12,001)

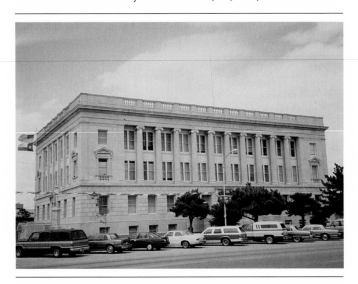

COURTHOUSES: three; 1883, 1890, 1928

STANDING: 1928 Classical Revival building designed by the firm of Voelcker and Dixon. Construction materials included steel, concrete, and stone.

LOCATION: Vernon: on the square, corner of Wilbarger Street (U.S. 287) and Main Street (U.S. 283).

NOTES: Vernon's Red River Valley Museum has interesting local exhibits about Wilbarger County (organized in 1881). Vernon got its name from Mount Vernon, George Washington's home. The county's namesakes were brothers Josiah Pugh and Mathias Wilbarger, early Texas pioneers. Josiah had the distinction of being scalped by Comanches, but living to tell about it. Josiah put a wool sock over his head until he was rescued the next day.

Willacy County
(17,705)
County Seat: Raymondville (8,880)

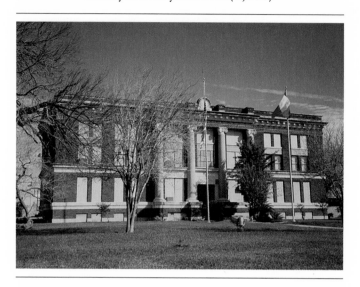

COURTHOUSES: one; 1922

STANDING: 1922 brick Classical Revival courthouse has been substantially remodeled over the years.

LOCATION: Raymondville: corner of Hidalgo Avenue (Texas 186) and Third Street.

NOTES: Sarita, now the seat of Kenedy County, was the original county seat when the county was organized in 1911. But the county reorganized in 1921 and changed the seat and the dimensions of the county. The legislature gave the new county the name of John G. Willacy, who introduced the bill to organize the county in 1911. Raymondville derives its name from Edward Burleson Raymond, a rancher and developer.

Raymondville Historical and Community Center has local history exhibits.

Williamson County

(139,551)

County Seat: Georgetown (14,842)

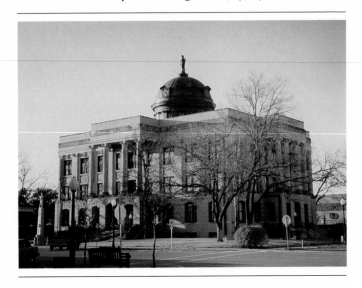

COURTHOUSES: five; 1849, 1851, 1857, 1877, 1911

STANDING: 1911 Beaux-Arts design of brick and stone by Charles H. Page, architect, of Austin. In 1965, a remodeling erased the pediments over the porticos, as well as the roof balustrade. These were replaced by the present solid and severe pediment; a National Register Property.

LOCATION: Georgetown: corner of Rock and Eighth streets.

NOTES: Robert McAlpin Williamson, for whom this county is named, lost the use of his right leg below the knee. He walked with a wooden leg. Williamson told the Texas Legislature about buffalo hunting in the proposed new county. One rainy day, his horse lost its footing and fell with him while chasing buffalo. The horse scampered off, but Williamson's wooden leg was stuck in the mud, and he could not rise. The legislators named the county after him. Georgetown's namesake was George Washington Glasscock, land promoter. The county was organized in 1848.

276

Wilson County

(22,650)

County Seat: Floresville (5,247)

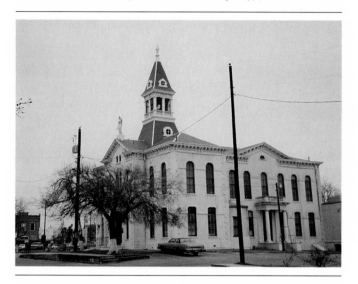

COURTHOUSES: two; 1872, 1884

STANDING: The 1884 courthouse was designed by Alfred Giles in a mixed style of Second Empire and Italianate. A National Register Property, it is built of brick. In 1936, the original brick was plastered, and the wooden galleries on the north and south were replaced by the present porticos.

LOCATION: Floresville: on Fourth Street, between C and D streets.

NOTES: James Charles Wilson, a Mier Expedition survivor, is the namesake of this county. Organized in 1860, the county has had only one seat, Floresville, named for the early rancher Don Francisco Flores de Abryo.

Winkler County

(8,626)

County Seat: Kermit (6,875)

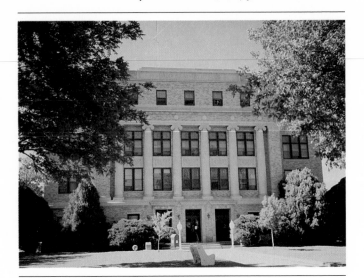

COURTHOUSES: two; 1910, 1929

STANDING: 1929 Texas Renaissance brick building with a columned facade.

LOCATION: Kermit: corner of Winkler and Poplar streets.

NOTES: The son of Pres. Theodore Roosevelt is the namesake of Kermit. Confederate colonel and judge Clinton M. Winkler provided the inspiration for the name of this county, which was organized in 1910.

Winkler County Park has some historic buildings of interest about the locality.

Wise County

(34,679)

County Seat: Decatur (4,252)

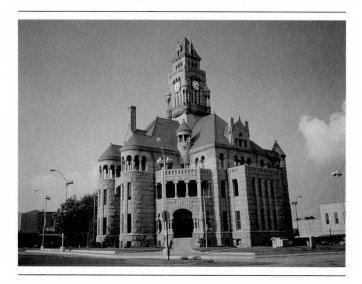

COURTHOUSES: four; 1858, 1861, 1883, 1896

STANDING: The 1896 courthouse is very similar to Ellis County's. Both were designed by J. Riely Gordon in a Romanesque Revival style and built of stone. The Wise County Courthouse is of pink granite; the interior boasts Vermont marble. It is a National Register Property.

LOCATION: Decatur: corner of Walnut (U.S. 81) and Trinity (FM 730).

NOTES: Commodore Stephen Decatur, one of America's most flamboyant naval heroes, served as the namesake for this county seat and close to a dozen other Decaturs in the United States. Henry A. Wise never lived in Texas, but he was an ardent supporter of the South and of the annexation of Texas. Wise County, organized in 1856, recognized this Virginian. The Wise County Heritage Museum is in the administration building of the old Decatur Baptist College. Decatur is dotted with historical markers.

Wood County

(29,380)

County Seat: Quitman (1,684)

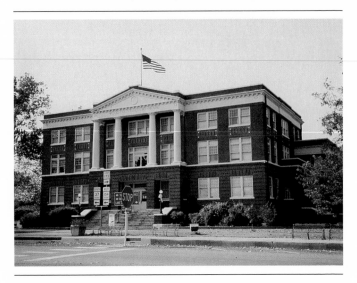

COURTHOUSES: four; 1851, 1854, 1883, 1925

STANDING: 1925 Classical Revival–style courthouse designed by C. H. Leinbach and built of brick. The county built an addition in 1949 and remodeling was done in 1976, 1979, and 1981.

LOCATION: Quitman: on the square, corner of Bermuda (Texas 154) and Main Street (FM 2966).

NOTES: George T. Wood, a Texas governor, officer in the Mexican War, and member of Congress in the Republic of Texas, is the namesake of this county. John Anthony Quitman raised a group of volunteers in Mississippi and led them to Texas to fight in the revolution. The county seat was named in his honor. Wood County was organized in 1850.

Yoakum County
(8,786)
County Seat: Plains (1,422)

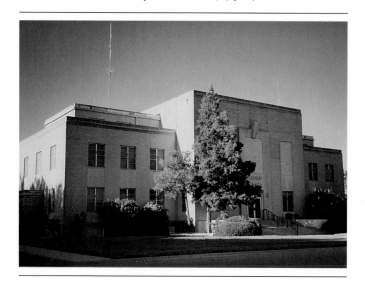

COURTHOUSES: three; 1908, 1926, 1949

STANDING: 1949 brick building in Moderne style with some Art Deco elements, designed by Wyatt C. Hedrick.

LOCATION: Plains: on the square, on Tenth Street (U.S. 82/U.S. 380) between Avenue G and Avenue I.

NOTES: Named for prominent Texas lawyer and pioneer historian Henderson King Yoakum, this county was organized in 1907. William Jackson Luna, founder of Plains, the county seat, gave the community its name based upon his description of the countryside.

A local club, Tsa Mo Ga, operates a museum with local history materials at 1109 Avenue H.

Young County
(18,126)
County Seat: Graham (8,986)

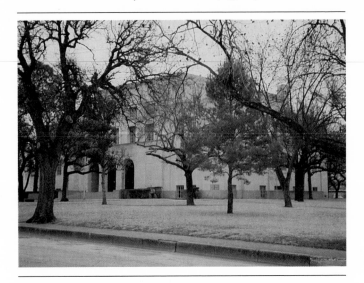

COURTHOUSES: three; 1876, 1884, 1932

STANDING: 1932 Moderne courthouse of limestone and concrete, whose design came from the firm of Withers & Thompson.

LOCATION: Graham: on Third Street, between Oak and Elm streets.

NOTES: Brothers Gustavus A. and Edwin S. Graham, local land developers, gave their name to the county seat. The county was organized twice, permanently in 1874. William Cocke Young, namesake of this county, wore the first sheriff's badge in Red River County, fought in the Mexican War, and commanded the 11th Texas Regiment for the Confederacy. Murdered by a band of outlaws in 1862, Young was avenged by his son, who tracked down the murderer and at pistol point took the perpetrator to the scene of the crime, where Young's slaves hanged him.

Zapata County

County Seat: Zapata (7,119)

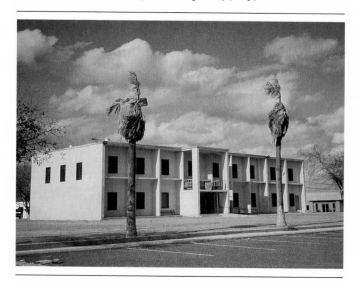

COURTHOUSES: three; 1874 (Carrizo), 1901, 1953

STANDING: 1953 Modern courthouse of brick. The 1901 courthouse still exists, but it is at the bottom of Falcon Reservoir.

LOCATION: Zapata: corner of Hidalgo Street and Sixth Avenue.

NOTES: Organized in 1858, the county was named for Col. Antonio Zapata, a powerful and political rancher in the area. There have been several county seats besides Zapata—Carrizo and San Bartolo among them. Courthouses before 1874 apparently were temporary. Carrizo was renamed Zapata and then subsequently relocated; that is, there has been more than one Zapata.

283

Zavala County

(12,162)

County Seat: Crystal City (8,263)

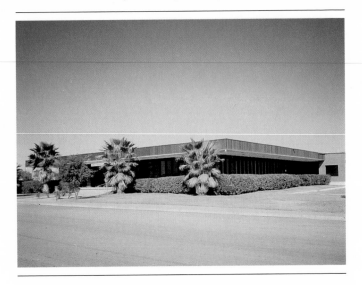

COURTHOUSES: three; 1885 (Batesville), 1928, 1970

STANDING: 1970 Modern one-story courthouse built of steel and concrete.

LOCATION: Crystal City: on the square, on First Avenue, between East Dimit and East Uvalde Street.

NOTES: Organized in 1884, Zavala County derived its name from Lorenzo de Zavala, Texas patriot and Mexican statesman. Originally misspelled, the name of the county was corrected in 1929—one of the few to do so. Bates City (later Batesville) was the original county seat. Crystal City, founded as a transportation center for truck crops such as onions, carrots, peppers, and spinach, became the county seat in 1928. At one time (1937) so much spinach was grown in Zavala County that the citizens of Crystal City had a statue of Popeye erected.

Appendixes

APPENDIX A
County Seats and Counties

County Seat	County	County Seat	County
Abilene	Taylor	Brownwood	Brown
Albany	Shackelford	Bryan	Brazos
Alice	Jim Wells	Burnet	Burnet
Alpine	Brewster		
Amarillo	Potter	Caldwell	Burleson
Anahuac	Chambers	Cameron	Milam
Anderson	Grimes	Canadian	Hemphill
Andrews	Andrews	Canton	Van Zandt
Angleton	Brazoria	Canyon	Randall
Anson	Jones	Carrizo Springs	Dimmit
Archer City	Archer	Carthage	Panola
Aspermont	Stonewall	Center	Shelby
Athens	Henderson	Centerville	Leon
Austin	Travis	Channing	Hartley
		Childress	Childress
Baird	Callahan	Clarendon	Donley
Ballinger	Runnels	Clarksville	Red River
Bandera	Bandera	Claude	Armstrong
Bastrop	Bastrop	Cleburne	Johnson
Bay City	Matagorda	Coldspring	San Jacinto
Beaumont	Jefferson	Coleman	Coleman
Beeville	Bee	Colorado City	Mitchell
Bellville	Austin	Columbus	Colorado
Belton	Bell	Comanche	Comanche
Benjamin	Knox	Conroe	Montgomery
Big Lake	Reagan	Cooper	Delta
Big Spring	Howard	Corpus Christi	Nueces
Boerne	Kendall	Corsicana	Navarro
Bonham	Fannin	Cotulla	La Salle
Brackettville	Kinney	Crane	Crane
Brady	McCulloch	Crockett	Houston
Breckenridge	Stephens	Crosbyton	Crosby
Brenham	Washington	Crowell	Foard
Brownfield	Terry	Crystal City	Zavala
Brownsville	Cameron	Cuero	DeWitt

County Seat	County	County Seat	County
Dalhart	Dallam	Groveton	Trinity
Dallas	Dallas	Guthrie	King
Daingerfield	Morris		
Decatur	Wise	Hallettsville	Lavaca
Del Rio	Val Verde	Hamilton	Hamilton
Denton	Denton	Haskell	Haskell
Dickens	Dickens	Hebbronville	Jim Hogg
Dimmit	Castro	Hemphill	Sabine
Dumas	Moore	Hempstead	Waller
		Henderson	Rusk
Eagle Pass	Maverick	Henrietta	Clay
Eastland	Eastland	Hereford	Deaf Smith
Edinburg	Hidalgo	Hillsboro	Hill
Edna	Jackson	Hondo	Medina
Eldorado	Schleicher	Houston	Harris
El Paso	El Paso	Huntsville	Walker
Emory	Rains		
		Jacksboro	Jack
Fairfield	Freestone	Jasper	Jasper
Falfurrias	Brooks	Jayton	Kent
Farwell	Parmer	Jefferson	Marion
Floresville	Wilson	Johnson City	Blanco
Floydada	Floyd	Jourdantown	Atascosa
Fort Davis	Jeff Davis	Junction	Kimble
Fort Stockton	Pecos		
Fort Worth	Tarrant	Karnes City	Karnes
Franklin	Robertson	Kaufman	Kaufman
Fredericksburg	Gillespie	Kermit	Winkler
		Kerrville	Kerr
Gail	Borden	Kingsville	Kleberg
Gainesville	Cooke	Kountze	Hardin
Galveston	Galveston		
Garden City	Glasscock	La Grange	Fayette
Gatesville	Coryell	Lamesa	Dawson
Georgetown	Williamson	Lampasas	Lampasas
George West	Live Oak	Laredo	Webb
Giddings	Lee	Leakey	Real
Gilmer	Upshur	Levelland	Hockley
Glen Rose	Somervell	Liberty	Liberty
Goldthwaite	Mills	Linden	Cass
Goliad	Goliad	Lipscomb	Lipscomb
Gonzales	Gonzales	Littlefield	Lamb
Graham	Young	Livingston	Polk
Granbury	Hood	Llano	Llano
Greenville	Hunt	Lockhart	Caldwell
Groesbeck	Limestone	Longview	Gregg

COUNTIES AND COUNTY SEATS

County Seat	County	County Seat	County
Lubbock	Lubbock	Port Lavaca	Calhoun
Lufkin	Angelina	Post	Garza
McKinney	Collin	Quanah	Hardeman
Madisonville	Madison	Quitman	Wood
Marfa	Presidio		
Marlin	Falls	Rankin	Upton
Marshall	Harrison	Raymondville	Willacy
Mason	Mason	Refugio	Refugio
Matador	Motley	Richmond	Fort Bend
Memphis	Hall	Rio Grande City	Starr
Menard	Menard	Robert Lee	Coke
Mentone	Loving	Roby	Fisher
Meridian	Bosque	Rockport	Aransas
Mertzon	Irion	Rocksprings	Edwards
Miami	Roberts	Rockwall	Rockwall
Midland	Midland	Rusk	Cherokee
Monahans	Ward		
Montague	Montague	San Angelo	Tom Green
Morton	Cochran	San Antonio	Bexar
Mount Pleasant	Titus	San Augustine	
Mount Vernon	Franklin		San Augustine
Muleshoe	Bailey	Sanderson	Terrell
		San Diego	Duval
Nacogdoches	Nacogdoches	San Marcos	Hays
New Boston	Bowie	San Saba	San Saba
New Braunfels	Comal	Sarita	Kenedy
Newton	Newton	Seguin	Guadalupe
		Seminole	Gaines
Odessa	Ector	Seymour	Baylor
Orange	Orange	Sherman	Grayson
Ozona	Crockett	Sierra Blanca	Hudspeth
		Silverton	Briscoe
Paducah	Cottle	Sinton	San Patricio
Paint Rock	Concho	Snyder	Scurry
Palestine	Anderson	Sonora	Sutton
Palo Pinto	Palo Pinto	Spearman	Hansford
Pampa	Gray	Stanton	Martin
Panhandle	Carson	Stephenville	Erath
Paris	Lamar	Sterling City	Sterling
Pearsall	Frio	Stinnett	Hutchinson
Pecos	Reeves	Stratford	Sherman
Perryton	Ochiltree	Sulphur Springs	Hopkins
Pittsburg	Camp	Sweetwater	Nolan
Plains	Yoakum		
Plainview	Hale	Tahoka	Lynn

289

County Seat	County	County Seat	County
Throckmorton		Waco	McLennan
	Throckmorton	Waxahachie	Ellis
Tilden	McMullen	Weatherford	Parker
Tulia	Swisher	Wellington	Collingsworth
Tyler	Smith	Wharton	Wharton
		Wheeler	Wheeler
Uvalde	Uvalde	Wichita Falls	Wichita
		Woodville	Tyler
Van Horn	Culberson		
Vega	Oldham	Zapata	Zapata
Vernon	Wilbarger		
Victoria	Victoria		

Naming Texas Counties

THE ORIGIN OF THE COUNTY NAME is given in the text for each county. Most of the original twenty-three Texas counties or municipal districts, as they were then called, were already named by Spain or Mexico before Texas won its independence in 1836. All other counties were named by the people of Texas through the Congress of the Republic or later through the Texas state legislature. For some counties, there is conflicting information. For example, was Bandera County named for Spanish General Bandera or for the Bandera Pass or Mountains, which were named for General Bandera, or for *bandera,* the Spanish word for flag, one of which marked the entrance to the pass? Approximately two hundred counties are named in honor of men or families. The remaining counties are named mainly for geographic or physical features, while a few have other origins.

Counties Named for Texians and Texans

AT LEAST 150 OF THE MEN for whom Texas counties are named may be referred to as Texians, or people who lived in Texas before its annexation to the Union. At least one hundred fought in one or more of the many battles of the Texas Revolution or acted in some official capacity. Twenty-three were killed in the revolution, twelve of these in the Battle of the Alamo. This most important group of Texians includes the first colonizers of Texas, such as Stephen F. Austin; heroes of the Alamo, such as David Crockett; heroes of the Battle of San Jacinto, such as Deaf Smith; presidents and officers of the Republic, such as Samuel Houston; signers of the Texas Declaration of Independence, including Richard Ellis and many others of the fifty-nine signers; signers of the Convention of 1845 which approved the annexation of Texas, such as Anson Jones; rangers like Capt. John Coffee Hays; and governors, such as George T. Wood. Many of these men participated in several activities.

About twenty-four counties (information varies) are named for people who came to Texas or were born in Texas after its annexation in 1846. About a dozen of these were honored because of their service in the Confederacy, including Gen. John Bell Hood of Hood's Texas Brigade; Benjamin Franklin Terry of Terry's

Texas Rangers; John Gregg, a Confederate congressman; and Williamson Simpson Oldham, a Confederate senator. Walker County first honored Robert J. Walker, a U.S. congressman from Mississippi who worked for the annexation of Texas. When Robert Walker joined the Union, the Texas legislature withdrew his name and honored instead Samuel H. Walker, a Texian Ranger Captain. Walker County is not the only county to have its namesake changed. See Stephens and Cass counties, for instance.

Among the 150 Texians who had counties named for them in honor of their role in the Texas Revolution and eventual annexation to the United States, at least 20 also served some role in the Confederacy, including signing the Ordinance of Secession. In spite of significant opposition, there was great partisanship for the Confederacy in Texas. Service in its cause may have been as important as service in the Texas Revolution in naming counties for some men. For example, Col. William Cocke Young of Grayson County, who came to Texas in 1837, was a sheriff, Indian fighter, and a member of the Convention of 1845. But he was most noted for organizing the 11th Texas Cavalry Regiment in the Confederacy. He was assassinated by bushwhackers while home on sick leave. William R. Scurry was a congressman in the Republic and later was a Confederate general, who was killed in combat. In all, more than 40 men who are county namesakes fought in the Confederacy, while none fought in the Union army. There was widespread intolerance for Texans who opposed slavery. One of the few Union monuments in Texas is in Comfort, Kendall County, erected in memory of 35 men, mostly German immigrants, who opposed slavery. They were killed by Confederate troops in 1862 while bound for Mexico to escape the Civil War.

Among the men who were born in Texas after annexation or who came after annexation were seven office-holders in Texas, such as Gov. James Stephen Hogg, the first native governor, and Gov. Richard Coke, who came from Virginia and also had been a Confederate captain. Other counties named for governors are Roberts, Jones, Wood, Henderson, Bell, and Runnels.

There were at least twenty-five counties named for Indian fighters, rangers, and peace officers. These include the following: Andrews, Bell, Brown, Burleson, Caldwell, Callahan, Coryell, Cooke, Denton, Eastland, Galvez, Gillespie, Gray, Green, Hemphill, Hudspeth, Irion, Karnes, Rusk, Sterling, Sutton, Tarrant, Walker, Young, and Zapata.

Garza, Armstrong, and Taylor counties were named for pioneer families. Duval, Hardeman, Hardin, Mitchell, Roberts, Upton, and Wharton counties were each named for two or more brothers. Some additional counties were probably named for two or more people; however insufficient records and conflicting stories make the origin of these hazy. Hopkins County may have been named for the Hopkins family, not for David Hopkins. Jack County may

have been named for the two Jack brothers, William H. and Patrick. Roberts County may have been named for both Oran Roberts and John S. Roberts.

Counties Named for Non-Texans

THERE ARE ONLY THIRTY-SIX COUNTIES named for persons who were not Texians or Texans. Four or five counties were named for American presidents: Jackson, Madison, Polk, and Tyler. There is conflicting information about whether Jefferson County was named for Pres. Thomas Jefferson. Many fifth-generation Beaumonters today claim that the county was named for Jefferson Beaumont, the brother-in-law of Henry Millard, who gave the land for the city of Beaumont, which was definitely named for Jefferson Beaumont. Washington County may not have been named for the first American president George Washington, as most people assume, but for Washington, Georgia, hometown of a settler, according to June Rayfield Welch and J. Larry Nash in *The Texas Courthouse*. Johnson, Wilson, Taylor, and Reagan counties were not named for American presidents. President Buchanan had a county named for him, but it was later changed to Stephens to honor Confederate vice-president Alexander H. Stephens.

Cass County had its name changed to Davis County to honor Confederate president Jefferson Davis, but the Reconstruction government changed it back to Cass County. Finally, Texas did honor the Confederate president when Jeff Davis County was organized in 1887. Two other counties are named for non-Texan Confederate heroes: Stonewall county for Gen. "Stonewall" Jackson and Lee County for Gen. Robert E. Lee.

Calhoun and probably Dallas counties were named for United States vice-presidents. Knox County was named for Henry Knox, secretary of war under George Washington, and Clay County was named for Henry Clay, the American patriot. Eleven counties were named for American statesmen who worked for the annexation of Texas, including Sen. Henry Wise and Sec. of State Abel Packer Upshur.

Counties Named for Other Military Leaders

SIX COUNTIES WERE NAMED FOR MEN who fought in the American Revolution: Sgt. William Jasper, Gen. Francis Marion, Gen. Richard Montgomery, Marquis de Lafayette (Fayette County), Cpl. John Newton, and Isaac Shelby of Tennessee. Shelby was the only Revolutionary veteran to come to Texas and have a county named for him. Philip Nolan (Nolan County) came to Texas in 1801 while it was a Spanish province. Spanish soldiers killed Nolan near present-day Waco while attempting to

arrest him for spying. David G. Burnet was the first American volunteer in the war to free Venezuela from Spain in 1806.

In addition to the one hundred men who fought in the Texas Revolution and the Civil War, fourteen or more fought in the War of 1812, twenty-one or more later fought in the Mexican War, and two were killed in it. Daniel Montague and possibly some other namesakes participated in the Snively Expedition. In 1843 Col. Jacob Snively attempted to capture rich wagon trains on the Santa Fe Trail on land claimed by Texas. The Snively party was dispersed or captured by the U.S. Cavalry, according to the *Handbook of Texas*. Two men who participated in the Texas Revolution, James Smith and Robert Potter, became embroiled in the Regulator-Moderator War in East Texas. Three men fought in the Mexican Army before the Texas Revolution. Alexander W. Terrell was a Confederate general who later became a general in the army of Maximilian, emperor of Mexico. At least one man, Henry Lawrence Kinney, was in the filibuster of Nicaragua in 1855.

Original Homes of Men for Whom Counties Are Named

WITH THE EXCEPTION OF A FEW I could not locate, I have compiled the states or countries of origin of men or families for whom Texas counties are named.

U.S. States of Origin				Other Countries	
Tennessee	28	Maryland	3	Spain	5
Virginia	25	Alabama	2	Ireland	4
Kentucky	22	Maine	2	France	3
Georgia	14	Mississippi	2	Scotland	2
South Carolina	13	Connecticut	1	Germany	2
North Carolina	12	Delaware	1	Canada	1
Pennsylvania	7	Michigan	1	England	1
New York	5	Missouri	1	Austria	1
Texas	4	New Hampshire	1		
New Jersey	4	Ohio	1		
Massachusetts	3	Vermont	1		

A significant number of Texas county namesakes emigrated from the heavily populated eastern states. The large numbers coming from Kentucky and Tennessee conform to westward migratory patterns of the early nineteenth century. After Daniel Boone opened the trail to Kentucky, American Revolutionary veterans from Virginia and the Carolinas settled on land grants in Tennessee and Kentucky. The sons and daughters of these frontiersmen continued the westward movement. The opening of Texas for settlement offered additional adventure and fortune for these pioneers.

Not many Texans were born in Alabama, Mississippi, or Louisiana. Actually, these lands were occupied mainly by Indians during the first third of the nineteenth century. However, many future Texans coming from the southern coastal states stopped over for a year or more in these territories before they were lured on to Texas. Some were plantation owners, office holders, traders, or boatmen. My wife's great-grandfather, James G. Thompson, provides an example. He was born in South Carolina in 1802. His parents moved the family to the Cherokee Nation in the Mississippi Territory in 1810. Here young James grew to manhood, married a part-Cherokee woman, and had a large family. The James Thompson family moved to the Western Cherokee Nation in 1829. Thompson operated an Indian trading post and ran keel boats on the Arkansas River. By 1833, he was in Texas buying peltries on the Red River. Hundreds of his descendants live in Texas today. His family plot in the Preston Bend Cemetery contains his tomb as well as the tomb of his mother, Anne McDonald Thompson, who was born in South Carolina in 1780.

For some emigrants "Gone to Texas" meant escape from the law. A few Texas counties are named for these refugees, such as the Hardin brothers and Robert Potter. Others, like Sam Houston, were disappointed in love or in business or had lost an election for public office. When it came time to leave, the place to go was Texas!

Many men had military training. Several men including James Fannin, Henderson Yoakum, and Robert E. Lee were graduates of the U.S. Military Academy. Some, like Fannin, were attracted by the opportunity to get into a fight such as the Texas Revolution promised to provide. I had two distant cousins, young single men, George Pagan and William Irvine Lewis, who came to Texas from South Carolina for adventure. The two were unfortunate enough to have been killed in the Battle of the Alamo. Their names are engraved on a monument memorializing the victims of the Alamo on the grounds of the state capitol in Austin.

Other Sources of County Names

TWO COUNTIES HAVE UNUSUAL NAMES. Val Verde County was named for the Civil War battle at Val Verde, New Mexico. Henry Hopkins Sibley raised a force of nearly two thousand men, mainly Texans, and marched them west from San Antonio in an attempt to drive the federal forces out of New Mexico. On February 21, 1862, Sibley's Brigade won the Battle of Val Verde, but was later defeated at Glorieta, New Mexico. One of Sibley's cannons was, with great difficulty, brought back to Texas where it was used with success in the defense of Galveston. The cannon is now on the lawn of the Freestone County Courthouse in Fairfield with appropriate historical markers.

APPENDIX B

San Patricio County was colonized in 1830 by forty Irish families who named a townsite after Saint Patrick, the patron saint of Ireland, which in Spanish is San Patricio Hibernia. Three counties are named for the Indian tribes that previously occupied the land: Cherokee, Comanche, and Nacogdoches. Panola County is named for *panola,* the Indian word for cotton. Perhaps the Indians grew cotton there; the American settlers certainly did. Another source for this name may be Panola County, Mississippi, which first took the Indian name for cotton. Leon County may have been named for the yellow wolf called *leona,* which was common in the area or, more likely, for the Spanish empresario, Martín de León. Only a few Texas counties are named for Spanish or Mexican leaders, but many counties are named for landmarks or missions with Spanish names.

Nearly fifty counties were named for their location or some geological feature. Twenty-five counties were named for the rivers that bordered or flowed through them. There would be more counties so named except for duplication of names. Only the Brazos has two counties named for it: Brazoria and Brazos. Other river counties are Angelina, Aransas, Atascosa, Blanco, Bosque, Colorado, Comal, Concho, Frio, Guadalupe, Lampasas, Lavaca, Llano, Medina, Nueces, Palo Pinto (Creek), Pecos, Red, Sabine, San Jacinto, San Saba, Trinity, and Wichita.

The Bandera Mountains, the Sulphur River delta, the Pass of the North, the falls of the Brazos, freestone, limestone, live oaks, orange groves, Matagorda Bay, a rock wall, and Uvalde Canyon each provided county names. Bexar, Fort Bend, Goliad, Liberty, Fort Mason, Presidio, Refugio, San Augustine, Victoria, and Galveston were already settlements when counties were named for them.

County Names Changed

A FEW COUNTIES HAVE HAD THEIR NAMES CHANGED. For some, this happened in the course of dividing larger counties into smaller ones. Some county names were abandoned between the time they were designated by the state legislature and the time they were formally organized. The following are examples:

Present Name	Former Name
Brazos	Navasota
Brewster	Santa Fe (never became an organized county)
Cass	Originally Cass, then Davis, finally Cass again
Donley	Wegefarth
El Paso	Santa Fe
Harris	Harrisburg

Present Name *Former Name*

Morris Paschal, declared an unconstitutional
 jurisdiction
Presidio Santa Fe
Red River Formerly claimed by the United States as
 Miller County, Arkansas Territory
Stephens Buchanan
Sutton Apache
Tyler Menard
Upshur Caddo
Wilson Cibolo

APPENDIX C

Lives of Those Honored
by County Names

FOR THOSE INTERESTED IN STORIES OF ADVENTURE, greatess, and heroism, there is no better source than the biographies of the men for whom Texas counties are named.
First and most important are the men who gave their lives for the independence of Texas. The first fatality of the Texas Revolution was Richard "Big Dick" Andrews. He was the only fatality in the Battle of Concepción on October 28, 1835, in which about one hundred Texians captured Concepción Mission near San Antonio. This battle was followed by the siege of Bexar, December 5–9, 1835, where Ben Milam led around three hundred Texians who overran and captured San Antonio. Ben Milam was among the four Texians killed in this battle. Thomas William Ward (Ward County) lost a leg in this battle, and the leg was buried with Milam's body. Ward then lost an arm celebrating Texas' independence. The Mexican Army recaptured San Antonio at the Battle of the Alamo, which lasted from February 23 to March 6, 1836. One hundred and eighty-seven Texians were killed in the Alamo, and Texas counties are named for twelve of these: Peter J. Bailey, James Bowie, Robert E. Cochran, George Washington Cottle, David Crockett, J. Dickens, Dolphin Ward Floyd, Andrew Kent, George C. Kimbell, William P. King, William Lynn (or Linn), and William Barrett Travis.

William P. King, at age fifteen, was the youngest of the twenty-two defenders under twenty-one years of age. Most of the Alamo's heroes are known mainly by historians, but David Crockett is a national folk hero. His autobiography was favorite reading for many decades. Born August 17, 1786, in Tennessee, he ran away from home to make his own way when he was thirteen years old. He was a noted hunter, having killed 105 bears in eight or nine months. He had to learn to write in order to carry out his duties as a Tennessee magistrate. Crockett rapidly moved up in politics as a militia colonel, state legislator, and United States representative. He refused to follow President Jackson's bidding, which led to his defeat for a third term in Congress. Feeling that he had been a victim of corruption, he came to Texas where his fame had preceded him, and he was warmly received. He joined William Barrett Travis in the defense of the Alamo, where he fought to the bitter end.

Jim Bowie also achieved folk hero status for his numerous adventures before he died in the Alamo. Also a Tennessean, by age nineteen, he was already a farmer and logger in the bayous of Louisiana, where he is said to have ridden alligators. He was a land speculator, a slave trader with Jean Lafitte, and a gold seeker. After being wounded at the Sandbar Duel in Louisiana, he designed the celebrated Bowie knife. William Barrett Travis, a young lawyer from South Carolina, came to Texas and settled at San Felipe in 1831. He soon became involved in the independence movement. He raised volunteers, captured the Mexican garrisons at Anahuac, and reinforced the Alamo garrison, which he commanded during the battle that cost him his life on March 6, 1836.

When the battles for Texas independence were underway around San Antonio, the campaigns around Goliad were being fought, from February 2, through March 22, 1836. These various battles and skirmishes were climaxed in a disastrous defeat for the Texians. James Walker Fannin, a 32-year-old West Point graduate, has been blamed, as commanding officer, for delaying a retreat from the embattled garrison at Goliad. The retreating Texian Army surrendered at the Battle of Coleto, were taken prisoner, and were marched back to Goliad, where on March 27, 342 Texians were executed in what is known as the Goliad Massacre. In addition to Fannin, Burr Duval and Charles Haskell were among the victims.

Finally, the victorious Battle of San Jacinto on March 21, 1836, brought independence to Texas and indirectly added one-third of the land area to the present-day lower forty-eight states. The battle lasted eighteen minutes, while 910 Texians killed 630 Mexicans and took 730 prisoners, including Gen. Santa Anna. Only 9 Texians were killed, 3 of whom have counties named for them: John C. Hale, George A. Lamb, and Dr. Junius William Motley.

After the Battle of San Jacinto, the Republic of Texas had more trouble with Mexico, which led to the Battle of Salado on September 18, 1842, where Nicholas Mosby Dawson was killed. This battle was followed by the ill-fated Mier Expedition in which 261 Texians invaded Mexico on December 23, 1842. They were ill-prepared, and most were soon captured by the Mexicans and marched toward Mexico City. After several attempted escapes by the Texians, the Mexican government ordered the execution of one out of ten of the remaining 176 prisoners. Those who drew one of the seventeen black beans were executed, including William Mosby Eastland. Ewen Cameron drew a white bean, but his execution was ordered by Santa Anna anyway because he was the Texian leader.

The last Texian fatalities in the battles for freedom were Nicholas Mosby Dawson and his company of fifty-three men who were killed or captured by General Woll's troops, who had reoccupied San Antonio in 1842. The Dawson Company survivors were

marched to Mexico to become prisoners of Perote; the last survivors were finally released on September 10, 1844. It is worth mentioning that a number of these and other later great men who were namesakes of our counties are buried in the State Cemetery in Austin.

Life was full of risks for the two hundred people who were county namesakes. At least fifty-eight, or 29 percent of the total, met violent death. Thirty-five died in some form of military action. Twenty-three were killed in various skirmishes leading to Texas independence.

Twenty-one men for whom counties are named also fought in the Mexican War of 1846. Two men were killed in this war, including Richard Allen Gillespie, who came to Texas in 1837 and took part in numerous Mexican and Indian fights. As commander of the Hays Ranger Regiment, he was killed in a charge on the Bishop's Palace in Monterrey, September 21, 1846. The second casualty of the Mexican War was Samuel Hamilton Walker, an experienced Mexican and Indian fighter, who also joined Hays Texas Rangers. He survived the black bean episode and Perote Prison only to die while leading a charge in the Mexican War on October 9, 1847. He is noted for designing the Walker Colt pistol. Nine counties are named for Confederate soldiers killed in the Civil War: Gregg, McCulloch, Randall, Scurry, Sutton, Terry, Tom Green, Upton, and Young. Several of these men had already served in the Texas Revolution and the Mexican War.

Of the twenty-four namesakes who were known Indian fighters, four were killed: John Denton, at the Battle of Village Creek, May 22, 1841; James Coryell, attacked by Indians while raiding a bee tree near the Falls of the Brazos, May 17, 1837; Oliver Loving, while droving cattle in New Mexico in 1867; and W. S. Sterling, ambushed by Apaches, as a U.S. marshal in Arizona in 1881. David Spangler Kaufman was wounded in East Texas in a fight against the Cherokees in 1839. He died in 1851; the wound he had received in 1839 was a contributing cause. Josiah Wilbarger never completely recovered from a scalping by Comanche Indians while he was hunting in August, 1833. He died in 1845. He would have died from the scalping but his wife had a dream of the scalping and directed her neighbors where to find him.

John M. Hansford and Robert Potter were killed in the East Texas Regulator-Moderator War in 1844.

Two men were killed in Mexican revolutions. Miguel Hidalgo y Costilla, a Catholic priest, often considered the father of Mexican independence and champion of human rights, led an unsuccessful revolt which resulted in his capture and execution in 1811. Col. Antonio Zapata, a Federalist, was captured by the Centralists as he attempted to defend the abortive Republic of the Rio Grande. He was executed on March 15, 1840. His head was preserved in a cask of brandy and taken to Guerrero, where it

was displayed on a pike to the townspeople in front of Zapata's residence.

Of the remaining twenty-three violent deaths not due to military action, a surprising six were suicides. Phillip Dimmitt committed suicide in 1841 while he was a Mexican prisoner in order to avoid execution, and James Collinsworth committed suicide in 1838 while a candidate for the presidency of the Republic of Texas. George Campbell Childress, committed suicide in Galveston October 6, 1841, during a mental depression. Peter William Grayson committed suicide on July 9, 1838, at Bean's Station, Tennessee, due to ill health. Anson Jones took his own life in Houston January 9, 1858, after the legislature did not send him to Washington as senator, and Royal T. Wheeler committed suicide in Washington County on April 9, 1864.

Three men were murdered: René-Robert Cavelier Sieur de La Salle never set foot in what is now La Salle County. He was exploring Texas in the name of France when his men killed him in 1687, probably in present-day Grimes County. Thomas Jefferson Chambers was murdered at his home in Anahuac in 1865. The same fate befell John McMullen in San Antonio January 21, 1853.

Three men drowned. Robert M. Coleman, survivor of many battles, drowned while bathing in the Brazos River near Velasco in 1837. James Hamilton, one-time governor of South Carolina, was a friend of Mirabeau B. Lamar and rendered financial aid for the Texas Revolution. He was about to arrange a $5,000,000 loan for the Republic when Sam Houston was elected president, canceled the project, and refused to pay Hamilton his fee of $210,000. In 1857, Hamilton finally had word that Texas was willing to settle the debt. On November 15, 1857, while in passage to Galveston, his ship was rammed. Hamilton drowned when he surrendered his life preserver to a woman and her child. Alexander Somervell, who commanded the Somervell Expedition, later became collector of customs at the port of Calhoun. His body, found under mysterious circumstances, was lashed to the timbers of the capsized boat in which he had started from Lavaca, carrying a large sum of money to Saluria.

Two men were killed accidentally. William Wharton was killed when his pistol discharged while he was dismounting near Hempstead in 1839. Abel Parker Upshur, secretary of state under Pres. John Tyler and a strong supporter of Texas annexation, was killed during an excursion down the Potomac River on the warship *Princeton*. Part of the entertainment was an exhibition of the ship's firing power. On the third discharge of the great gun, the breech exploded, killing Upshur and Thomas W. Gilmer. Upshur County was named for Upshur, and its county seat was named for Gilmer.

Apparently none of these men were killed in duels, even though several participated in them. James Bowie and Andrew Jackson

killed their opponents in duels. Wylie Martin, of Georgia, came to Texas in 1823 after killing a man in a duel. The Hardin brothers came to Texas to avoid an indictment of murder against one of the brothers. Robert Potter left North Carolina because he had maimed several people. Volney Ershine Howard, while editor of *The Mississipian,* fought several duels and was wounded in one with Hiram Runnels, then governor of Mississippi. Both Howard and Runnels later came to Texas and had counties named for them. Dr. Anson Jones returned to Brazoria after the Texas Revolution and evicted James Collinsworth from his office by a challenge to duel; he then resumed practice. Both of these men also had counties named for them.

In spite of fame and heroism, several men died in poverty, including Sidney Sherman, Baron de Bastrop, and Gen. John B. Hood, who also lost an arm and a leg in the Civil War.

The occupations of the men honored by county names are quite varied. I have described numerous military figures, Indian fighters, rangers, and government officials. Before coming to Texas, several men had been governors of other states: Mississippi, Tennessee, Virginia, and South Carolina. Most of these men had two or more occupations. They lived during a time when most people worked in agriculture, so it is not surprising to find that dozens of these men were also farmers, plantation owners, ranchers, and cattle drovers. For example, George T. Wood chartered a sloop to transport his family and thirty slaves to Texas in 1839. He operated a large plantation in present-day San Jacinto County, fought in the Mexican War, and was later governor of Texas. Oliver Loving was a farmer, freighter, rancher, and cattle drover. Samuel Maverick, Mifflin Kenedy, and Jim Wells were famous ranchers.

There were at least a dozen doctors honored by county names. One was Anson Jones, a physician, diplomat, plantation owner, and president of the Republic of Texas. There were several flatboat operators and ship captains, including Ben Milam, John Richardson Harris, Mifflin Kenedy, and George Washington Glasscock, who operated a flatboat in partnership with Abraham Lincoln. There were dozens of lawyers serving in every capacity from county judge to president of the Republic, from private to general, as well as conducting private practice: Jonas Harrison represented Sam Houston in his divorce from his first wife, Eliza Allen.

There were a few ministers. Rev. William Carey Crane was a Baptist preacher and president of Baylor University; Rev. John Denton, the Indian fighter, was an itinerant Methodist preacher; Rev. James C. Wilson was an Oxford graduate and a Methodist minister; and Father Miguel Hidalgo y Costilla was a Catholic priest. Empresarios, or colonizers, included David G. Burnett, Green DeWitt, Haden Edwards, Ben Milam, Sterling Robertson,

Stephen F. Austin, John McMullen, Martín de León, and Lorenzo de Zavala. There were several successful writers: George Wilkins Kendall, a journalist, explorer, and sheep rancher, wrote *Narrative of the Santa Fe Expedition;* and Henderson Yoakum, a West Point graduate, war veteran, and lawyer wrote the important *History of Texas.* Both these books are valuable historical sources today.

Although the great western fur trade declined before Texas' independence, there were a few trappers, including Michel B. Menard and Martin Parmer, who was called the "Ringtailed Panther from the forks of the creek." Buffalo hunters included W. S. Sterling. Some of the counties named for merchants and Indian traders include Briscoe, Burnett, Gillespie, Harris, and McMullen. As large areas were being settled, there were opportunities for surveyors, engineers, and architects, such as Daniel Montague, Gustav Schleicher, and William Ward.

Naming County Seats

THE 254 COUNTY SEATS at the time of the 1990 census varied in population from 50 in Mentone, Loving County, to 1,630,553 in Houston, Harris County. Many county seats were named long after the county had been designated by the state legislature. The location of county seats has been changed in many counties: Dallam, DeWitt, and Robertson county seats have changed five or more times.

The majority of county seats, at least 140, are named for an important person or family. About 100 county seats are named for a geographic location, and the remainder are named for various other reasons, some quite sentimental or frivolous. The persons honored by county seat names are a diverse group, from princes to cowboys. Fredericksburg and New Braunfels are named for German princes. The Duke of Wellington, victor at the Battle of Waterloo, was honored by the British ranch owner who settled Collingsworth County. There are county seats named for several American presidents (Madison, Jefferson, and Tyler) and presidents of the Republic of Texas (Jones, Austin, Burnet, and Lamar), and the president of the Confederacy (Fort Davis). There are numerous Texas and Confederate heroes and martyrs, such as James Bonham, Gen. Thomas Jefferson Rusk, David Crockett, John B. Denton, Gen. Robert E. Lee, and "Stonewall" Jackson. Several county seats, including Seguin, Uvalde, Zapata, Gonzales, and Floresville, are named for Spanish or Mexican leaders. Quanah, Parker County, is the only county seat named for an Indian, Comanche chief Quanah Parker. Several county seats are named for Indian fighters, including Denton, Andrews, Rusk, and Eastland.

When the counties of the great western plains were organized, there were very few people around. Sometimes naming the county seat wasn't taken very seriously. In 1887, the first train was brought into a watering stop, which was to become the seat of Armstrong County. Apparently no one had a name for the proposed new town. "It ain't got a name; well, call it Claude," said Claude Ayres, the locomotive engineer, and the town was named Claude after that remark. Numerous other county seats-to-be were named by and for railroad workers or their family members. Land specu-

lators and developers also named several county seats. Charles W. Post, the cereal manufacturer, started a settlement in Garza County and the county seat is named for him. Brady, McCulloch County, and Montague, Montague County, are named for the early surveyors who laid out the towns.

Prominent ranchers and other early settlers have county seats named in their honor, including Kingsville of Kleberg, Beeville of Bee, Marlin of Falls, Cotulla of La Salle, Benjamin of Knox, and George West of Live Oak, Seymour, the Baylor county seat, is named for a cowboy, Seymour Munday. Early storekeepers honored by county seats include W. J. Boston in Bowie County and Oscar Brackett for Brackettville in Kinney County. Isaac Conroe's sawmill is the source for Conroe, seat of Montgomery County.

Although no counties are named for women, several county seats are. Alice, Jim Wells County, was named for Alice Gertrudis King Kleberg when the King ranch extended into the county. Edna, Jackson County, was named for a daughter of railroad builder Joseph Telferner. Clarendon, Donley County, was named for Clara, wife of the founder, Rev. Lewis Henry Carhart. Hallettsville, Lavaca County, was named for Mrs. John Hallett, who gave the land for the townsite. Sarita, Kenedy County, was named for Mifflin Kenedy's granddaughter, Sara. Henrietta, Clay County, was meant to be for the wife of Henry Clay, for whom the county was named. Marfa, Presidio County, was named by the wife of the president of the Texas and New Orleans Railroad for the heroine of a Russian novel. Silverton, Briscoe County, was named not for, but by, a woman—Mrs. Z. T. Braidort, an early settler. San Angelo, Tom Green County, was named by Bart DeWitt, an early trader, for his wife's sister. The sister was a Mexican nun named Santa Angela. I suspect that women had a greater role in naming county seats and designing courthouses than is generally known.

I haven't studied the wives of the men for whom the counties and county seats were named. Some of these women are well known in their own right and have been widely publicized. Mary, wife of Samuel Maverick, wrote a delightful and historically valuable autobiography. On the romantic side, Lorenzo de Zavala married Emily West, otherwise known as the "Yellow Rose of Texas." There are a few county seats which originated during Spanish occupation and were given religious names; Santísima Trinidad de la Libertad (Liberty), Nuestra Señora del Refugio (Refugio), and Nuestra Señora de Guadalupe de Jesus Victoria (Victoria).

A few counties honored men by naming the county by their family name and the county seat by their given name, or vice versa.

APPENDIX D

County	County Seat	Namesake
Borden	Gail	Gail Borden
Collin	McKinney	Collin McKinney
Jefferson	Beaumont	Jefferson Beaumont?
Rains	Emory	Emory Rains

George Glasscock was honored by having Georgetown, seat of
Williamson County named for him; then later Glasscock County
was named for him.

Of the hundred county seats named for geographic locations,
twenty-three are named for other cities, most of which are readily recognizable.

County Seat	County	Named For
Abilene	Taylor	Abilene, Kansas
Albany	Shackelford	Albany, Georgia
Anahuac	Chambers	Ancient capital of Mexico
Athens	Henderson	Athens, Georgia, or Greece?
Canton	Van Zandt	Old Canton, Smith County, Texas
Carthage	Panola	Carthage, Mississippi
Columbus	Colorado	Columbus, Ohio
Corsicana	Navarro	Corsica, Italy
Edinburg	Hidalgo	Edinburgh, Scotland
Fairfield	Freestone	Fairfield, Alabama
Huntsville	Walker	Huntsville, Alabama
La Grange	Fayette	LaGrange, Tennessee
Laredo	Webb	Laredo, Spain
Linden	Cass	Linden, Tennessee
Livingston	Polk	Livingston, Alabama
Memphis	Hall	Memphis, Tennessee
Mentone	Loving	Mentone, France
Odessa	Ector	Odessa, Russia
Paducah	Cottle	Paducah, Kentucky
Palestine	Anderson	Palestine, Ohio
Paris	Lamar	Paris, France
Richmond	Fort Bend	Richmond, Virginia
Stratford	Sherman	Stratford-on-Avon

There are twenty-four county seats with the same name as another county. This creates a very confusing situation unless you
are a local citizen.

County Seat and County	County and County Seat
Anderson—Grimes	Anderson—Palestine
Austin—Travis	Austin—Bellville
Bellville—Austin	Bell—Belton
Caldwell—Burleson	Caldwell—Lockhart
Cameron—Milam	Cameron—Brownsville
Colorado City—Mitchell	Colorado—Columbus
Crockett—Houston	Crockett—Ozona
Dimmitt—Castro	Dimmit—Carrizo Springs
Franklin—Robertson	Franklin—Mount Vernon
Gainesville—Cook	Gaines—Seminole
Hemphill—Sabine	Hemphill—Canadian
Henderson—Rusk	Henderson—Athens
Houston—Harris	Houston—Crockett
Huntsville—Walker	Hunt—Greenville
Jefferson—Marion	Jefferson—Beaumont
Johnson City—Blanco	Johnson—Cleburne
Kingsville—Kleberg	King—Guthrie
Pecos—Reeves	Pecos—Fort Stockton
Robert Lee—Coke	Lee—Giddings
Rusk—Cherokee	Rusk—Henderson
Sherman—Grayson	Sherman—Stratford
Stephenville—Erath	Stephens—Breckenridge
Tyler—Smith	Tyler—Woodville
Woodville—Tyler	Wood—Quitman

Among the specific locations for which county seats were named, we find forts (Mason), Spanish missions (Victoria), rivers (San Marcos), creeks (Hondo), bays (Matagorda), ranches (Muleshoe), lakes (Big Lake), springs (Rock Springs), passes (Eagle Pass), buffalo hunters' camps (Sweetwater), caves (the caves of Sonora), mountains (Bandera), and geologic formations (Rockwall).

Several towns are named for their general location or surroundings instead of for a specific location. These are often euphemistic names, and some are obviously named to promote the town. There's Alpine (Brewster), Crystal City (Zavala), Eldorado (Schleicher), Glen Rose (Somervell), Groveton (Trinity), Junction (Kimble), Lamesa (Dawson), Longview (Gregg), Garden City (Glasscock), Levelland (Hockley), Plainview (Hale), Pampa (Gray), Aspermont (Stonewall), and Mount Pleasant (Titus). Other names are Hereford for the Hereford cattle ranches in Deaf Smith County, Cuero for buffalo hides in DeWitt County, Orange for orange groves in Orange County, Waxahachie which is Indian for buffalo in Ellis County. Then there are Center and Centerville, for location in the center of their counties. Midland is

halfway between Fort Worth and El Paso. Meridian is named for its proximity to the 98th meridian longitude. Miami (Roberts County) is Indian for sweetheart, and Falfurrias may be Spanish for a flower named "heart's delight."

Some county seat names have been changed for the better:

County	Present Name	Former Name
Coke	Robert Lee	Hayrick
Dallam	Dalhart	Twist
Donley	Clarendon	Saint's Roost
Edwards	Rocksprings	Bullhead
Fannin	Bonham	Bois d' arc
Jackson	Edna	Macaroni Station
Lamar	Paris	Pinhook
Lamb	Littlefield	Burro School
McMullen	Tilden	Dogtown
Nolan	Sweetwater	Blue Goose
Potter	Amarillo	Ragtown
San Jacinto	Coldspring	Coonskin
Waller	Hempstead	Six-Shooter Junction

Some county seats may have been better with the original names. Waxahachie, or Indian for Buffalo Creek, would have been easier to spell if the English translation had been used.

There are fifty-six county seats with the exact name as their county or a name derived from the county name such as Archer City, Archer County, and Beeville, Bee County.

Andrews	Floydada	Mason
Archer City	Fort Davis	Menard
Bandera	Galveston	Midland
Bastrop	Goliad	Montague
Beeville	Gonzales	Nacogdoches
Belton	Hamilton	Newton
Brownwood	Haskell	Orange
Burnet	Hillsboro	Palo Pinto
Childress	Jacksboro	Rockwall
Coleman	Jasper	San Augustine
Comanche	Karnes City	San Saba
Crane	Kaufman	Throckmorton
Crosbyton	Kerrville	Uvalde
Dalhart	Lampasas	Victoria
Dallas	Liberty	Wharton
Denton	Lipscomb	Wheeler
Dickens	Llano	Wichita Falls
Eastland	Lubbock	Zapata
El Paso	Madisonville	

NAMING COUNTY SEATS

Several county seats were originally county seats of other counties. This came about when a county was divided into two or more counties and the existing county seat became the seat of a newly organized county. The following are examples:

County Seat	Original County	Present County
Rockport	Refugio	Aransas
Caldwell	Milam	Burleson
Leakey	Edwards	Real
Fort Davis	Presidio	Jeff Davis

Bibliographic Essay

T HE LITERATURE SURROUNDING TEXAS COURTHOUSES is sparse. Clark Coursey's *Courthouses of Texas* (Brownwood: Banner Printing, 1962) is almost a classic, and it is just thirty years old. The only other works to attempt descriptions of courthouses in all 254 counties are *The Texas Courthouse* (Dallas: G.L.A. Press, 1971) and *The Texas Courthouse Revisited* (Dallas: G.L.A. Press, 1984), both by June Rayfield Welch and J. Larry Nash. These two, along with Coursey's book, appear to have been compiled from questionnaires or surveys sent to each courthouse. They are still very useful in that they list each county and present a photograph of each courthouse.

More depth of architectural feeling and commentary is in Willard B. Robinson's books. Particularly useful are *The People's Architecture, Texas Courthouses, Jails, and Municipal Buildings* (Austin: Texas State Historical Association, 1983), *Texas Public Buildings of the Nineteenth Century* (Austin: University of Texas Press, 1974), and *Gone from Texas* (College Station: Texas A&M University Press, 1982). Robinson's love for Texas architecture burned with a clear blue flame and that love is reflected in his books.

Immensely useful also is James Wright Steely, *A Catalog of Texas Properties in the National Register of Historic Places* (Austin: Texas Historical Commission, 1984); this needs to be used with the pamphlet *Texas County Courthouses,* also by the Historical Commission. Other general studies include Richard Pare's *Court House: A Photographic Document* (New York: Horizon Press, 1978) and Paul Goeldner's *Texas Catalog: Historic American Buildings Survey* (San Antonio: Trinity University Press, 1976).

The social history of courthouses in Texas is somewhat elusive. Some of the best works were not widely published, such as Paul Goeldner's "Temples of Justice: Nineteenth-Century County Courthouses in the Midwest and Texas" (Dissertation, Columbia University, 1970). Goeldner's work is an interesting and human survey and recitation of style, attitudes, and vignettes about courthouses, their builders, and relationships with county officials. The best sources for social history, and often courthouse history, are the hundreds of county histories compiled by dedicated Texans. There are few such histories that do not make men-

tion of the courthouses of the county and particulars about them. While the quality of these histories varies dramatically, all county histories seem to have an enthusiasm for their subject that is infectious. Many county history writers themselves spent untold hours in the clerks' offices patiently paging through county records and faithfully transcribing them. This heroic effort, often unrecognized, deserves greater appreciation. County histories chronicle much of the work-a-day lives of early Texans, and the investigation of these histories in regional groups reveals patterns of historical development, immigration, and social structure that have a special fascination.

Related to the social history is a body of work on the geographic and historical derivations and significance of the courthouse square. Such studies include Garland Sadler Anderson, Jr., "The Courthouse Square: Six Case Studies in Texas" (Master's thesis, University of Texas, Austin, 1968); Edward T. Price, "The Central Courthouse Square in the American County Seat," *Geographical Review* 58 (1968): 29–60 (an intriguing study that places courthouse squares in a national and regional perspective); and finally, the redoubtable Willard B. Robinson's "The Public Square as a Determinant of Courthouse Form in Texas," *Southwestern Historical Quarterly* 75 (1971–72): 339–72. All are helpful.

Biographical and critical studies on major historical Texas architects are difficult to obtain. Mary Carolyn Hollers Jutson, *Alfred Giles: An English Architect in Texas and Mexico* (San Antonio: Trinity University Press, 1972) is excellent, but unfortunately appears to be almost unique. Paul Goeldner "Our Architectural Ancestry," *Texas Architect* 24 (July–August, 1974): 5–8 provides brief biographical entries on Giles, Ruffini, Flanders, Wilson, Gordon, and others, but much more needs to be done. Actually, there is biographical literature available, but it is fugitive—difficult to obtain. There is quite a bit of material on J. Riely Gordon, for example, but it is contemporary (Gordon left Texas for New York and was thirteen times the president of the New York Society of Architects).

Last, but by no means least, the venerable *Handbook of Texas* is both the historian's bane and blessing. It is indispensable and frustrating at the same time. It is a blessing because some of the essays are startlingly informative—frustrating, because only *some* of the entries are. We must eagerly await the new edition.

Index

Galvez, Bernardo de, 114
Galvez, 292
Garden City, 117, 288, 307
Garner, John Nance, 262
Garza County, 7, 11, 13, 19,
 115, 289, 292, 305
Garza County Museum, 115
Gatesville, 80, 288
Gentry, A. C., 231
geography, 3–4
Georgetown, 46, 117, 288, 306
George West, 179, 288, 305
Geren, Preston M., 212, 213
Gibson, John Joseph Emmett,
 240
Giddings, Jabez Deming, 174
Giddings, 174, 288, 307
Giles, Alfred, 15, 54, 58, 116,
 118, 160, 179, 219, 270, 277,
 312
Gill and Bennett, Inc., 67
Gillcoat and Skinner, 136
Gillespie, Richard Addison,
 116, 300
Gillespie County, 25, 116, 288,
 292, 303
Gilmer, Thomas W., 260, 301
Gilmer, 260, 288
Glasscock, George W., 117,
 276, 302, 306
Glasscock County, 19, 27, 117,
 288, 306, 307
Glen Rose, 10, 243, 288, 307
Glover, F. S., 123
Glover, J. M., 56
Goeldner, Paul, 311, 312
Goldthwaite, Joseph G., 197
Goldthwaite, 4, 197, 288
Goliad, 5, 118, 288, 299, 308
Goliad County, 15, 16, 17, 23,
 118, 288, 296
Goliad Massacre, 60
Gonzales, Rafael, 119
Gonzales, 5, 119, 288, 304, 308
Gonzales County, 14, 16, 17,
 119, 288
Gordon, J. Riely, 15, 312;
 courthouses by, 45, 76, 100,
 102, 105, 119, 132, 142, 174,
 185, 265, 279
Graham, Edwin S., 282
Graham, Gustavus A., 282
Graham, 282, 288

Granbury, Hiram C., 141
Granbury, 141, 288
Gray, Ephraim, 266
Gray, Peter W., 120
Gray, Pleasant, 266
Gray County, 19, 120, 289,
 292, 307
Grayson County, 14, 20, 121,
 289, 292
Grayson, Peter William, 121,
 301
Green, L. S., 258
Green, Thomas, 146, 256
Greenville, 13, 146, 288, 307
Gregg, John, 122, 292
Gregg County, 20, 122, 288,
 300, 307
Gregg County Historical Mu-
 seum, 122
Grimes, Jesse, 123
Grimes County, 7, 16, 17, 123,
 287, 301
Groesbeck, 177, 288
Groos, Clift & Ball, 82
Groveton, 258, 288, 307
Guadalupe County, 14, 124,
 289, 296
Gunn & Curtis, 250
Guthrie, W. H., 165
Guthrie, 15, 26, 165, 288, 307

Hale, John C., 125, 299
Hale County, 7, 18, 125, 289,
 307
Hall, Warren D. C., 126
Hall County, 19, 126, 289, 306
Hallet, John, 173
Hallet, Mrs. John, 305
Hallettsville, 8, 173, 288, 305
Hamilton, James, 127, 301
Hamilton, 4, 57, 127, 288, 308
Hamilton County, 4, 17, 24,
 127, 288
Hamilton County Museum,
 127
Hammond House, 228
Hansford, John M., 128, 300
Hansford, 128
Hansford County, 128, 289
Hardeman, Bailey, 129
Hardeman, Thomas Jones, 129
Hardeman County, 19, 129,
 289, 292

The Courthouses of Texas was composed into type on a Compu-graphic digital phototypesetter in nine and one half point Sabon with one and one half points of spacing between the lines. Sabon was also selected for display. The book was designed by Cameron Poulter, typeset by Metricomp, Inc., and printed offset by Hart Graphics, Inc. The paperback books were bound by Hart Graphics, Inc. The cloth bound books were bound by Custom Bookbindery, Inc. The paper on which this book is printed carries acid-free characteristics for an effective life of at least three hundred years.

TEXAS A&M UNIVERSITY PRESS
COLLEGE STATION